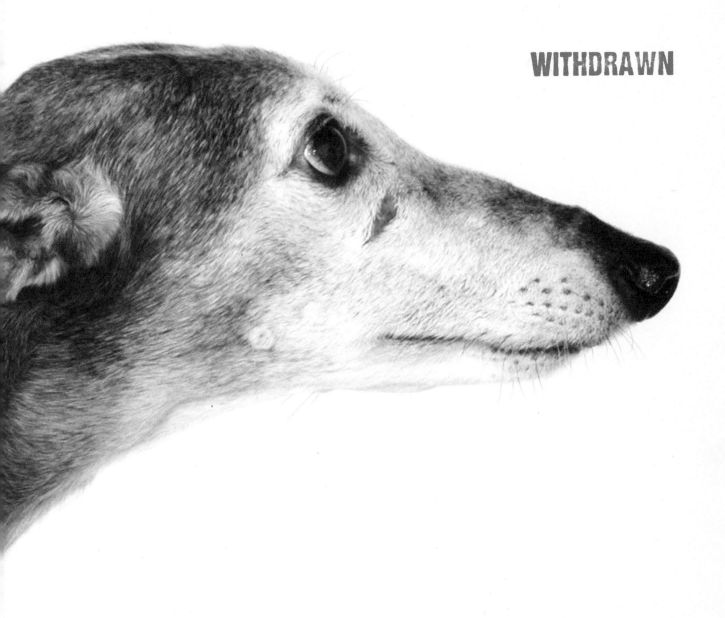

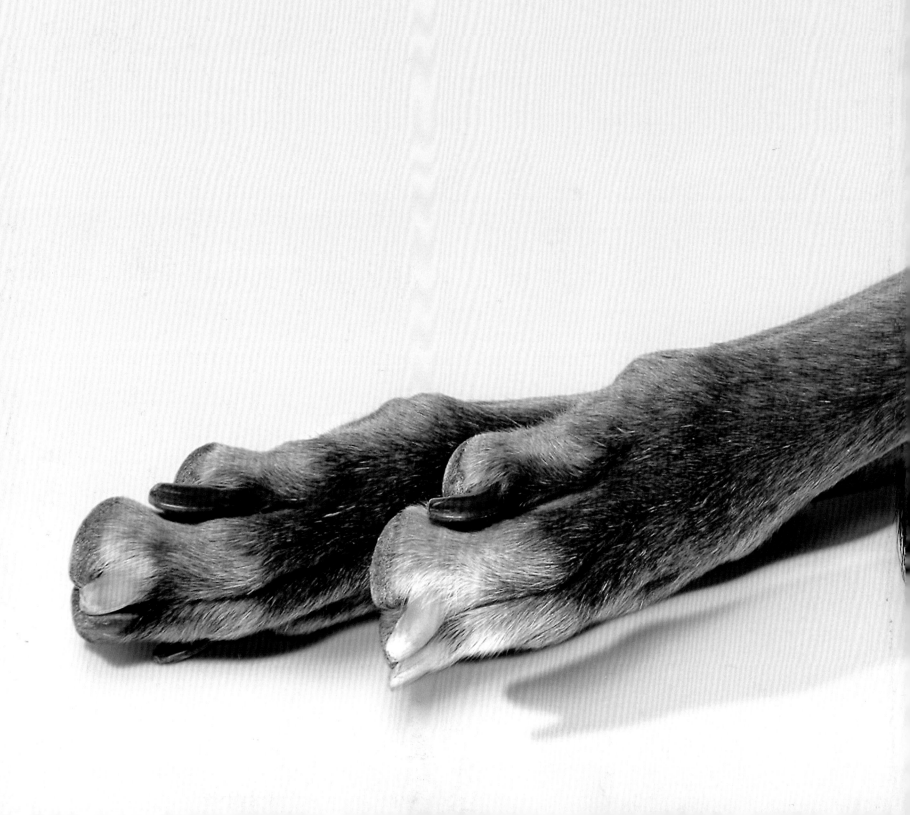

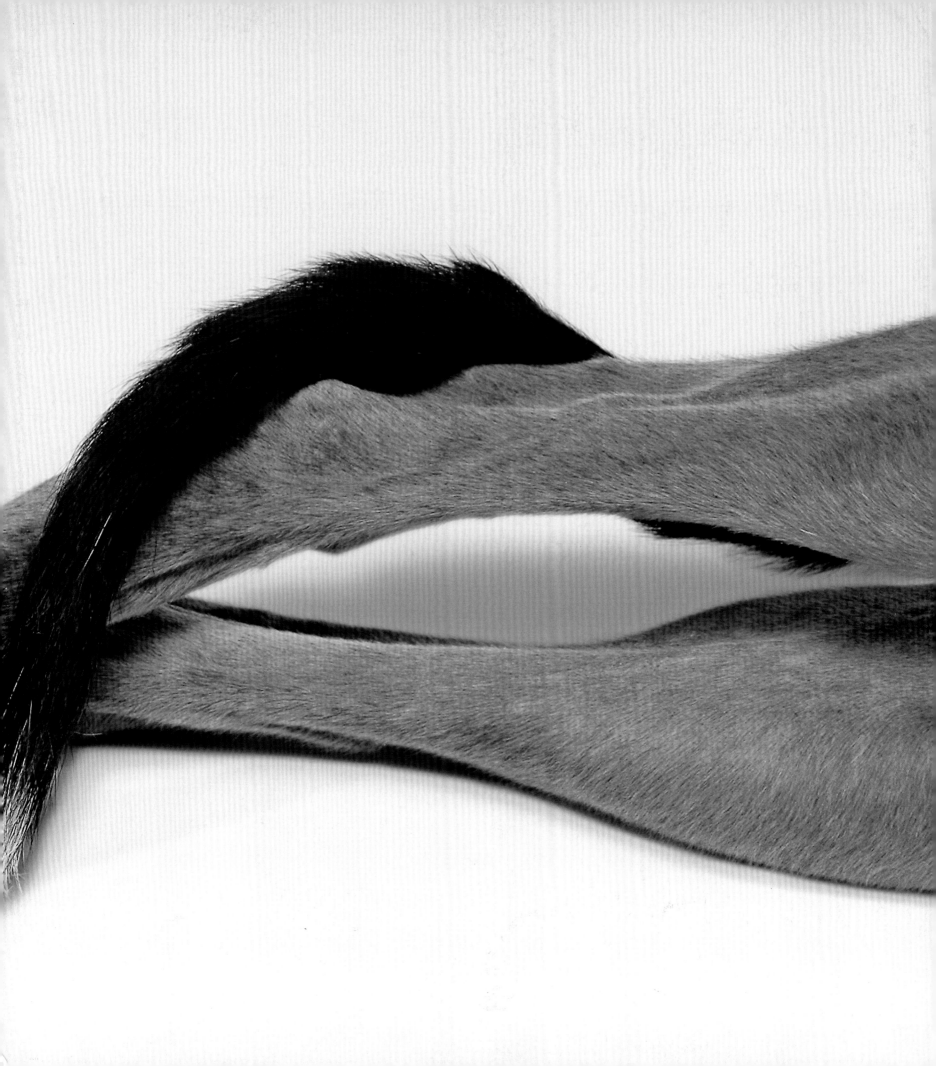

BARBARA KARANT
GREYHOUNDS

STEWART, TABORI & CHANG
NEW YORK

THE DOGS: ODYSSEY PRIDE AMBER BOY MAURA BRUCE BRIANNA LACEY JOSIE FINN RILEY CANCAN JOE OSAGE DOC TRAVIS DOLLY LEENA JAKE PENELOPE MAYA AURA AZURA JOSEPH BLANCA MAX FRILLY JULIET DINO DOVE HALEY FRAN VAL BABY BUTTERCUP BLOOMBERG SPREE BASH RIVER PETALS BAR BLUE ELMO ANNIE GEM MATTIE BART ZUMO BRITTANY GABLE TUFFIE RY RY DUSTY BRENDA RALEIGH JETHRO PEARL RIP TIDE WYATT WHIZ BILLY PEACHES STETSON EASTON SLIM FANCY TURTLEDOVE G.T. HATTIE JOKER BILL MINDY EARL FRISKY JUMPER SADIE MONTY SILVIE ELLA TIPPER SALLY EMMA LOVE CHIEF IZZY CLAUDETTE PATTY SHADOW COOKIE THUNDER MOSES RADAR CHEETO COPPER OLIVE SAMPSON VELVET INDIGO CHICO RUSH WALT CYNTHIA

FOREWORD ALAN LIGHTMAN INTRODUCTION ALICE SEBOLD

AFTERWORD YVONNE ZIPTER LAST WORD NEKO CASE KIMMY DIP STINGER CHANCE KAHUNA CRYSTAL ROXY BABI BEAN MIDI LUCY GAIL SCOOTER REMBRANDT COWBOY GOLDIE SUPER JAVA ONYX ANDRETTI PESCE BECKAM ROPES LADY TWIST TSAR LITTLE B WRIGLEY DUKE TOPAZ JANIE PIRATE DOUGIE MISS BLUE BB GUN DESPERADO CHATEAU NACHO BAY YOKO KNIGHT GARVEY KIMBA RAMSEY CHASE TONY LILY ARIELLE HOPE HONCHO TULIA IRIS TINA BABS WINSTON TULLY POSEY ALEXANDRA MIKE MASON DRAKE ZSA ZSA PATSY DIME CENTS TERRI LEXI BO FRANKLIN PENNY FISHER MIKEY SHEILA ALBERT WITH A LITTLE LICK FROM MONKEY BUDDY DUO ROSS GENIUS FOOTS NOBLE MARCUS HENRY JADE TREAT EMERSON SURFRIDER CHAMP RHETT MISSY LINDA GAREN BLAZE DANDY LOLA NOODLE ARGUS ARRUBA BASIL

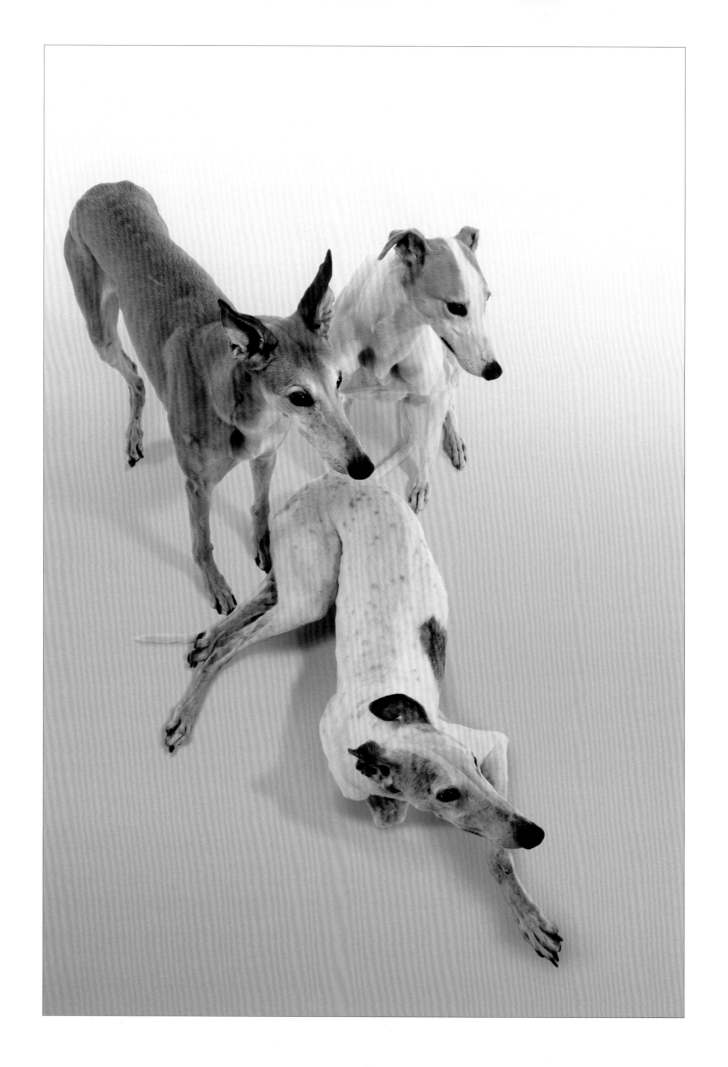

ALAN LIGHTMAN
MAGGIE, CAVAN, AND WHISPER

It is a snowy Tuesday afternoon in February. Maggie, Cavan, and Whisper have just arrived for their first visit, standing quietly and respectfully inside the front door until unleashed, then walking and sniffing about my house. For some reason, the three greyhounds remind me of tall, thin, and elegant women dressed in evening gowns. When I sit in a chair, they wander over and lie next to me. These animals are affectionate.

I look into their brown eyes and feel something at rest. And for me, this is the wonderful paradox of the greyhound: its speed mixed with stillness. The animal is built to run, with its sleek lines, the graceful rise of its belly to its high haunches, the nearly hairless coat, and the long weightless legs. Like a Gothic cathedral, its body illustrates function from form. It is the essence of motion in flesh. At the same time, the greyhound projects a calm and serenity. There is a gentleness. Runner, hunter, and yet center of stillness, the greyhound knows who it is. Could this be why pictures of greyhounds are etched on the walls of ancient Egyptian tombs? Why

the nomadic Arabs allowed only greyhounds, of all animals, into their tents? And doesn't the yin and yang of these noble animals have a message for us today in our time-driven world?

The ladies are gathered up again by their owner, seemingly satisfied by this small adventure and gently awaiting their car ride home. Their presence will linger long in my house.

Barbara Karant's love and respect for greyhounds shines through in her stunning photographs. She has made her greyhounds personal while also celebrating their majesty. I can add nothing to the superb essays by Alice Sebold and Yvonne Zipter. They have embraced these beautiful animals with their words as Karant has with her photographs.

As everyone knows, we human beings race greyhounds at the track for our amusement. Let us also befriend them, love them, and, finally, honor them as some of nature's most exquisite creations and as lessons for our own hearts.

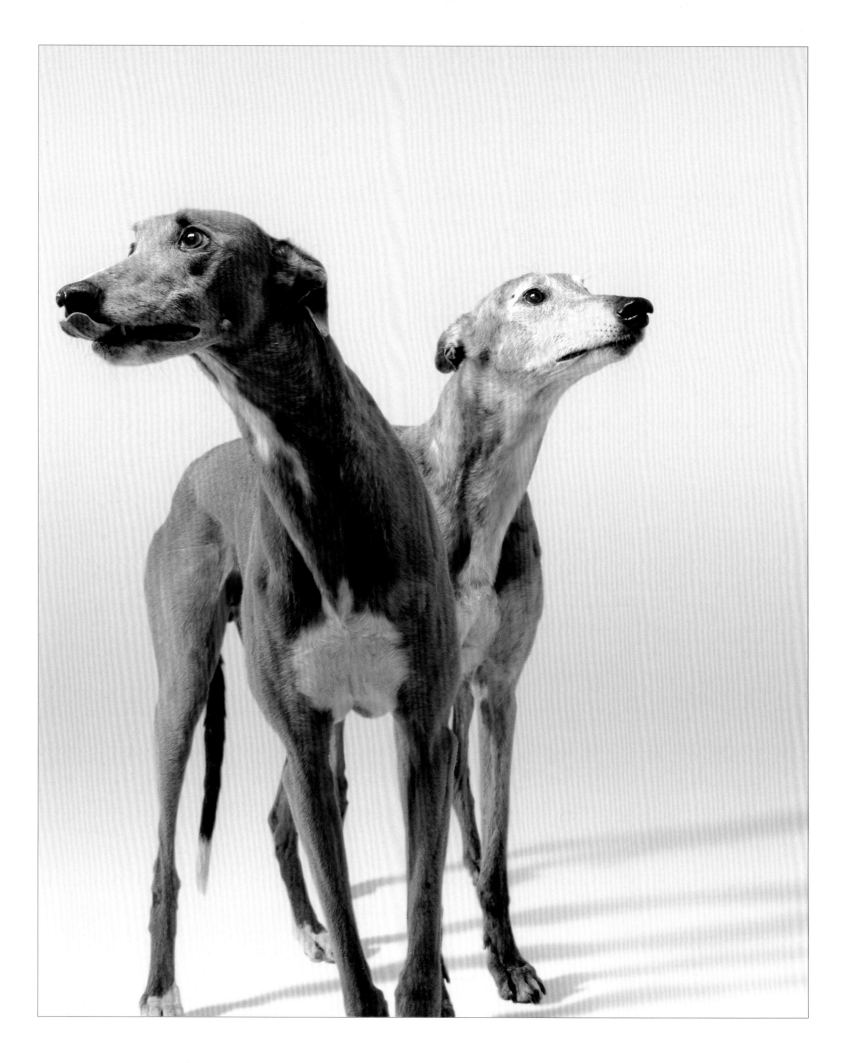

ALICE SEBOLD
TO LIVE WITH BEAUTY

To live among greyhounds is to live with beauty. There is no escaping it.

When I first saw Barbara Karant's photographs, I was stunned. Her marriage of the greyhound's line with transparent light makes the images at once so immediate and iconic that even strangers to the breed feel they know these dogs, feel they understand what it might be like to be among them.

I am a life-long dog lover—all dogs without exception—for one cannot hold a dog accountable for whether it was bred to sit on velvet tuffets or rip the throat out of a stranger. A dog is a dog is a dog.

Except, perhaps, when a dog is also a dragon, an athlete, a beautifully articulated dancer, a fine long bow's quiver, a mythic beast seen from a distance that occupies your dreams. This, for me, has always been the greyhound. A dog, until I saw Karant's photographs, that had been part of a life-long fantasy of the perfect adulthood. I did not dream of houses or trips abroad when I was younger but of perhaps more simple visions: five acres and five greyhounds, that was my goal— the ultimate mark of a worthy life.

It was the fan-like photograph of five dogs—three brindles and two fawns— that made me fall into the book of Karant's images and be lost among greyhounds for the remainder of a day. There it was on the page: the dream, so simple and so very doggy at once. These gorgeous dragons are also life companions after all, cuddlers, dogs that pant, scratch, turn about on their beds, or roll over to show you their divinely elongated bellies: your very own El Greco in the house!

From the fan of five I grazed among the photographs, looking at two faces with eyes cast up, one sweet muzzle dappled with gray, the other dog's ear at attention while also displaying that tender ear flap that whips in the wind when they run and can provide both comedy and nuance at rest (these marvelous fragile things tattooed for the track, numbers stamped into them!).

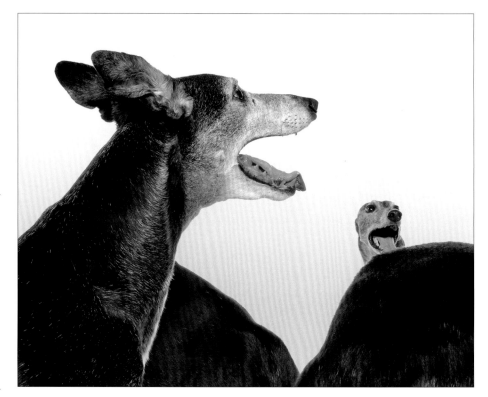

Karant has a particular ability to catch the angles and curves of the breed. She seems almost determined to stay away from the classic pose of greyhounds long seen in statues and paintings from the past. The greyhound sitting up, his lines softened, mouth closed. Dignified to the point of being not animal—but object. Perfect, like a lion, to guard a building's entrance, to make a bookend, to serve as lamp base. Not for Karant this choice. Her greyhounds are animals full of movement halted only by the close of her camera's shutter. A snowy-muzzled black hound widely smiling while in the background, almost hidden by the haunches of another black hound, is a fawn also smiling, his ears invisible they are so drawn back (making even further allusion in my mind to a classically trained ballerina). That tight skull with the hair pulled back. That tight skull with the ears drawn back. Obviously, despite the white backgrounds, these animals are responding, engaged, alive to their environment, the photographer, her assistants, the studio. (They know there are treats! They sense there are rubs!) The mythic beast, after all, evolves from the pure base animal.

Those white backgrounds. What do they do? They make the animals almost float, shifting perspective in the viewer's eye so that what the eye focuses on is the life and light animated by the dog or dogs. The white points out what it surrounds and simultaneously disappears, like someone whispering to you the answer to a question.

Isn't it unfathomable, I find myself thinking repeatedly as I dole out head rubs and flank scratches, that such an animal not only lives among us but chooses to love us?

The question is: what is a greyhound? These animals most of us don't think about except vaguely to know that they are both gifted and mistreated like so many of nature's most beautiful things. How can photographs lead to action? Lead to another way of seeing?

The network for greyhounds is large. On the frontlines to rescue these gorgeous animals are arrayed a varied number of groups. Karant in Chicago calls Judson in Berkeley and I have an address to go to: a meeting with the myth. More than myth, dream. This woman has five greyhounds and if not five acres of her own, the friendly hills of Berkeley as surround.

Inside the warm—it must be said, *dog friendly*—home of Barbara Judson, I meet the real McCoy. Lounging around the living room like displaced supermodels (only better because they are not human) are five rescued greyhounds. Two girls,

Squeak and Jubilee, fawn and brindle. And three boys, Rory, Elroy, and Bobby who, as the oldest, is both boss and fashion plate. He wears a Polartec wrapper for necessary warmth. I catch their names, I memorize their genders and the colors of their coats, I listen to snatches of their back stories: which track they came from in what state, how old they were when they retired, what their original soulless track names were and how Judson has changed or modified them. Mostly though, I sit with them, notice details about the breed. Those quivering ears that Karant photographs to perfection, the long toes of each paw as Rory extends his two legs against the floor in front of me. The divine leaning of the large light Jubilee against me. And when Elroy stands in front of the window for a moment, how the sun

shines in and *through* the back of his legs—how I can literally see bone and tendon as if the afternoon sun provides an impromptu X-ray.

They are—and this is what I think Karant gets just right—both icon and silly beast. Both athlete and heart's companion. How at once to show a dog's dogginess and not to overlook the fact that greyhounds are "other than" in that way that they are living works of art. Isn't it unfathomable, I find myself thinking repeatedly as I dole out head rubs and flank scratches, that such an animal not only lives among us but chooses to love us? And it is then that I think of another quality of Karant's work—how she catches both the moments of engagement: the smile, the head tilted up seeking eye contact—but also the moments of the animals' private thoughts. When their dignity and reserve, the culture that is not human, does not require us, takes over. A greyhound can be circumspect, it seems, lost in dream (too often, as they kick out at night in their beds, a racing nightmare), and blissfully removed from us.

A photograph: a dark gray shot from the back over the ridge of the back of another dog who you do not see except for dog-as-horizon-line. She or he is standing and looking away. The ears are semi-erect—half-mast as it were—and the profile of the face is at three quarters. And you and I and Karant have no idea what this animal is thinking or feeling in this captured moment. The animal is respected in this photograph, is acknowledged as a thing apart from us, an entity that try as we might we can never fully own, even if, clearly, we can dominate.

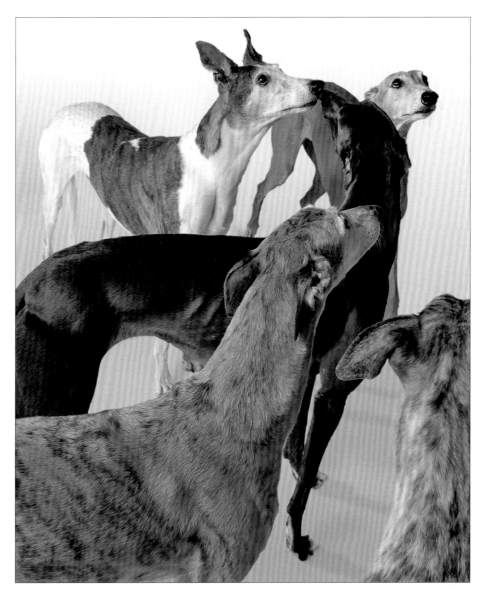

They are…both icon and silly beast. Both athlete and heart's companion.

To live with greyhounds is to live with beauty. It is also to be brave, to acknowledge that we accept the responsibility of being trustees for this beauty. It is this position in life—as a true trustee of beauty—that led Karant to take on this project, to know that it was not a choice to pursue it but a moral necessity. She has combined her acute skills as a photographer with her commitment to the breed and come to the obvious conclusion. That it was her duty to create this book. That she had the dedication to pull it off is a gift to us and perhaps a gift to the greyhound as a breed. How can you look into the eyes of these dogs and not wish to rescue them?

What is wonderful about this book is that it has provided you with that chance. You are helping them by holding it, by coming to a fuller understanding via every curve of haunch and splay of paw, of what these animals are. Flesh and bone; beauty and athlete; reality and dream.

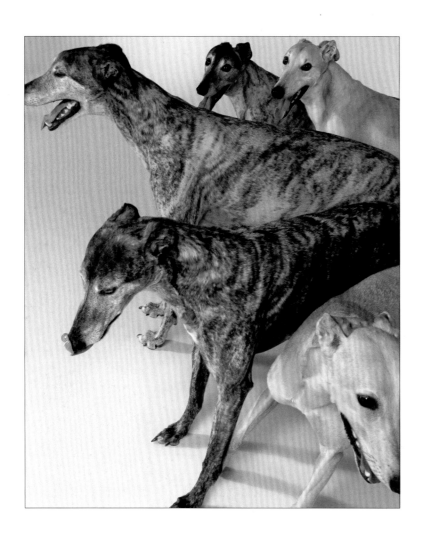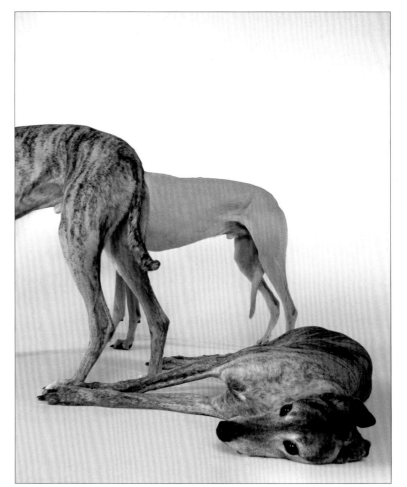

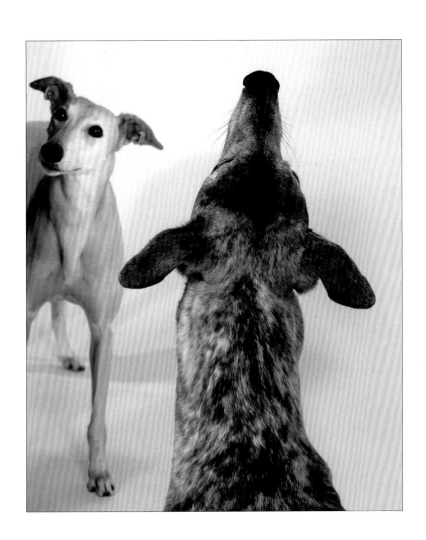

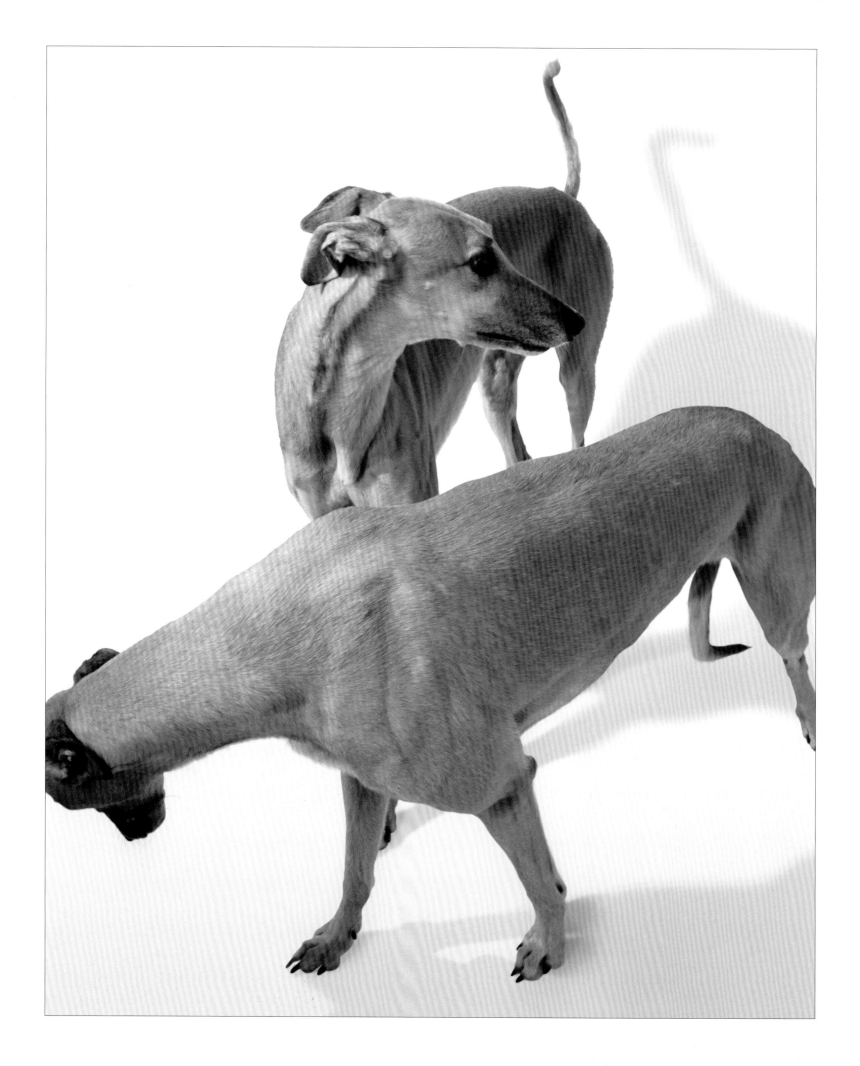

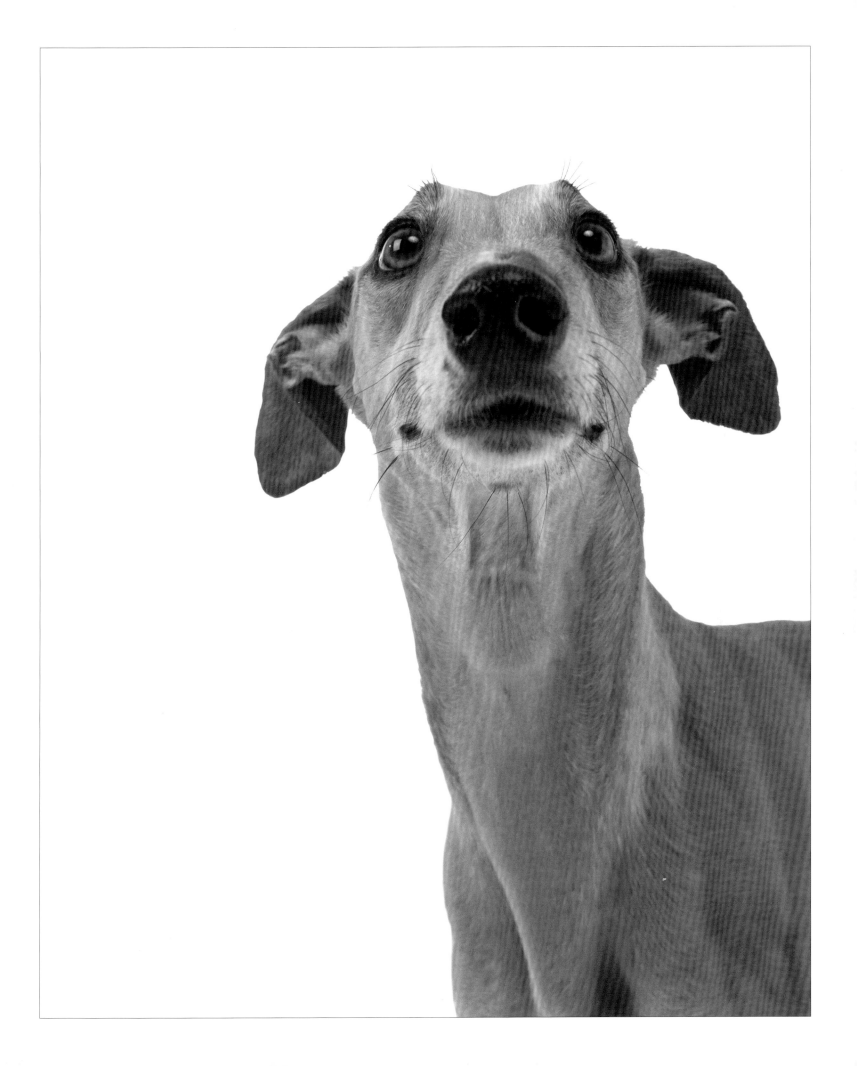

A GREYHOUND SHOULD BE HEADED LIKE A SNAKE AND NECKED LIKE A DRAKE,
FOOTED LIKE A CAT, TAILED LIKE A RAT,
BACKED LIKE A BEAM, SIDED LIKE A BREAM.

DAME JULIANA BERNERS, "THE PROPERTIES OF A GOOD GREHOUNDE," *THE BOOKE OF ST. ALBANS*, 1486

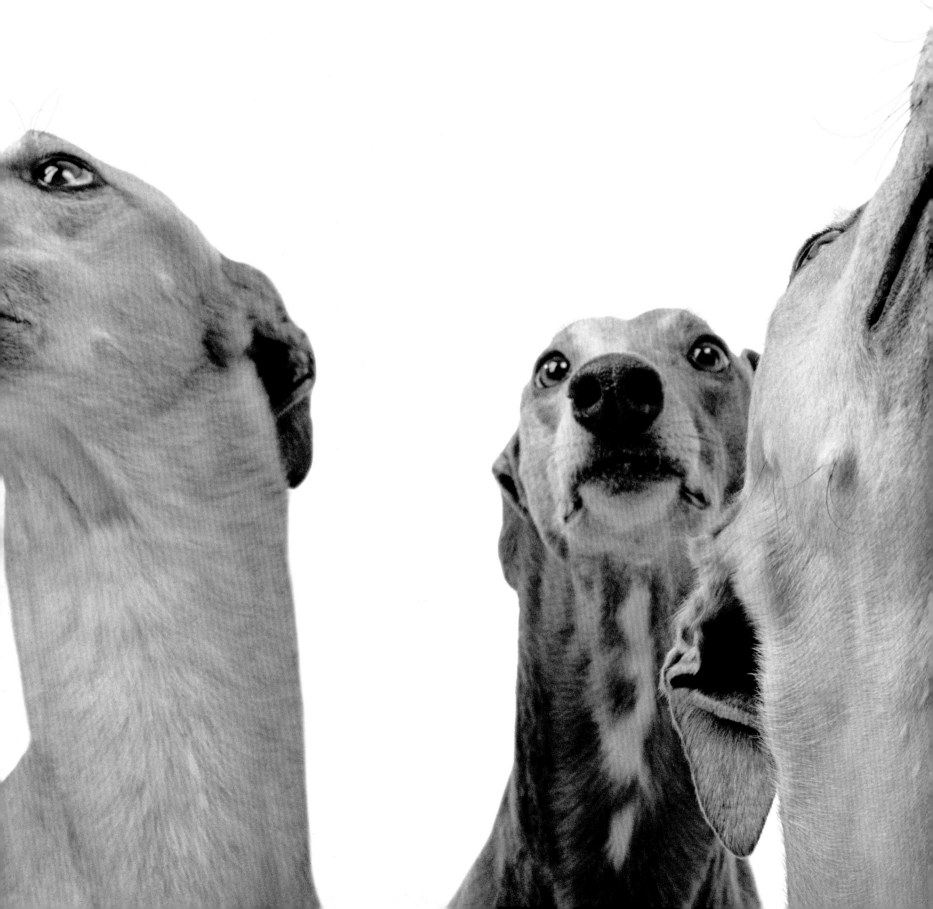

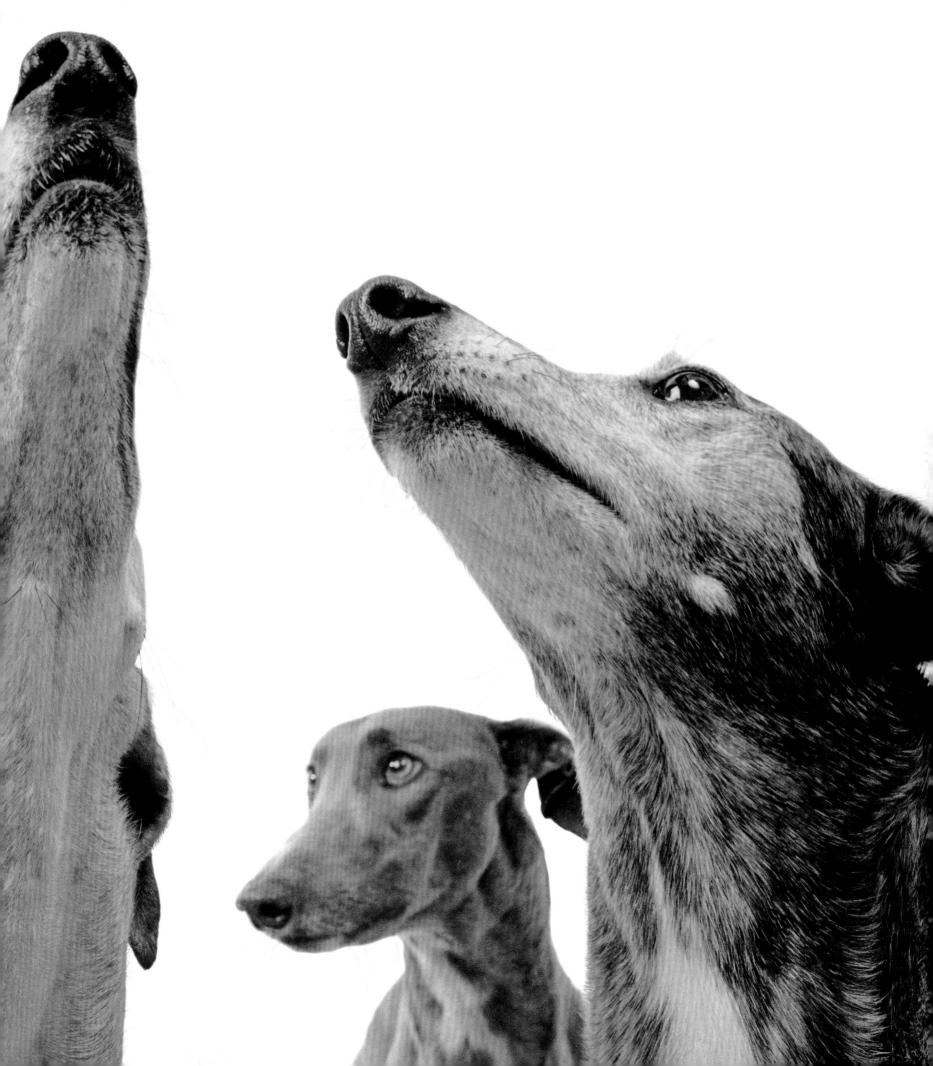

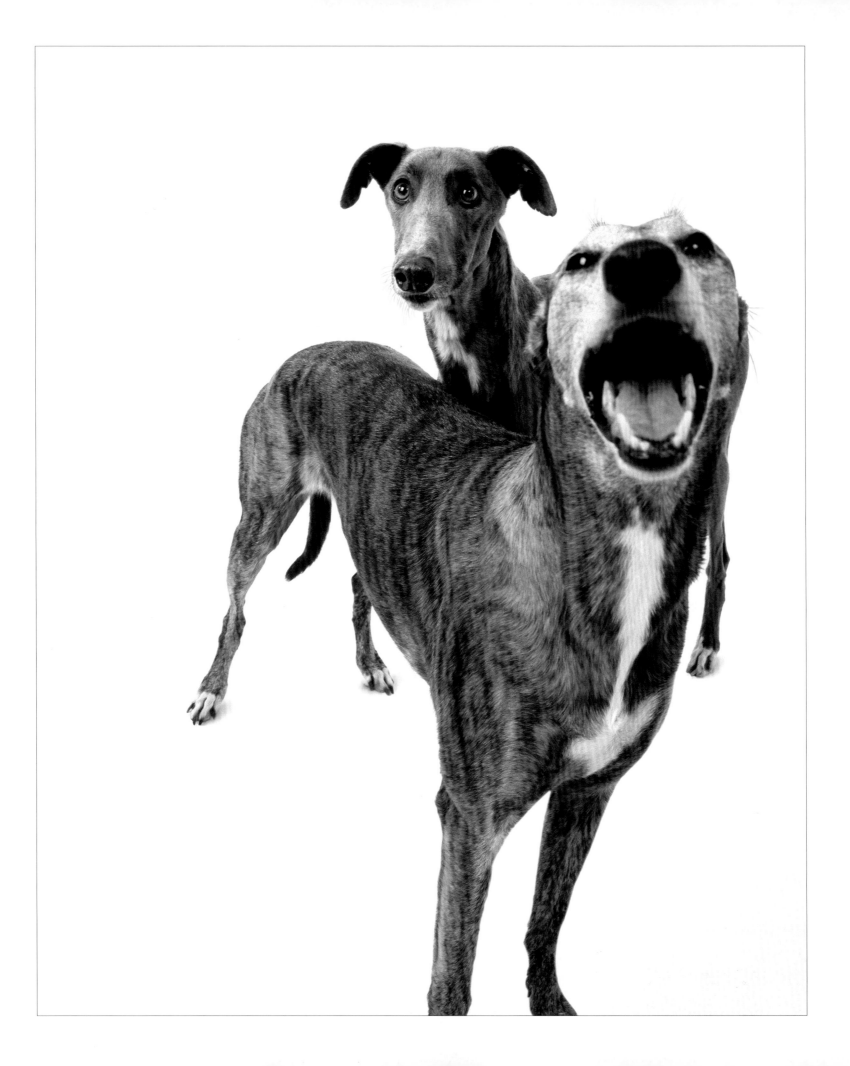

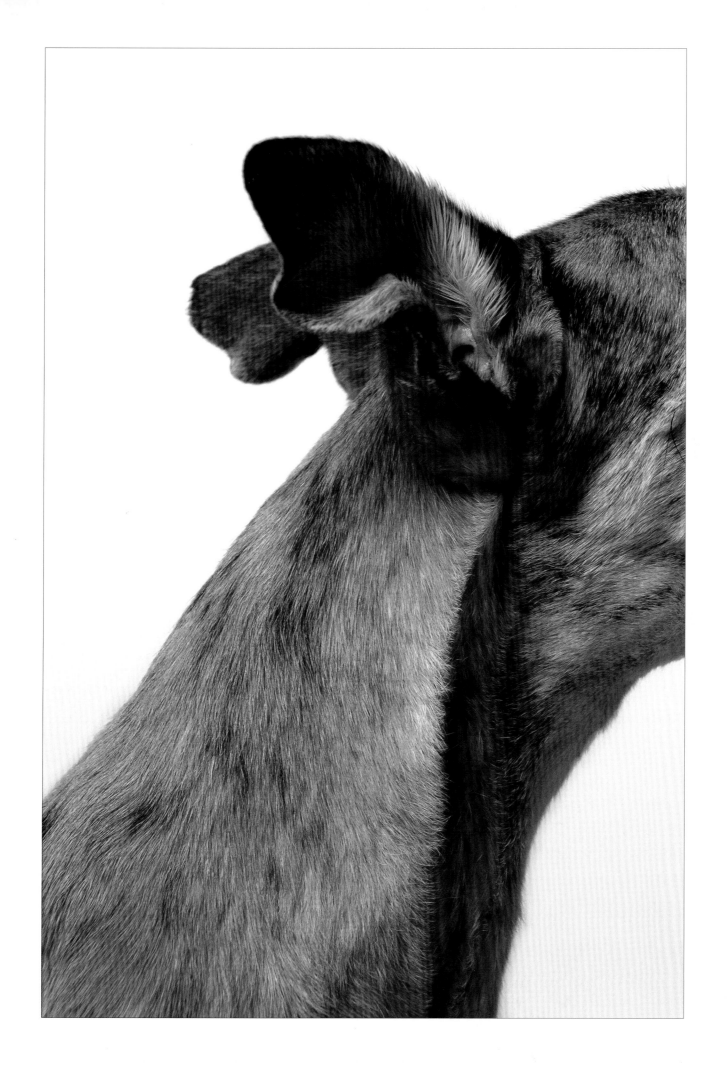

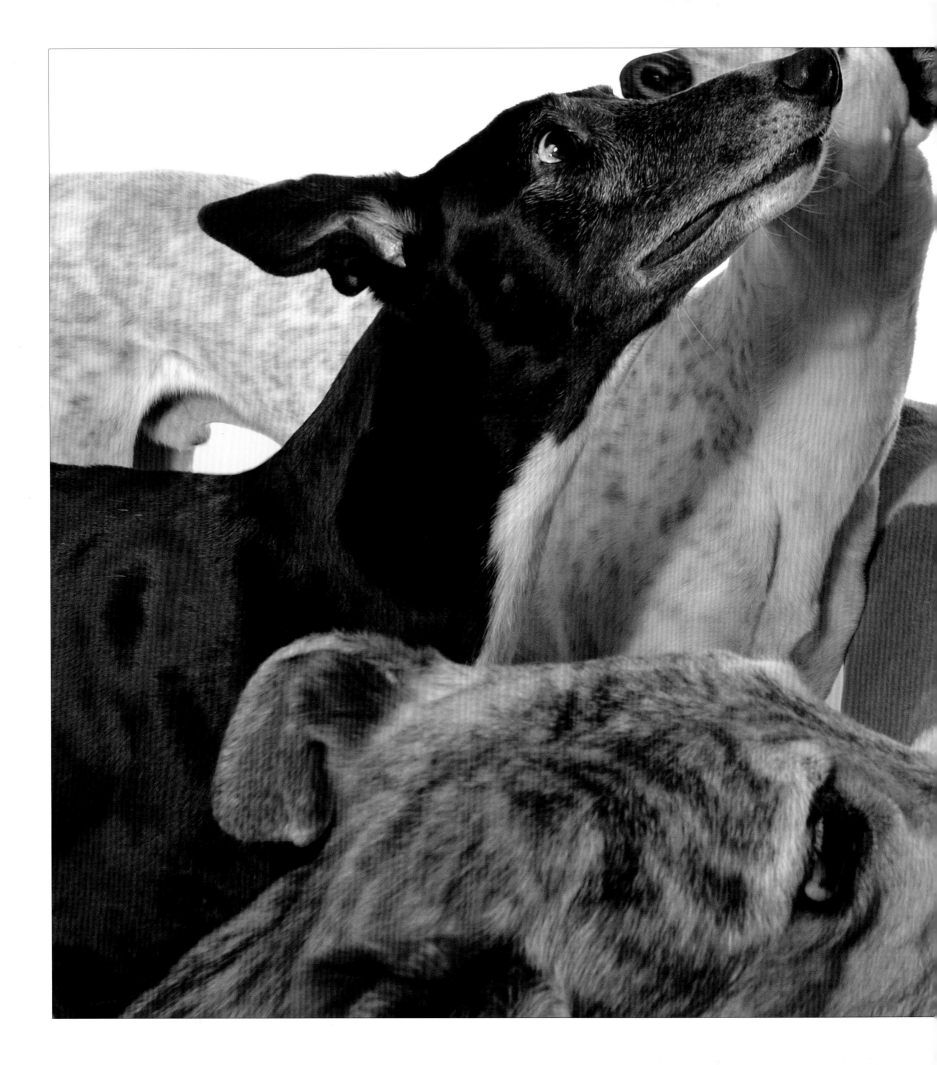

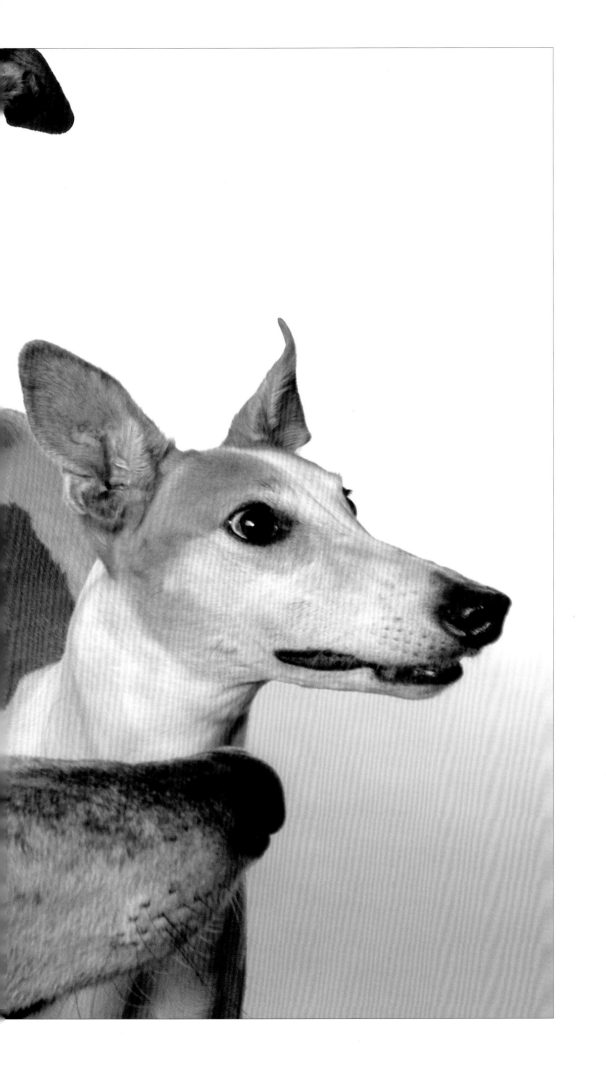

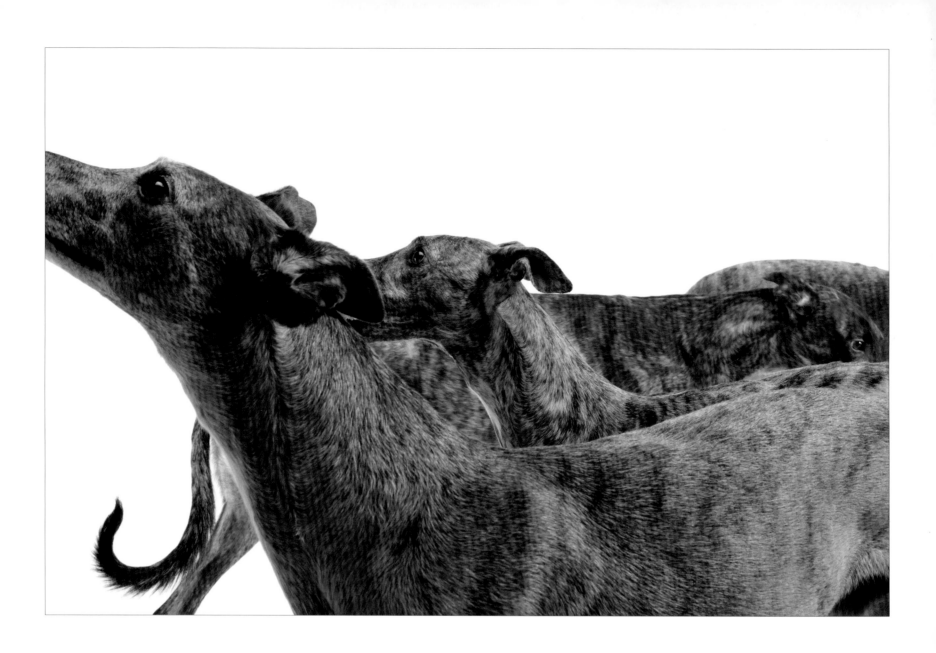

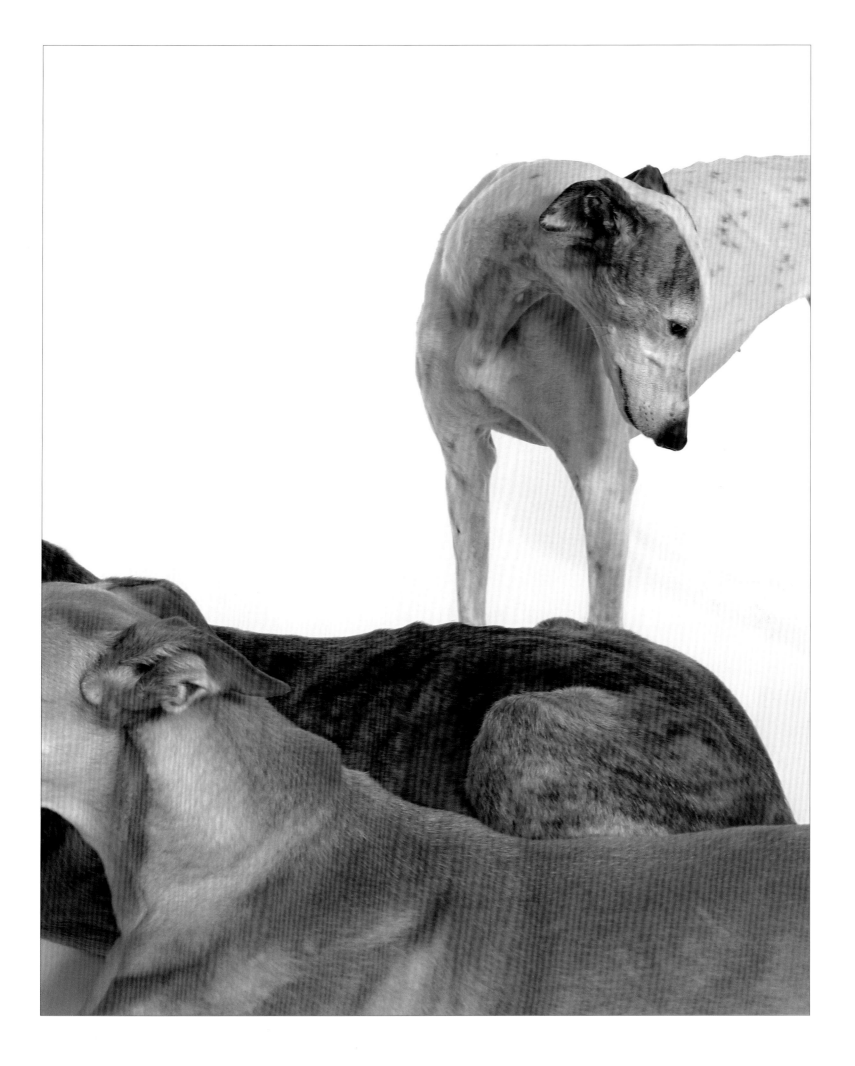

SCARCELY ANY THING CAN BE CONCEIVED
TO GO WITH GREATER FLEETNESS,
IN FULL CHASE, THAN A GREYHOUND
WITH ITS PREY IN VIEW:
IT SEEMS TO SWIM OVER THE EARTH.

ADAM CLARKE, *COMMENTARY ON THE BIBLE*, 1810-26

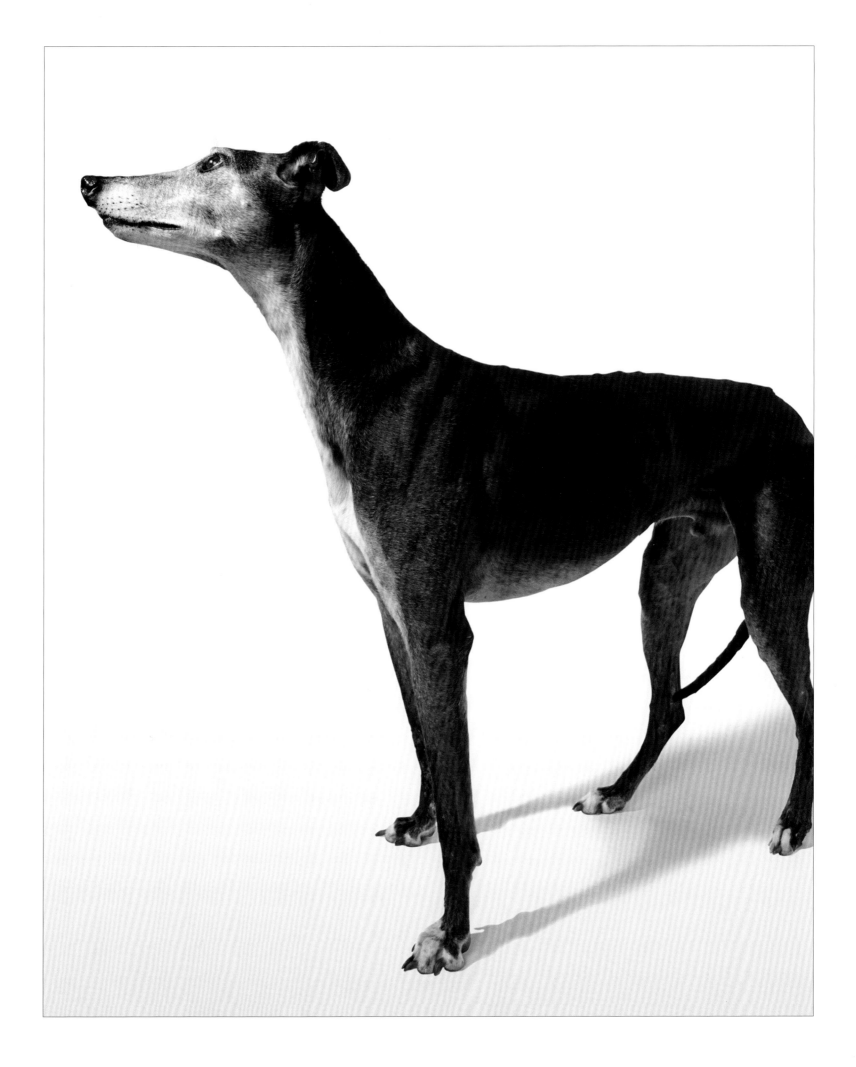

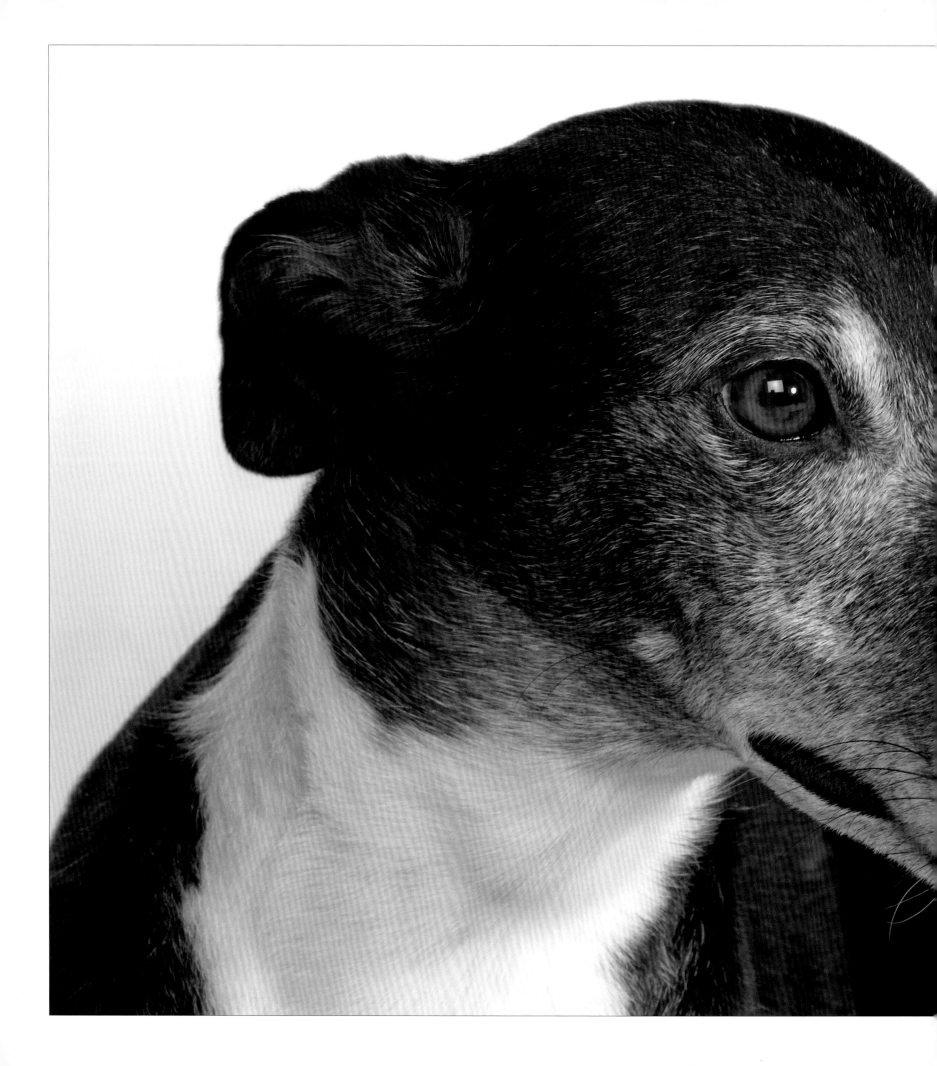

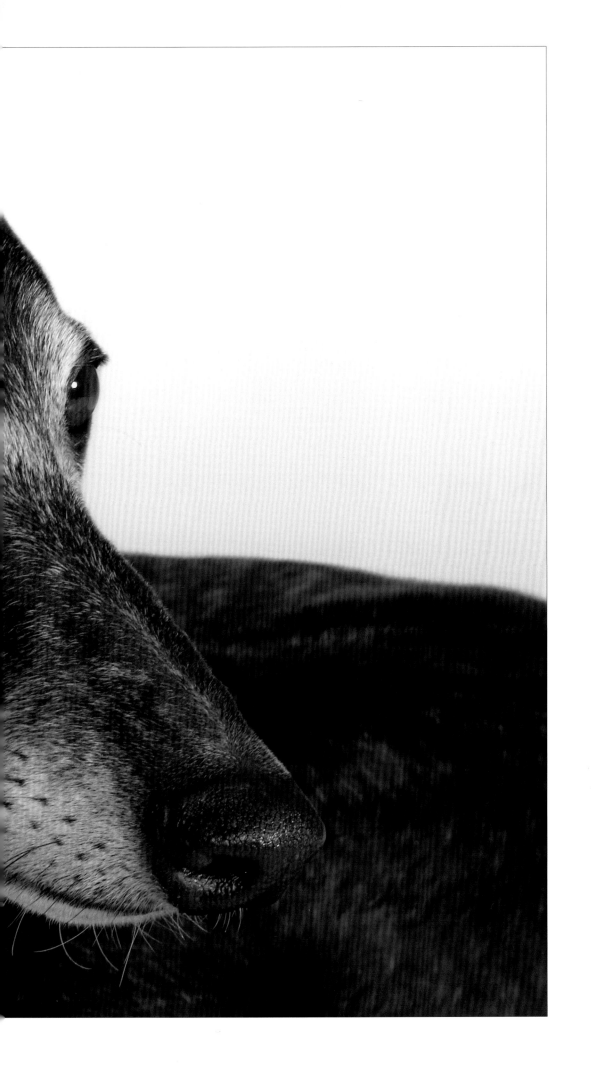

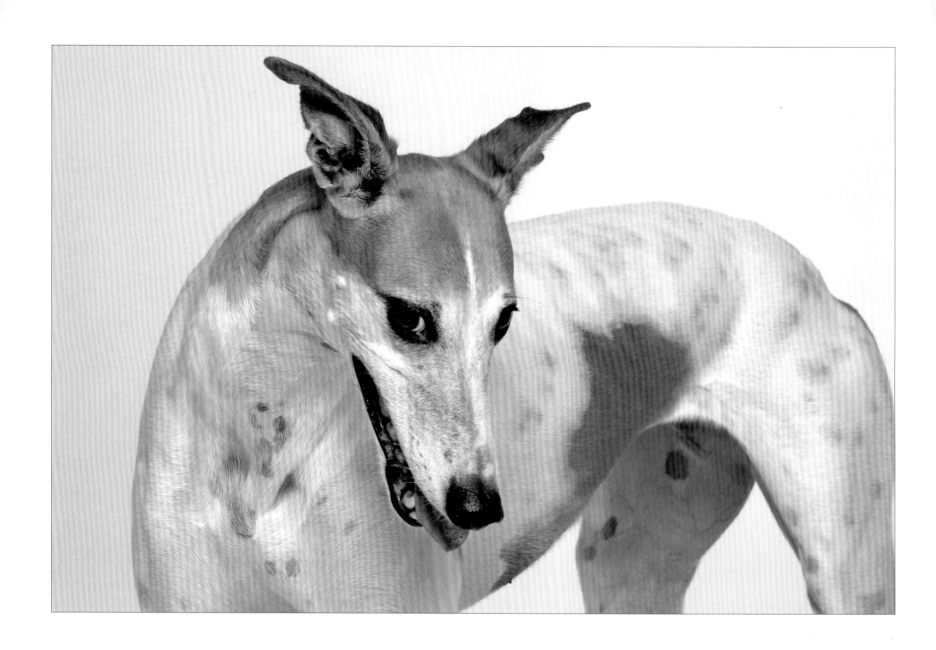

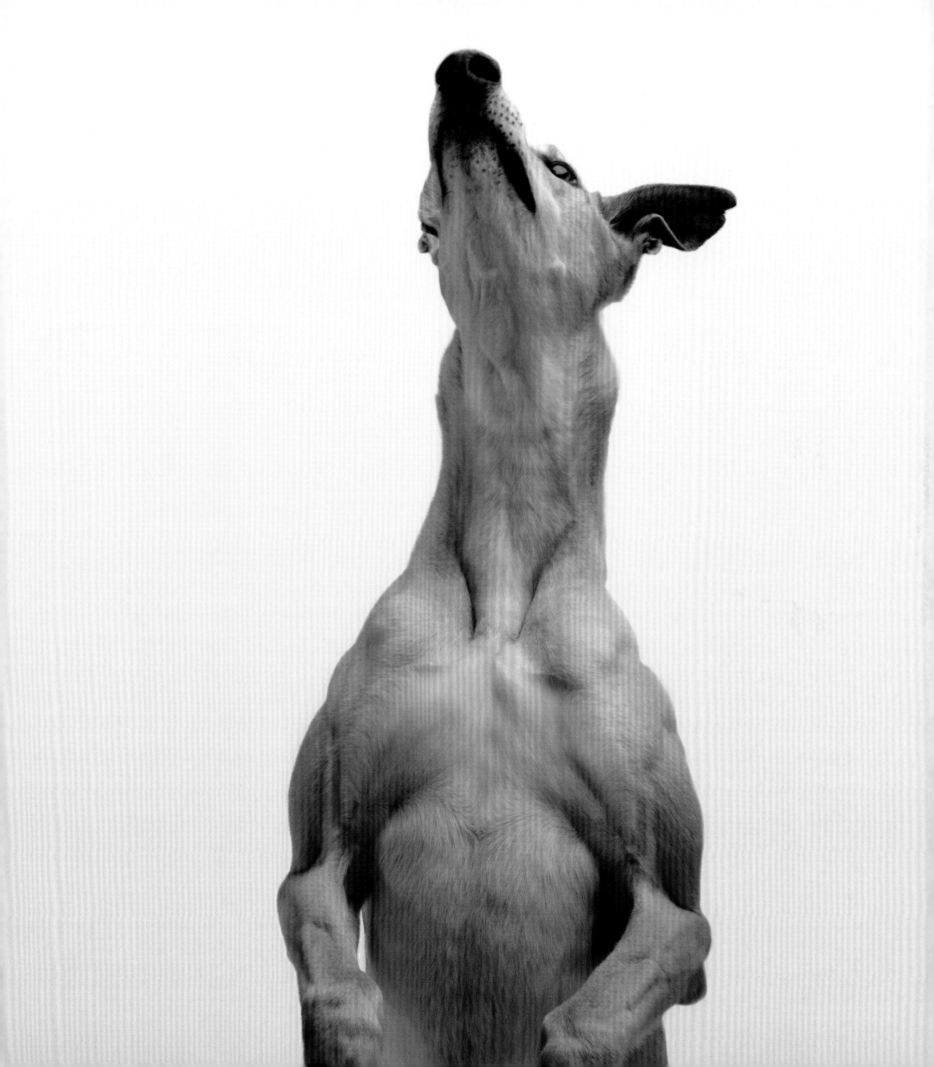

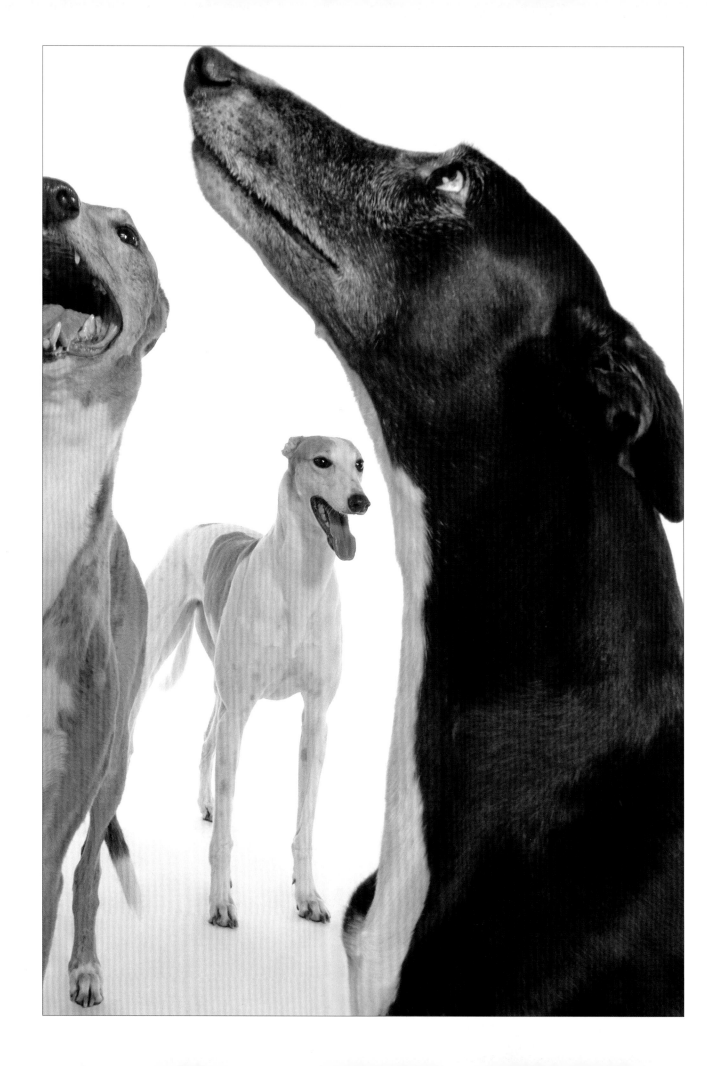

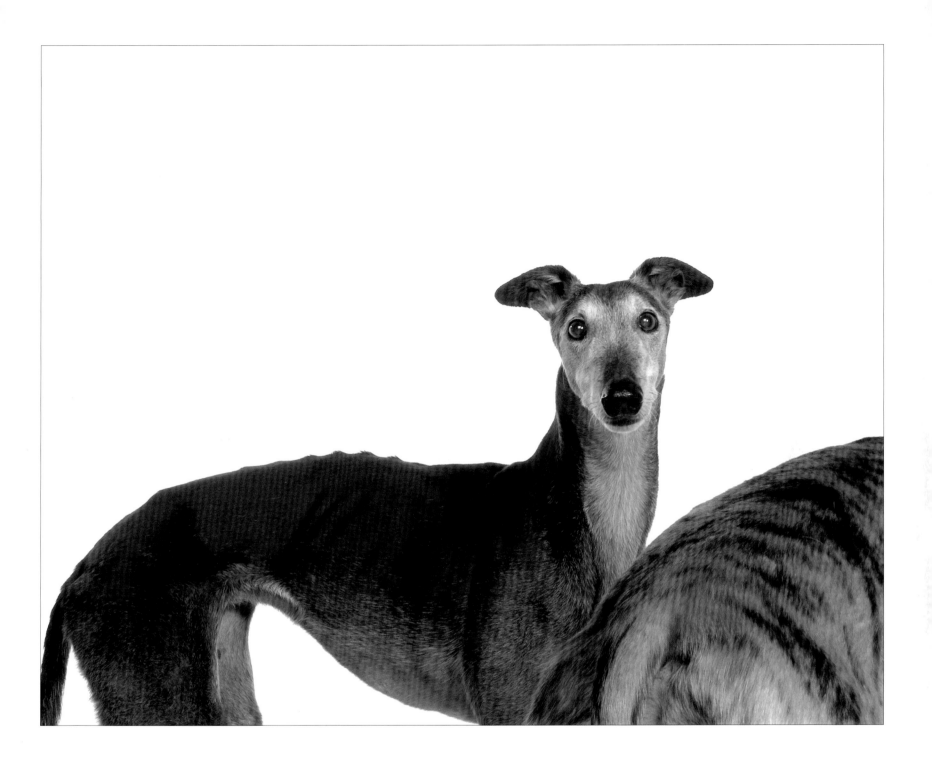

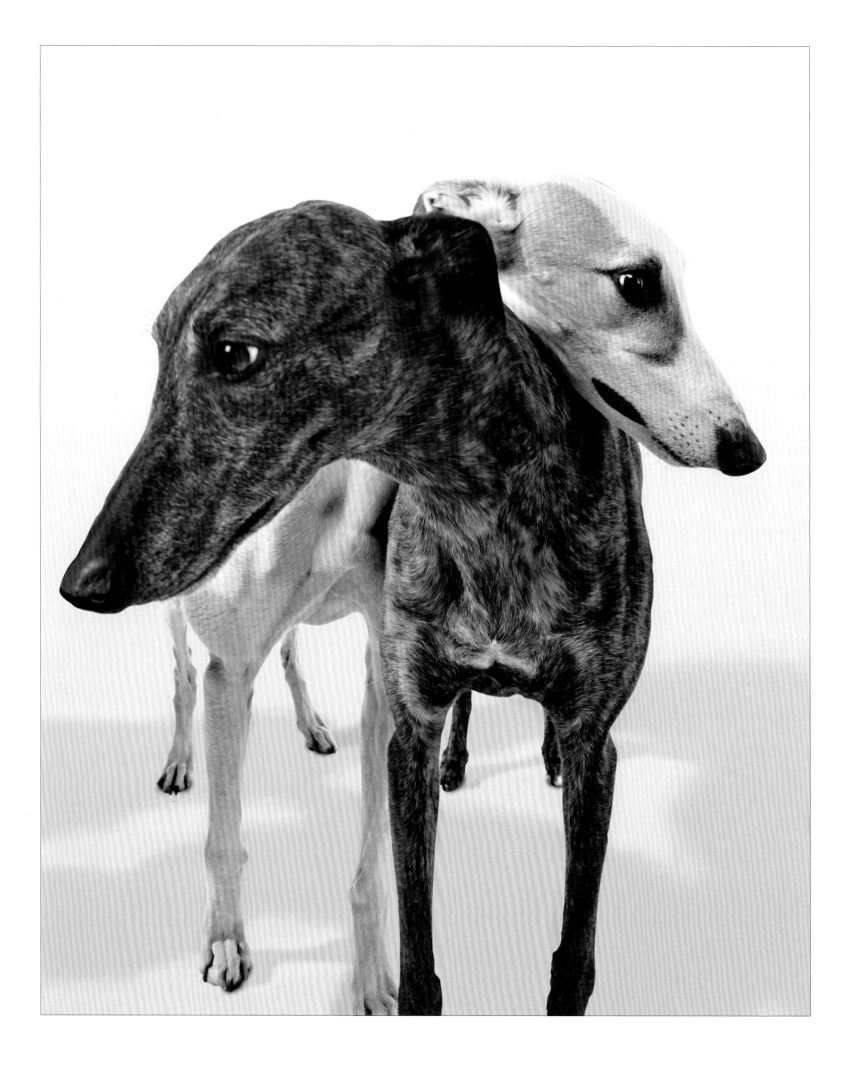

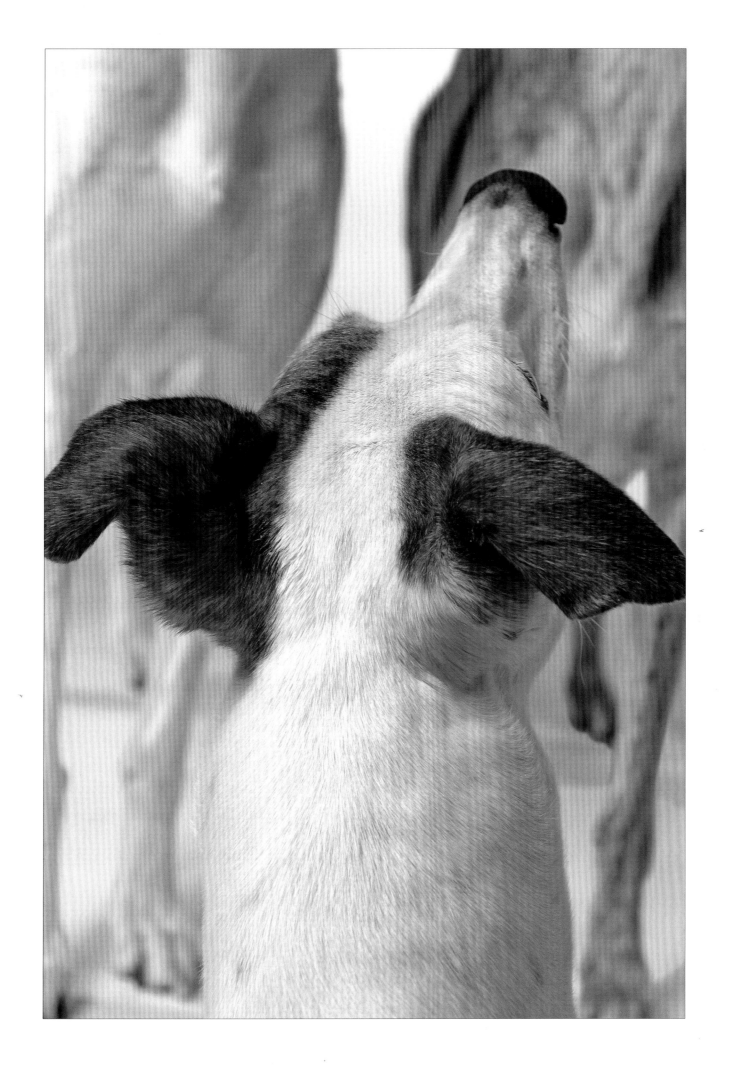

HOW VERY UNLIKE ARE POODLES AND GREYHOUNDS!
YET THEY ARE OF ONE SPECIES.

ADAM SEDGWICK, *SPECTATOR*, 1860

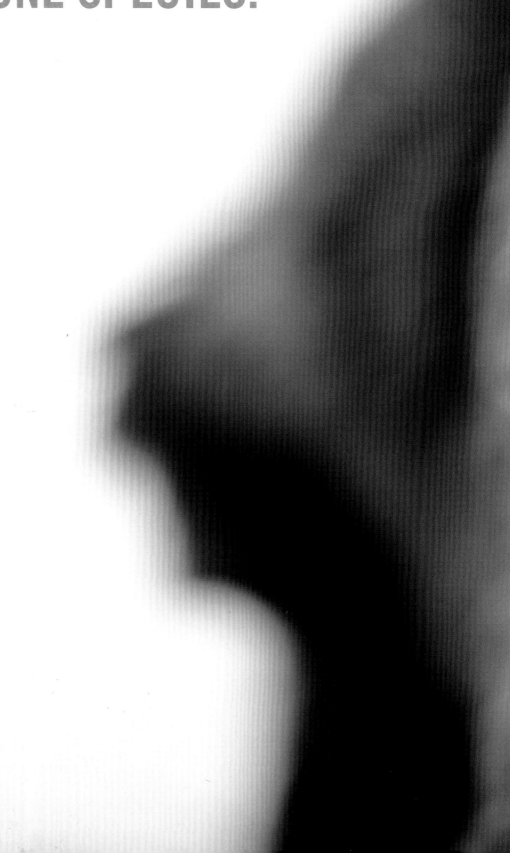

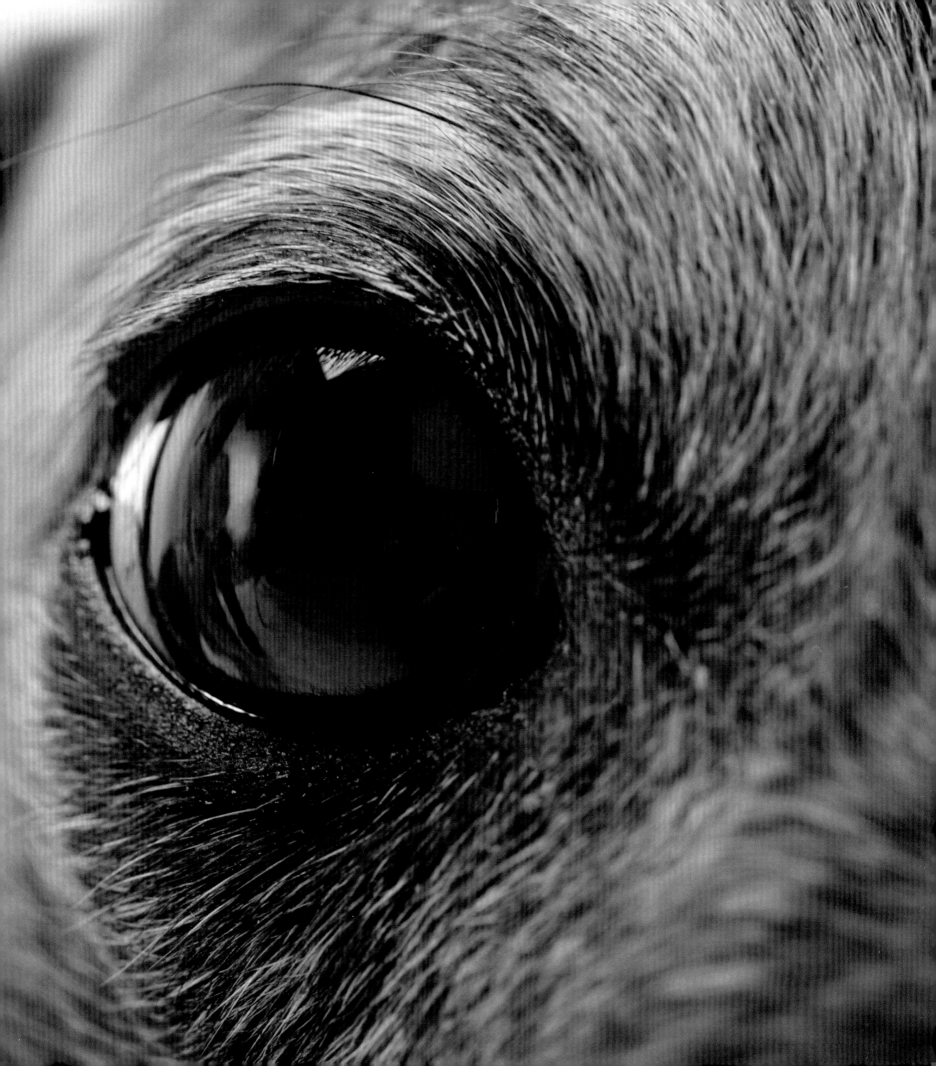

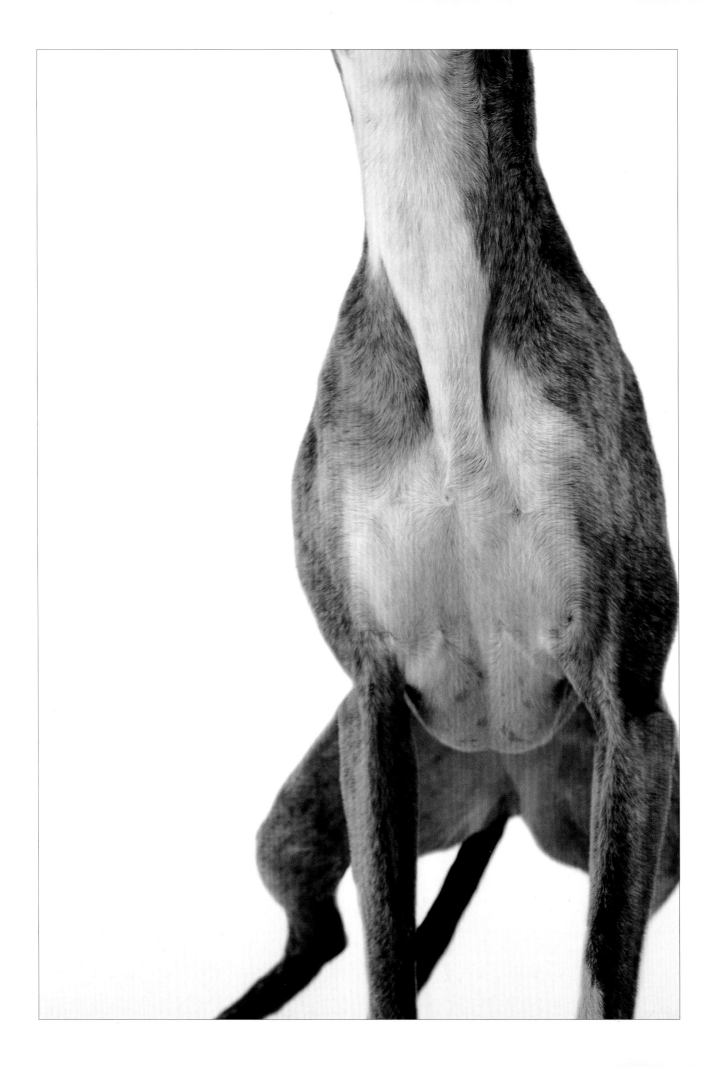

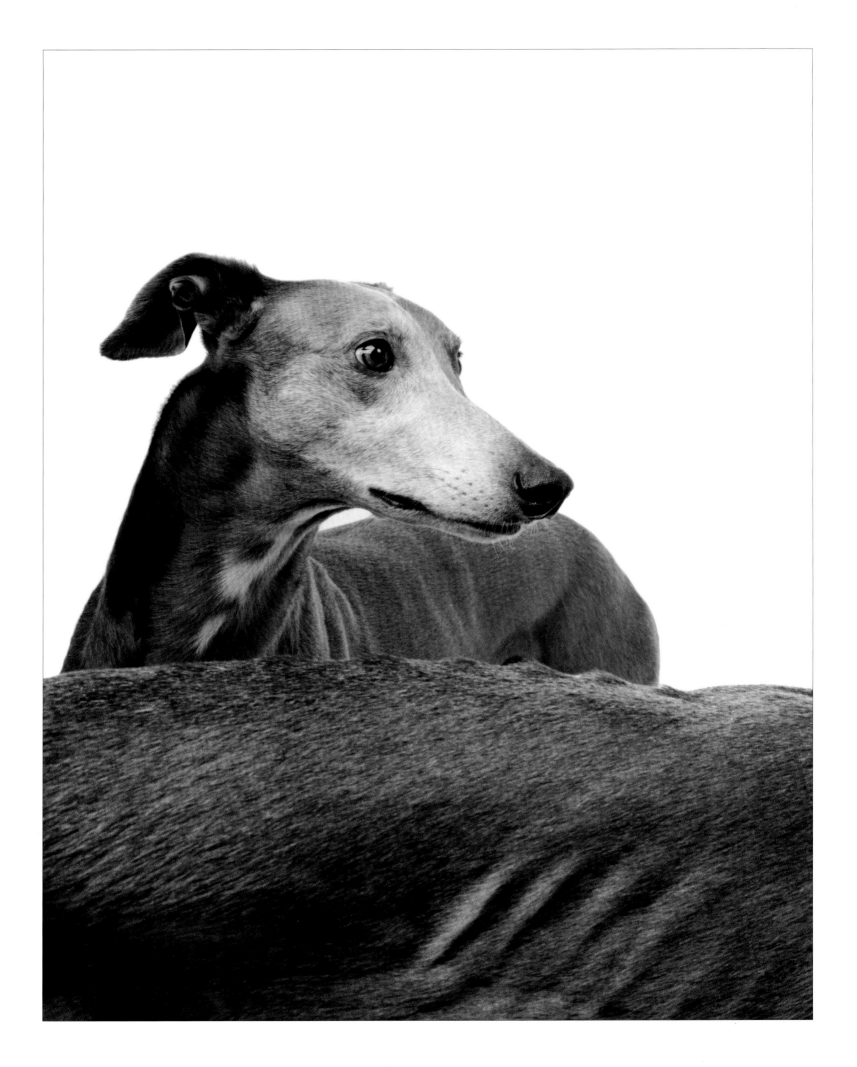

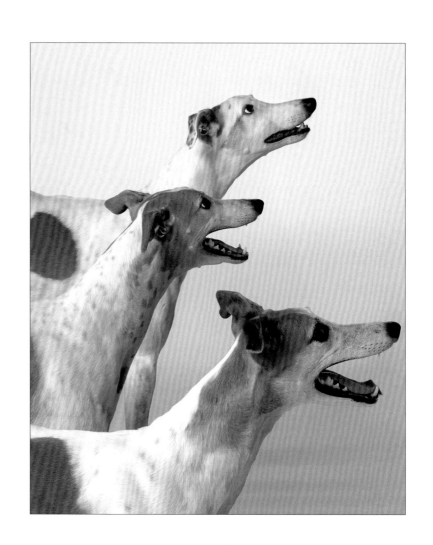

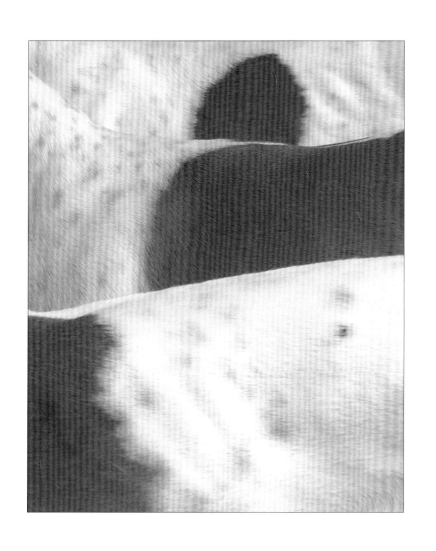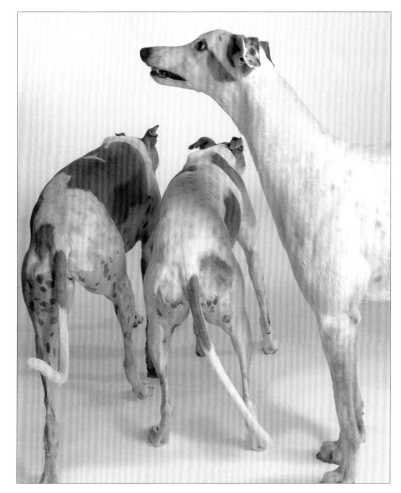

[THE INTELLIGENCE OF A GREYHOUND] DEFIES ALL ATTEMPTS AT DESCRIPTION. THERE WOULD APPEAR TO BE NOTHING WHICH HE DOES NOT UNDERSTAND EITHER IN WORD OR IN GESTURE OR THE SHADOW OF COMING EVENTS. WHEN YOUR FAVOURITE HAS DONE HIS WORK, CHERISH HIM AND GIVE HIM PLACE WITH YOURSELF FOR THE REST OF HIS BUT TOO SHORT LIFE. IT IS HIS ONE DRAWBACK. HE SHOULD LIVE AS LONG AS HIS OWNER.

JAMES MATHESON, *THE GREYHOUND: BREEDING, COURSING, RACING, ETC.*, 1929

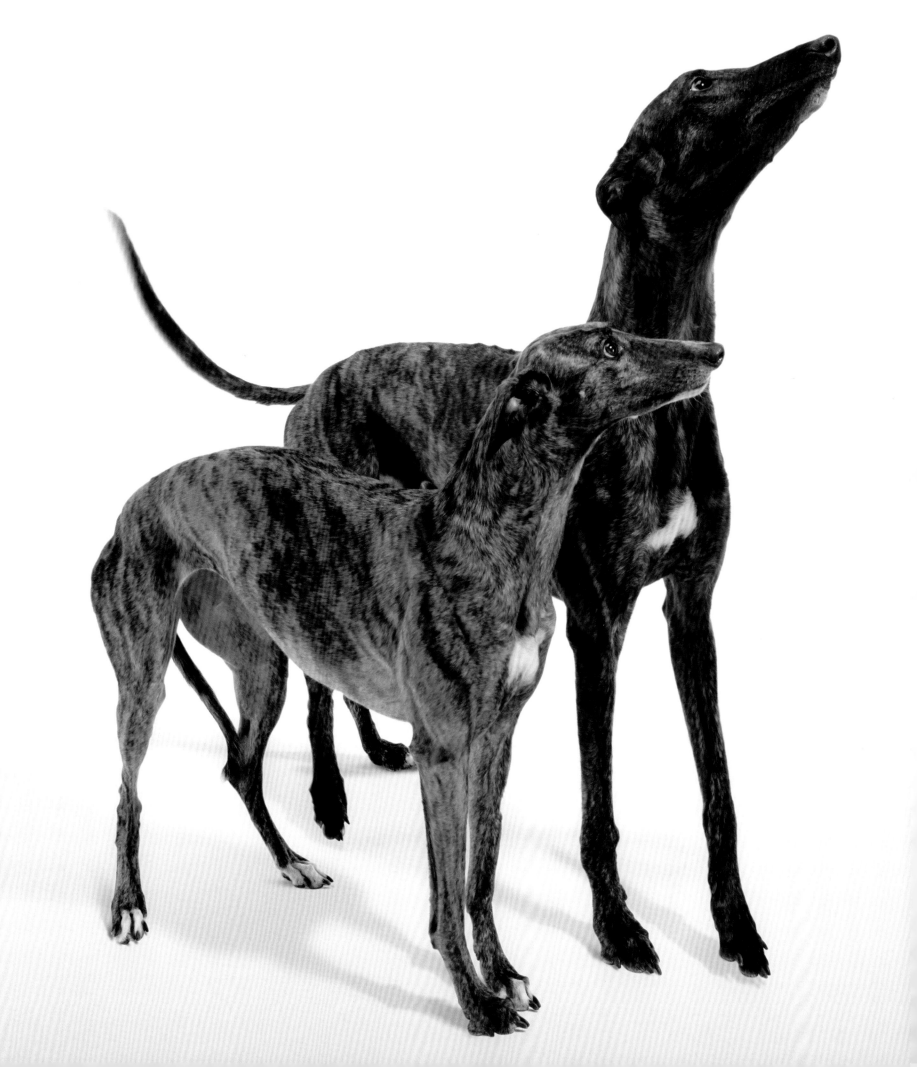

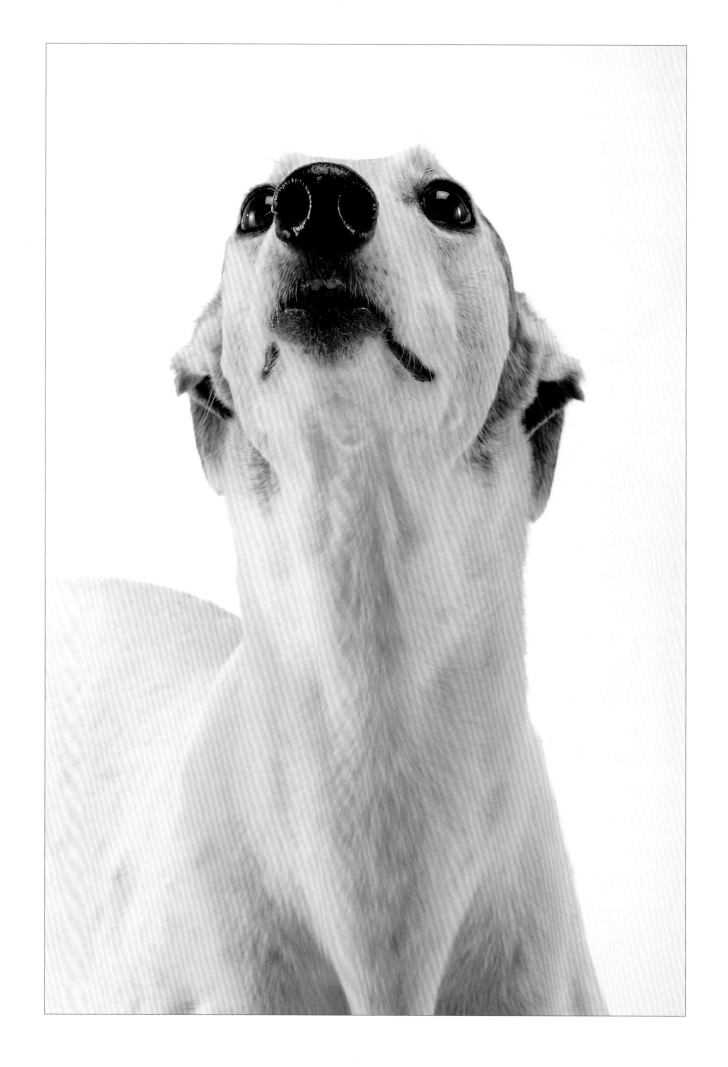

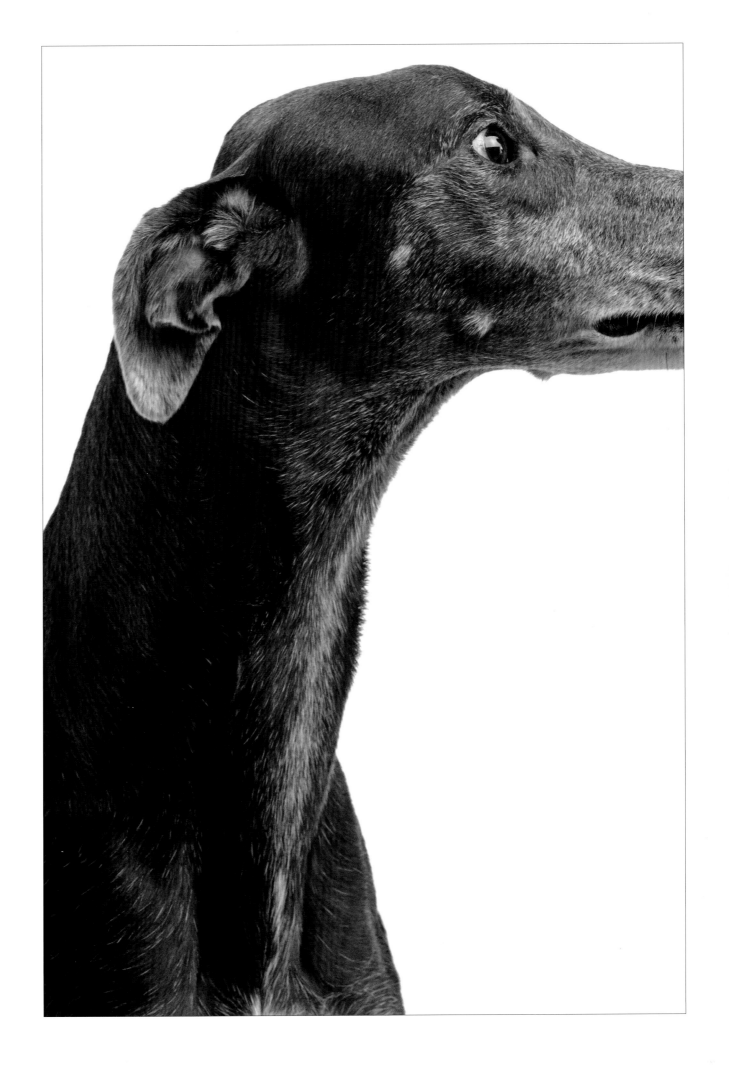

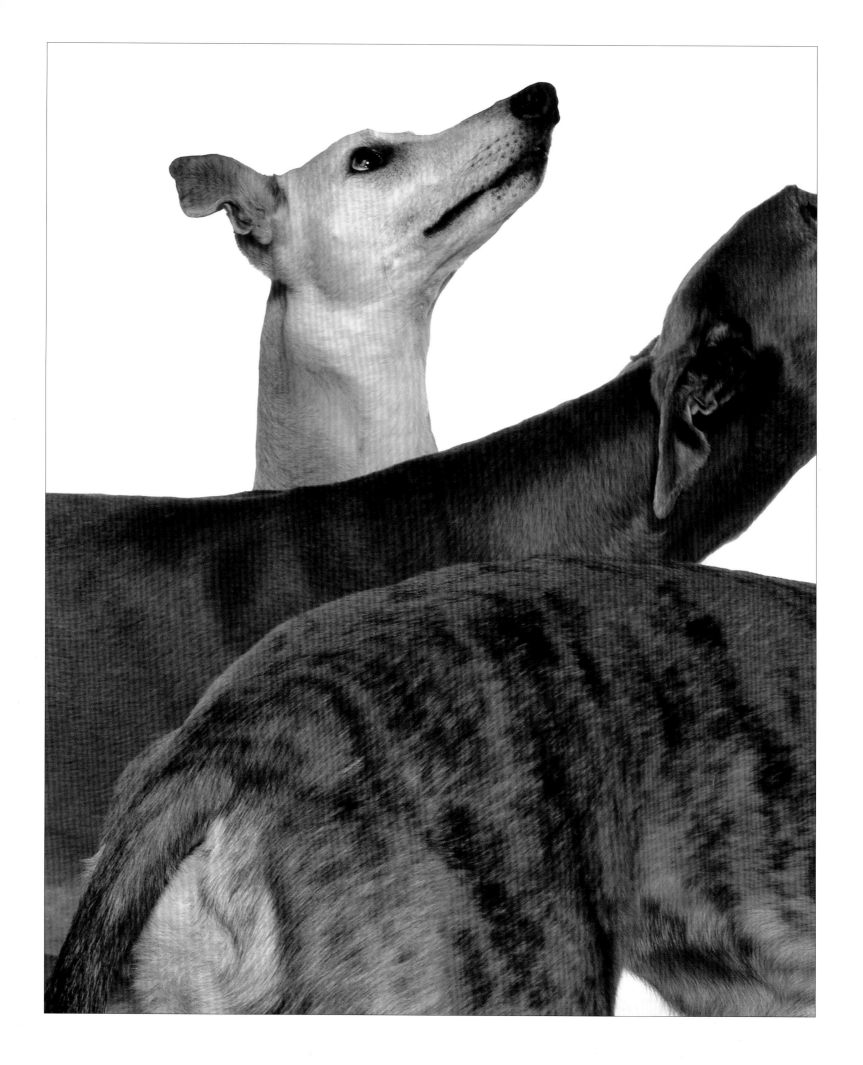

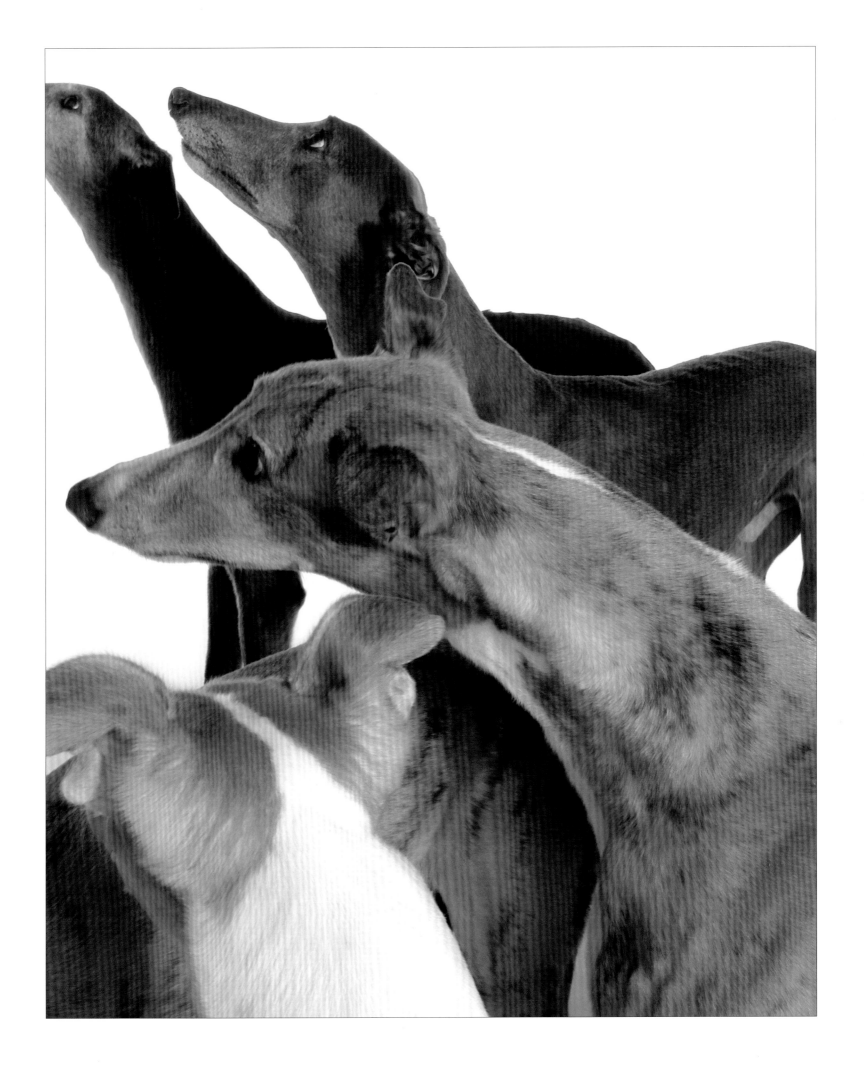

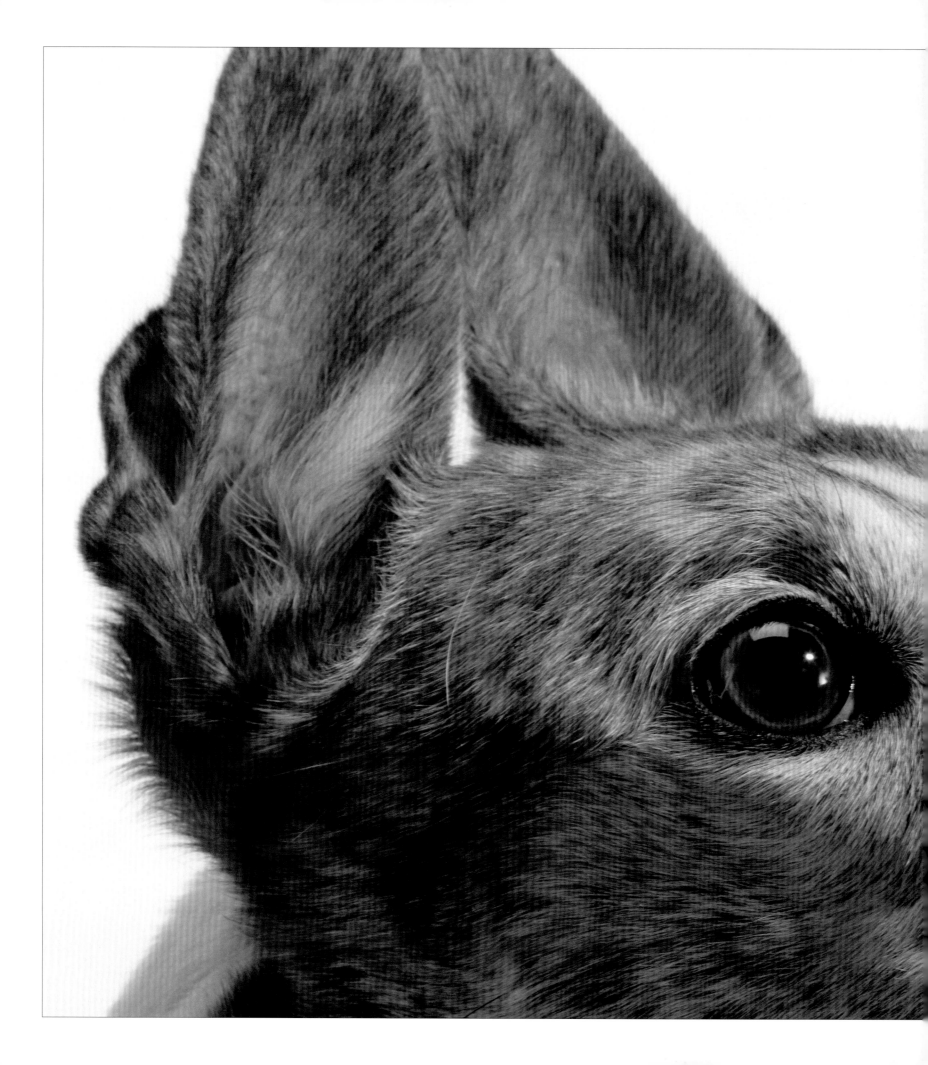

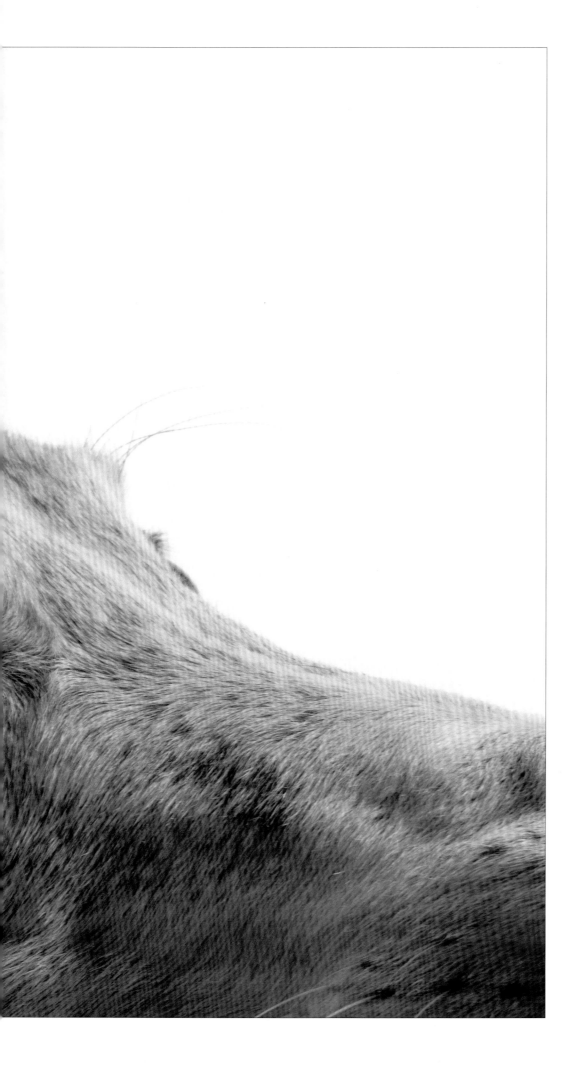

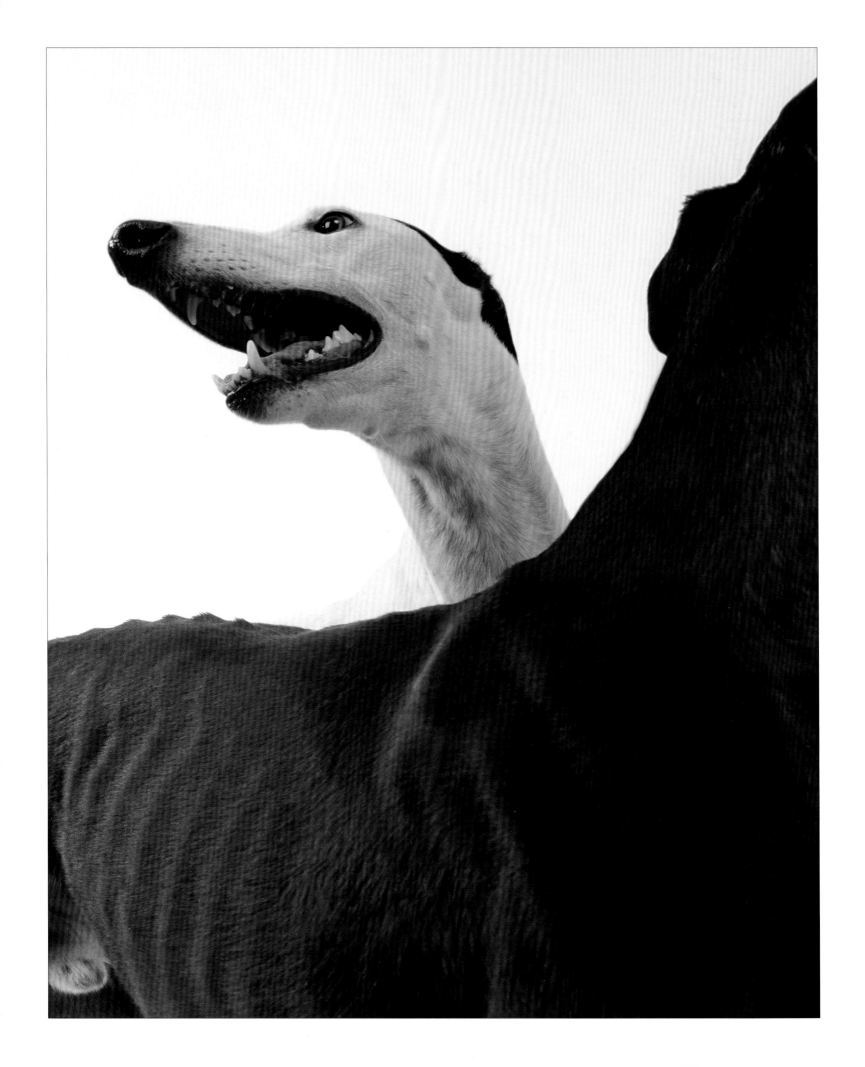

THE LENGTHS OF GIGANTIC GREYHOUND BACKS
COURSING ALONG THE SOUTH, WERE HIS VISION OF DELIGHT;
NO IMAGE OF REPOSE FOR HIM, BUT OF THE LIFE IN SWIFTNESS.

GEORGE MEREDITH, *BEAUCHAMP'S CAREER,* 1876

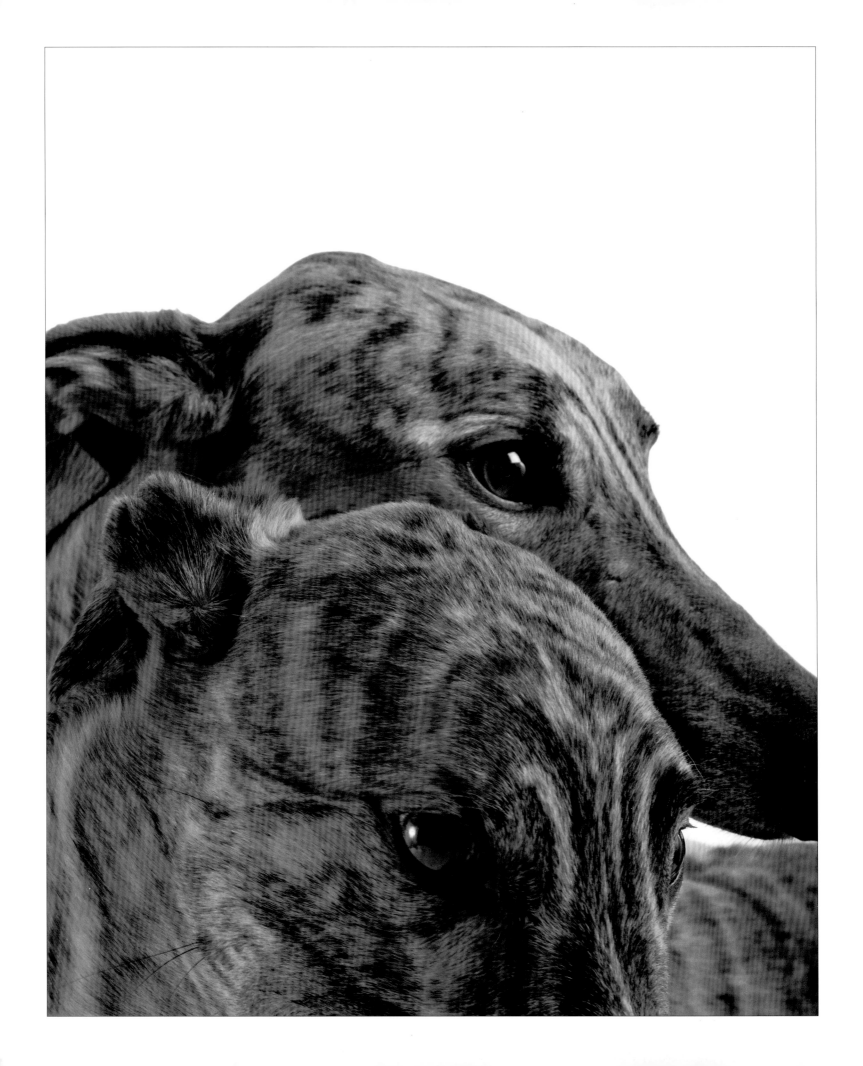

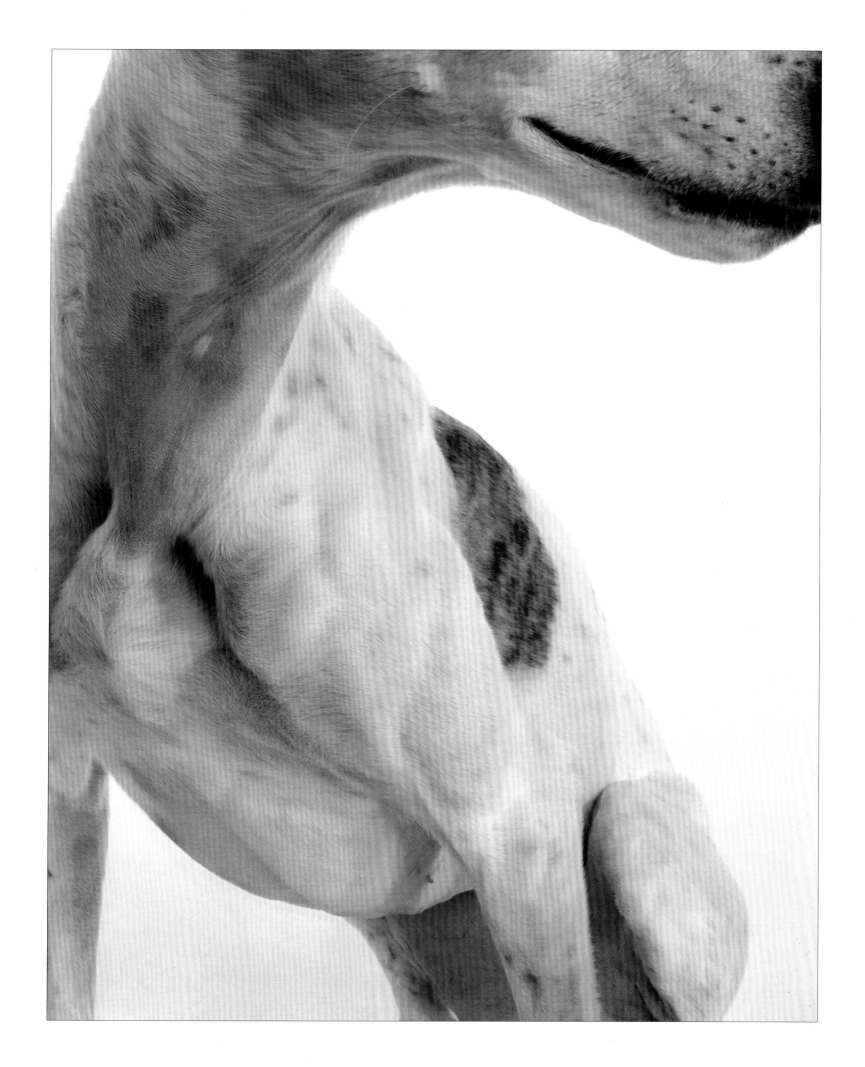

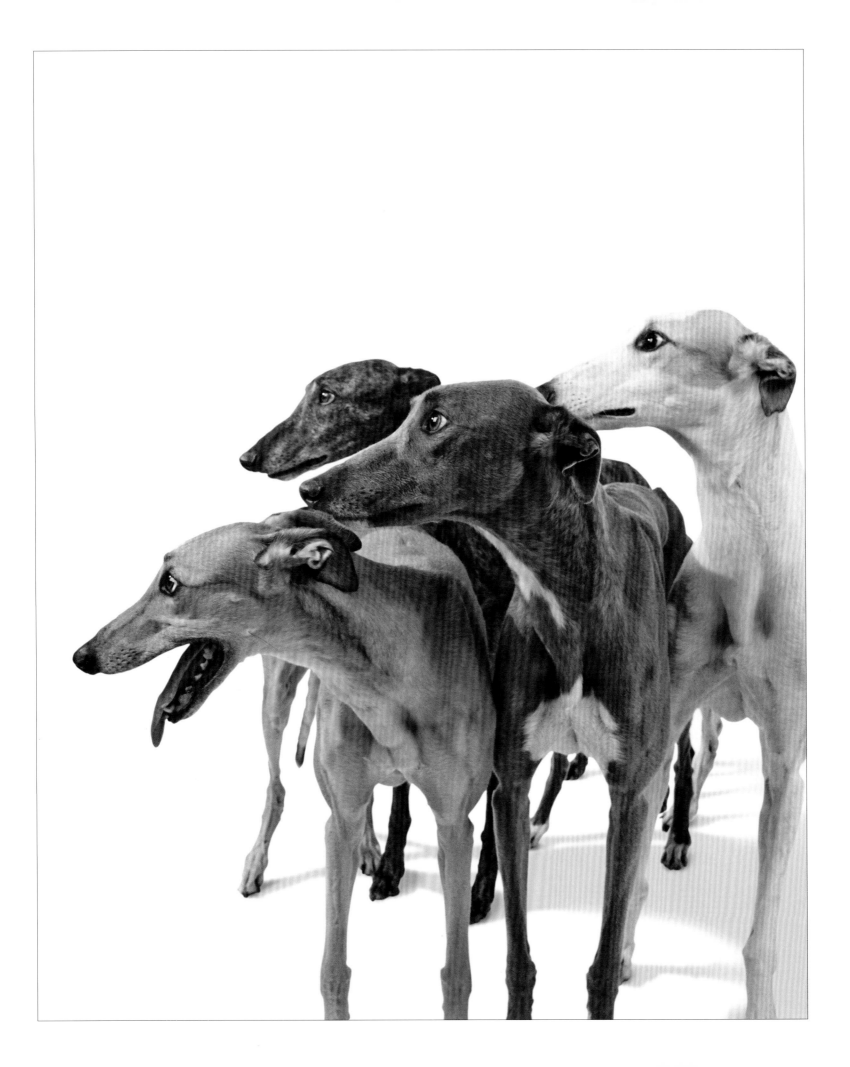

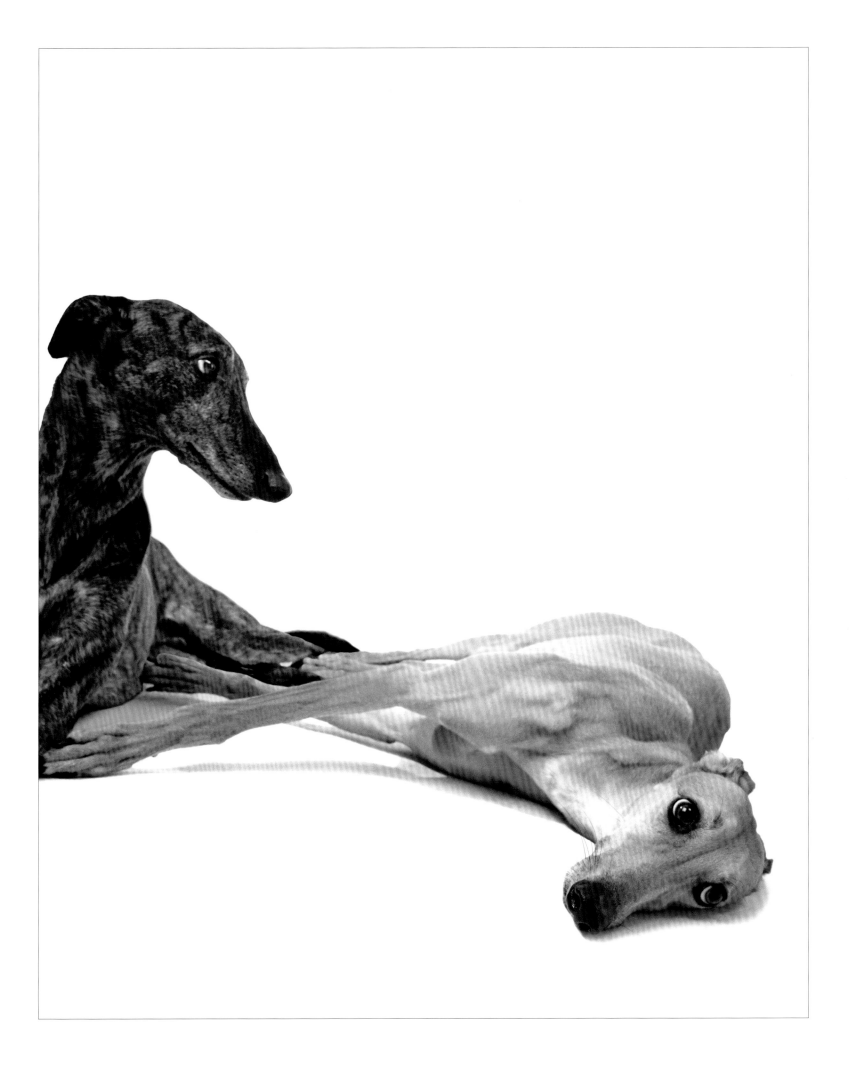

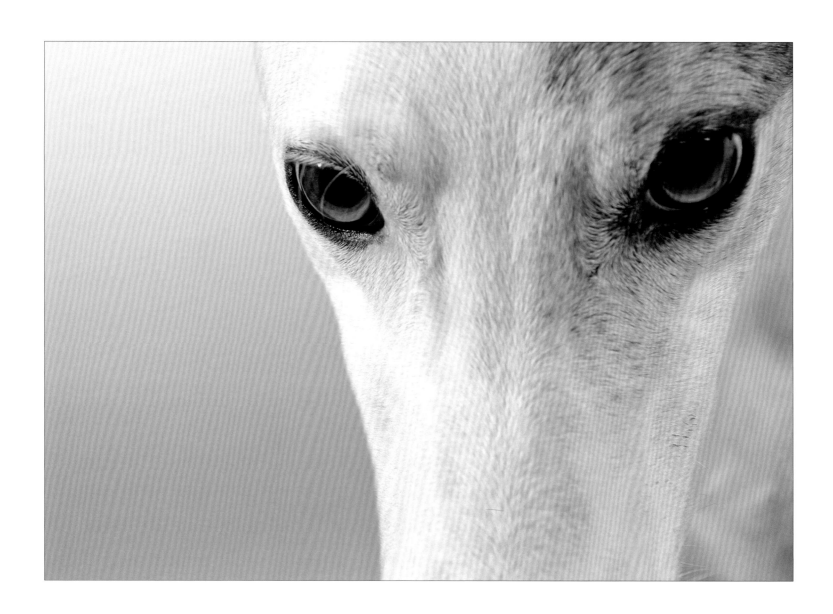

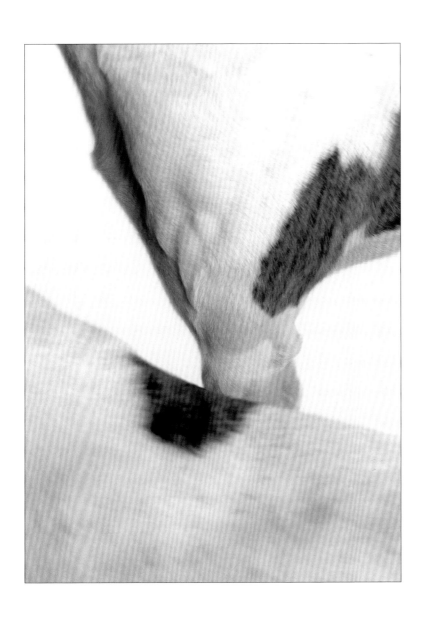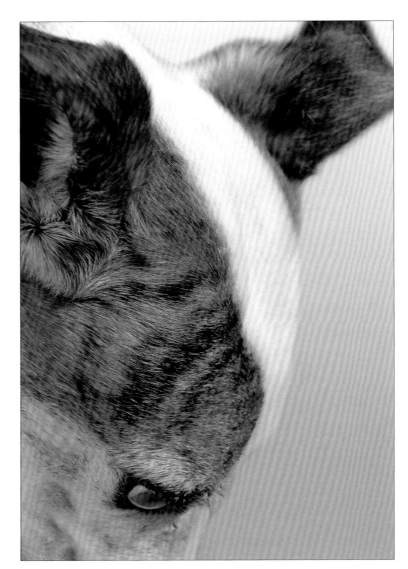

I WOULD AS LEAVE PUT A GREYHOUND TO WATCH THE HOUSE, OR A RACE HORSE TO DRAG AN OX WAGGON.

WASHINGTON IRVING, *A HISTORY OF NEW YORK*, 1809

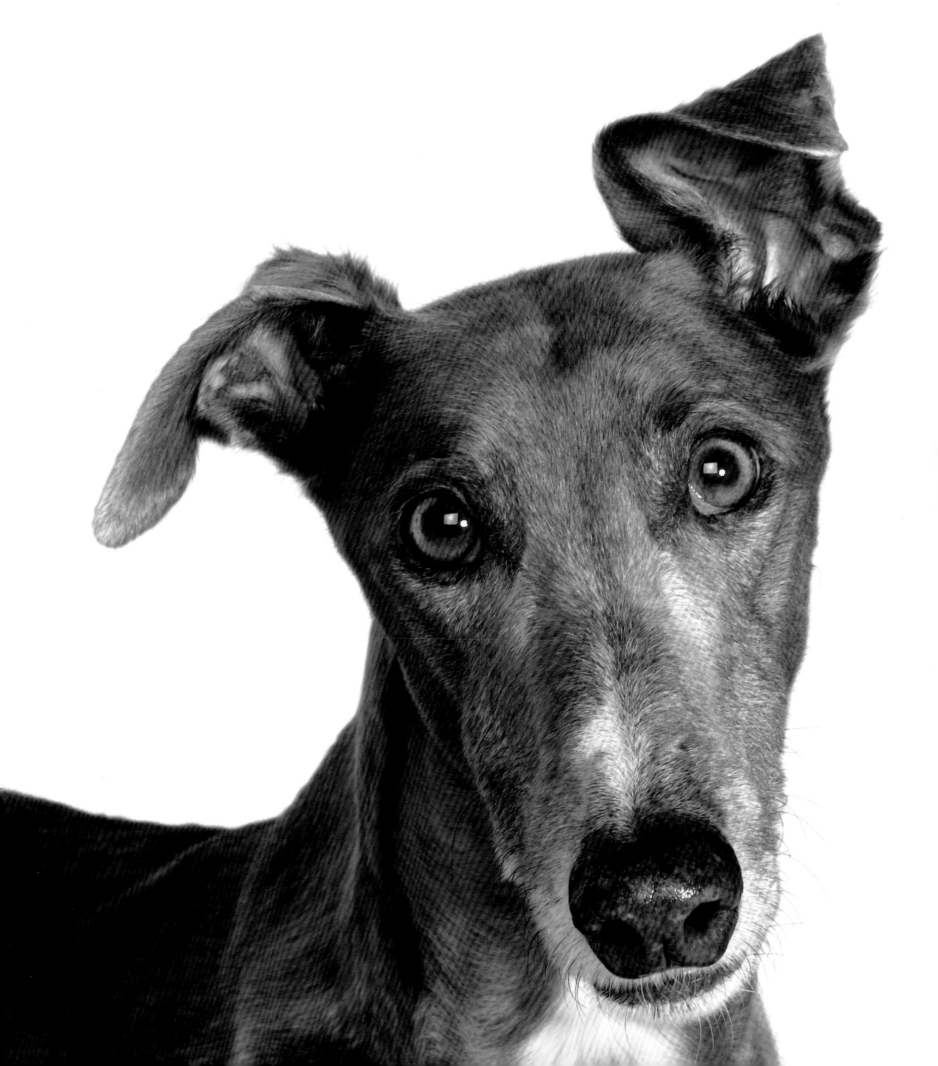

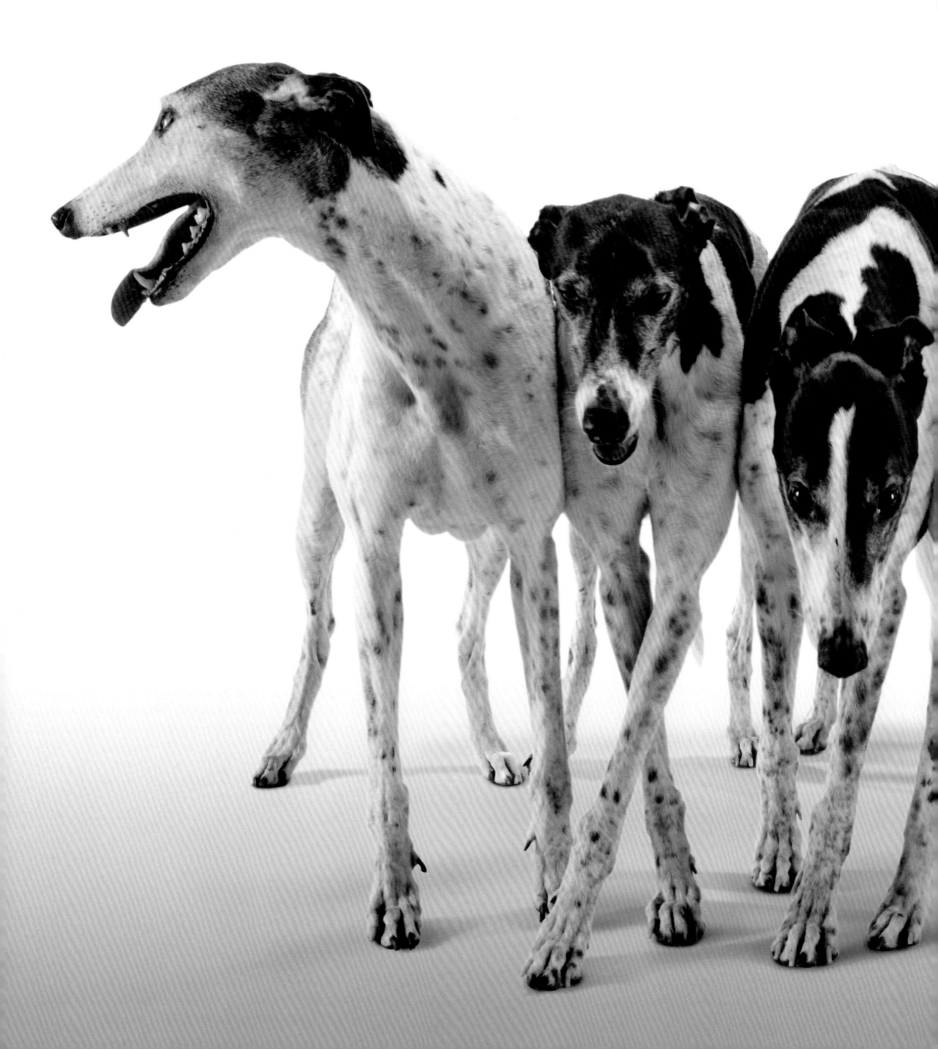

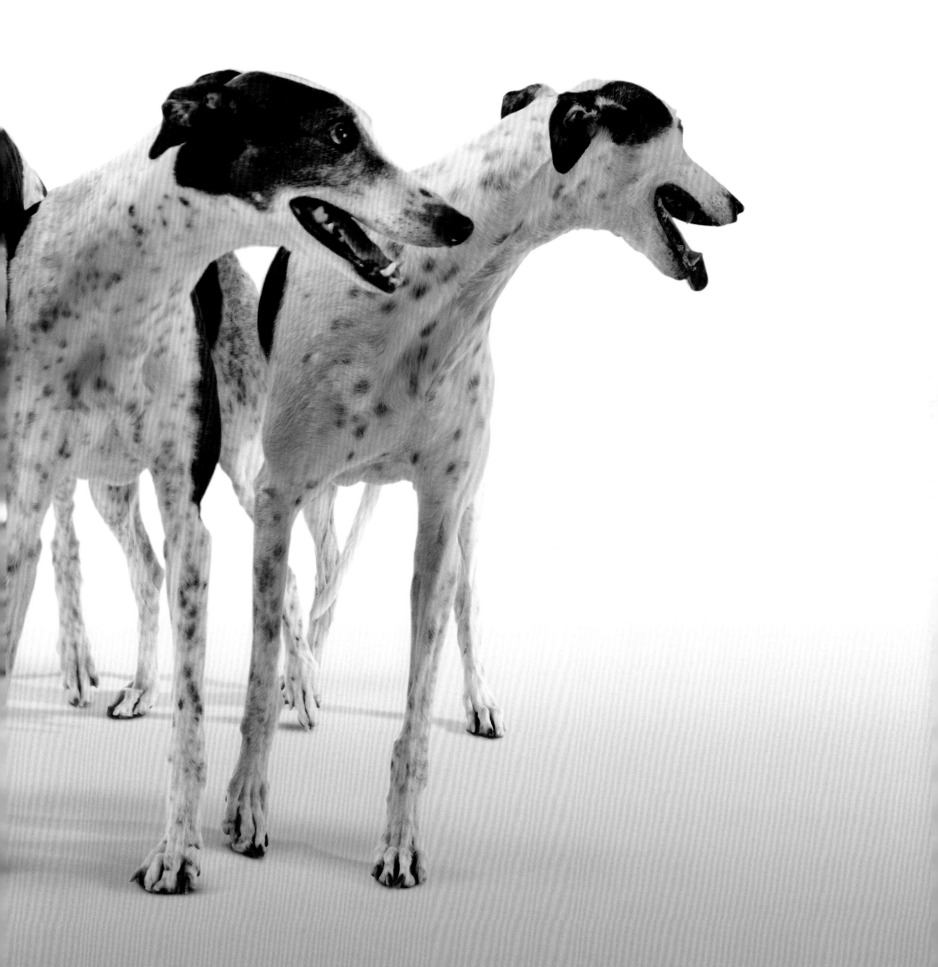

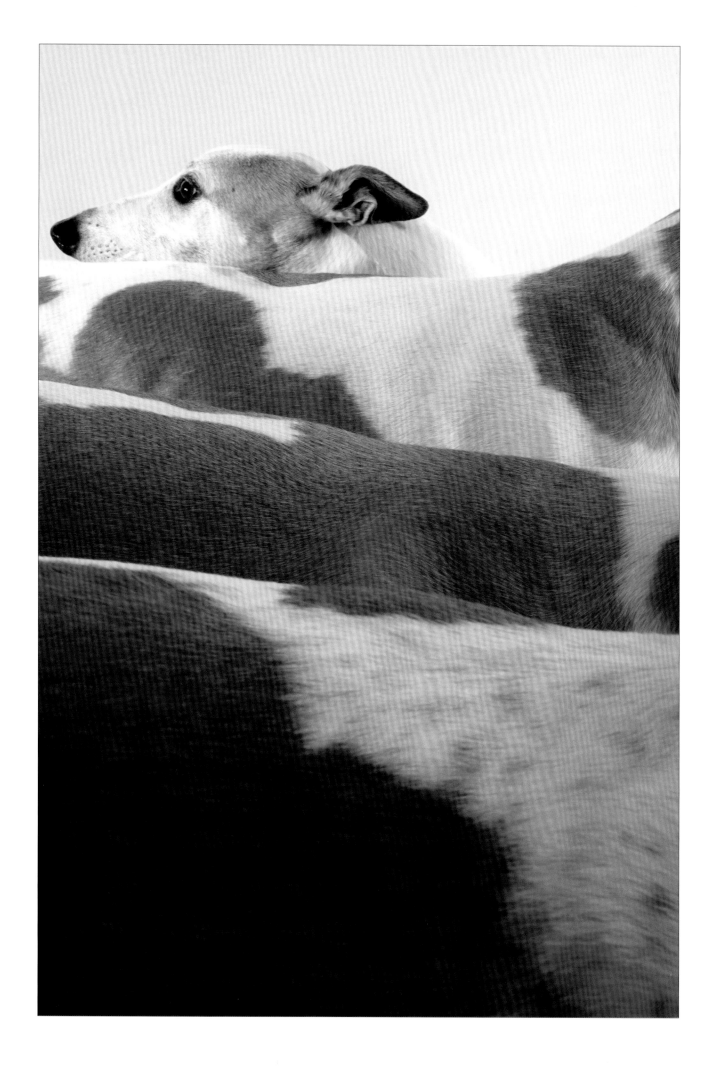

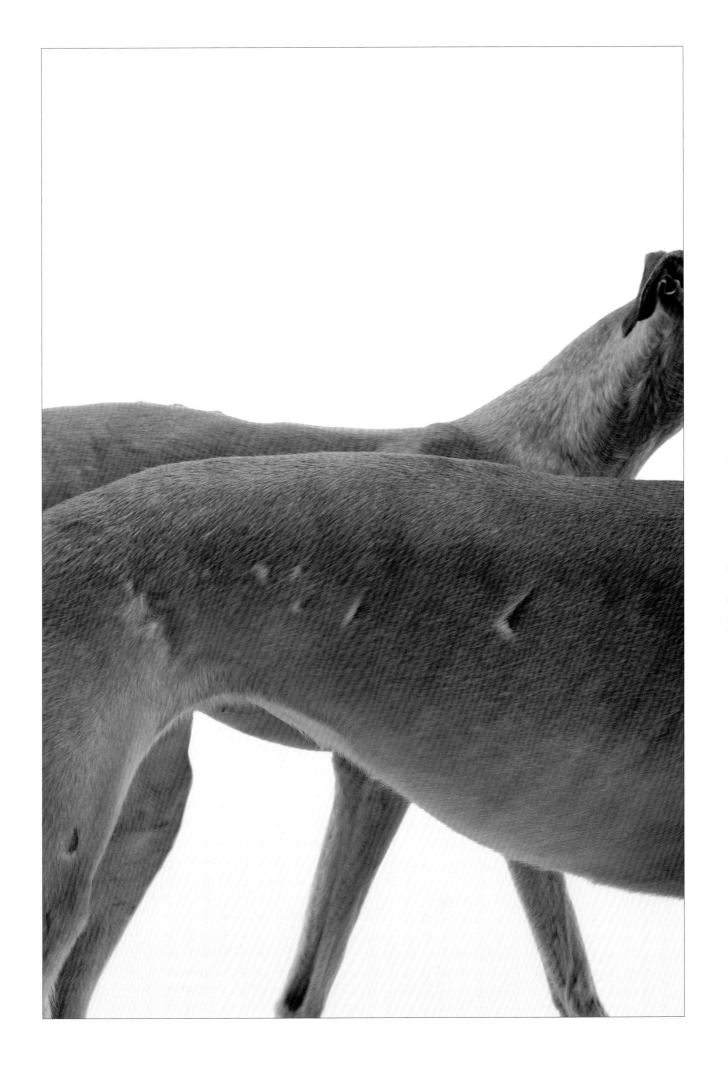

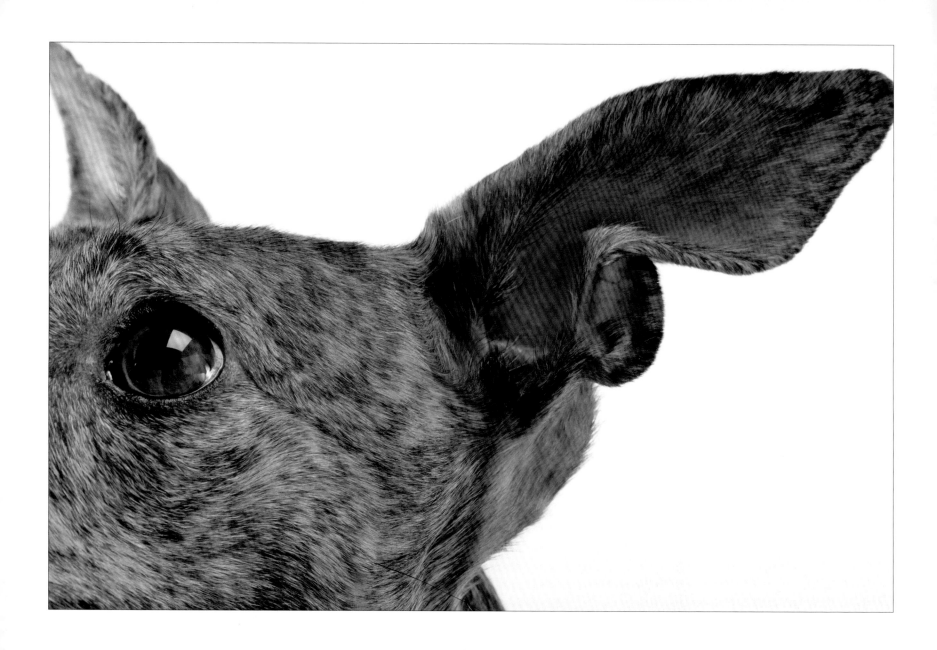

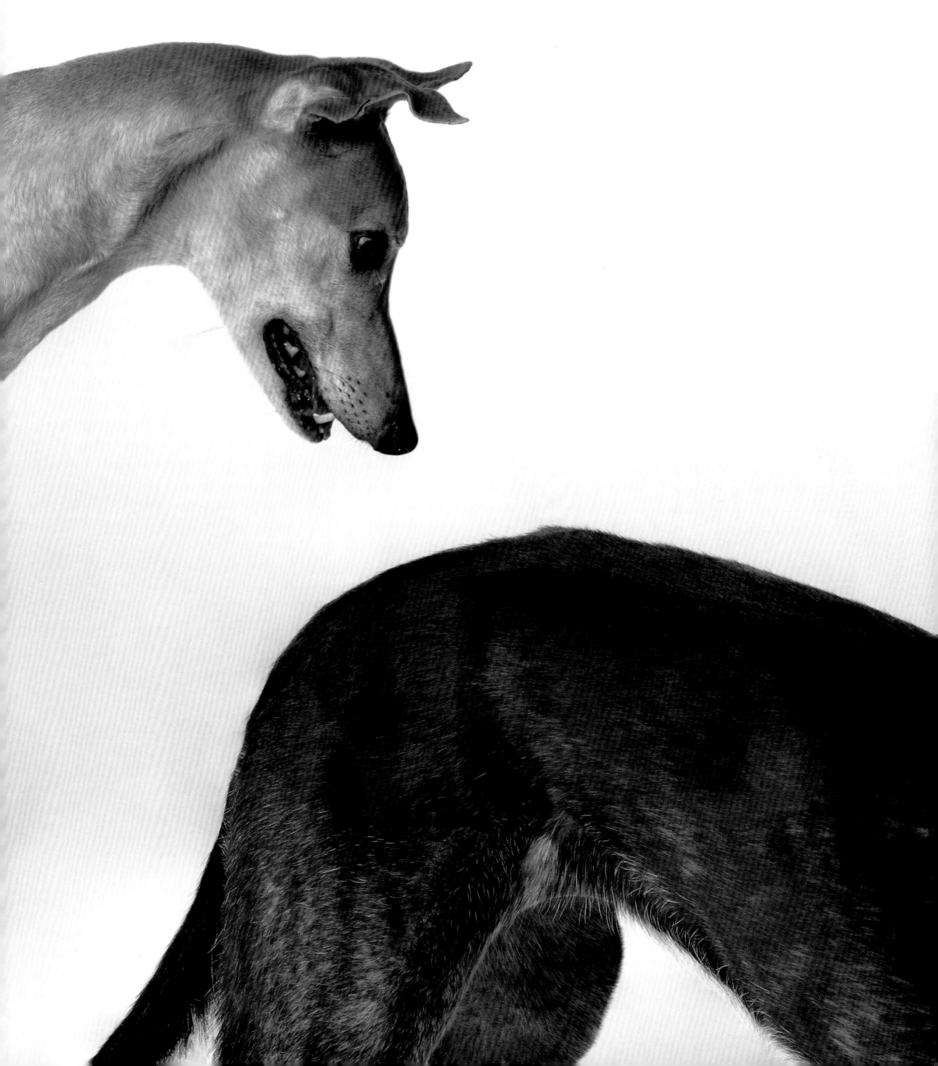

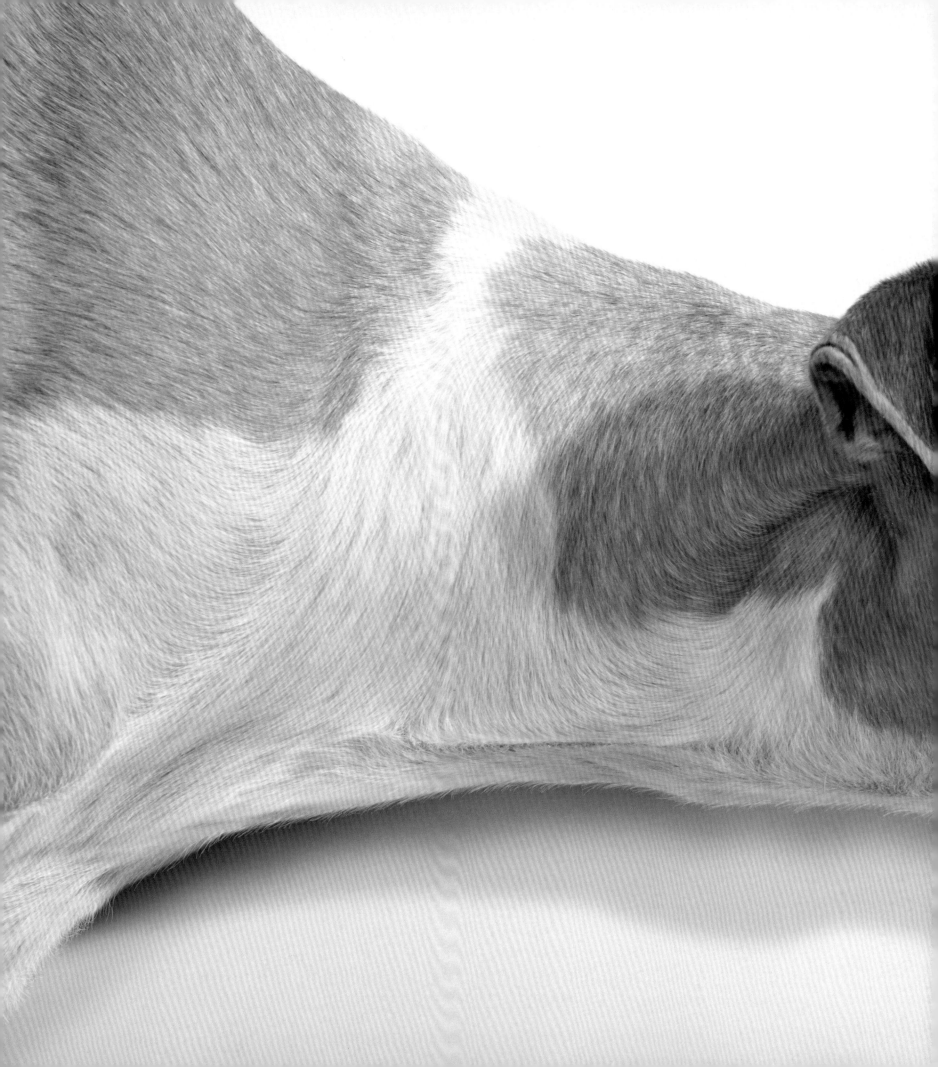

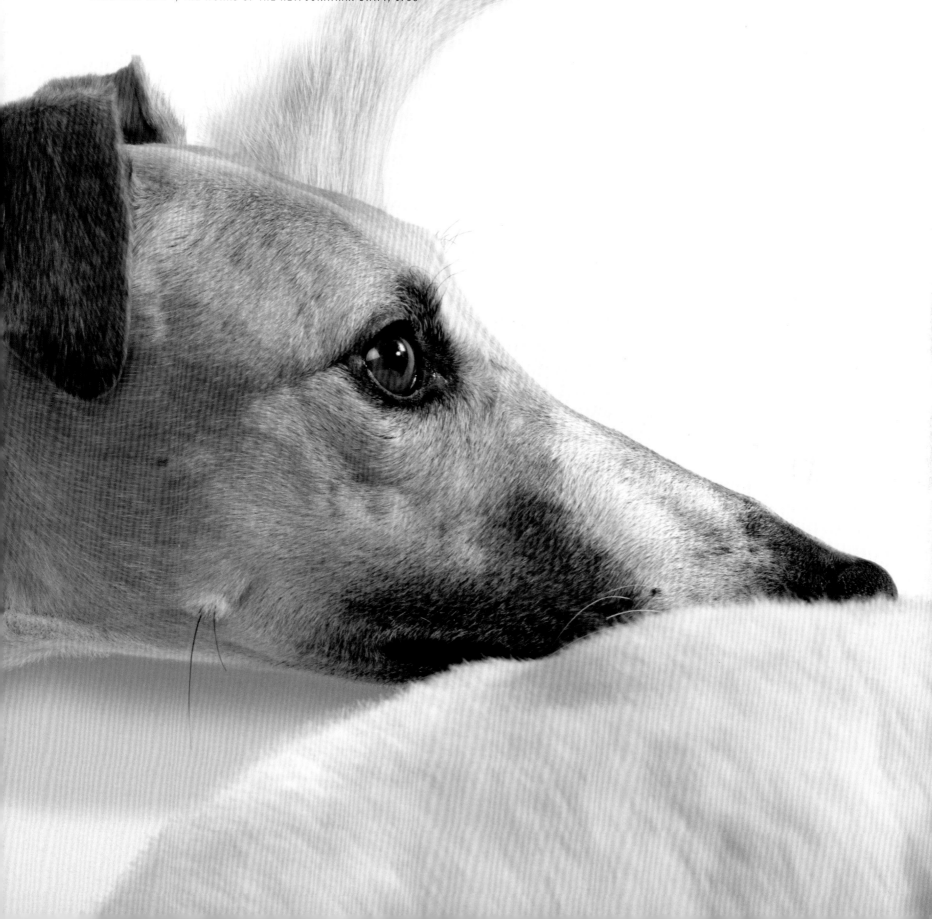

...A GREYHOUND OUT-RUNS THE WHOLE PACK IN A RACE,
YET WOULD RATHER BE HANG'D THAN HE'D LEAVE A WARM PLACE.

JONATHAN SWIFT, *THE WORKS OF THE REV. JONATHAN SWIFT*, 1733

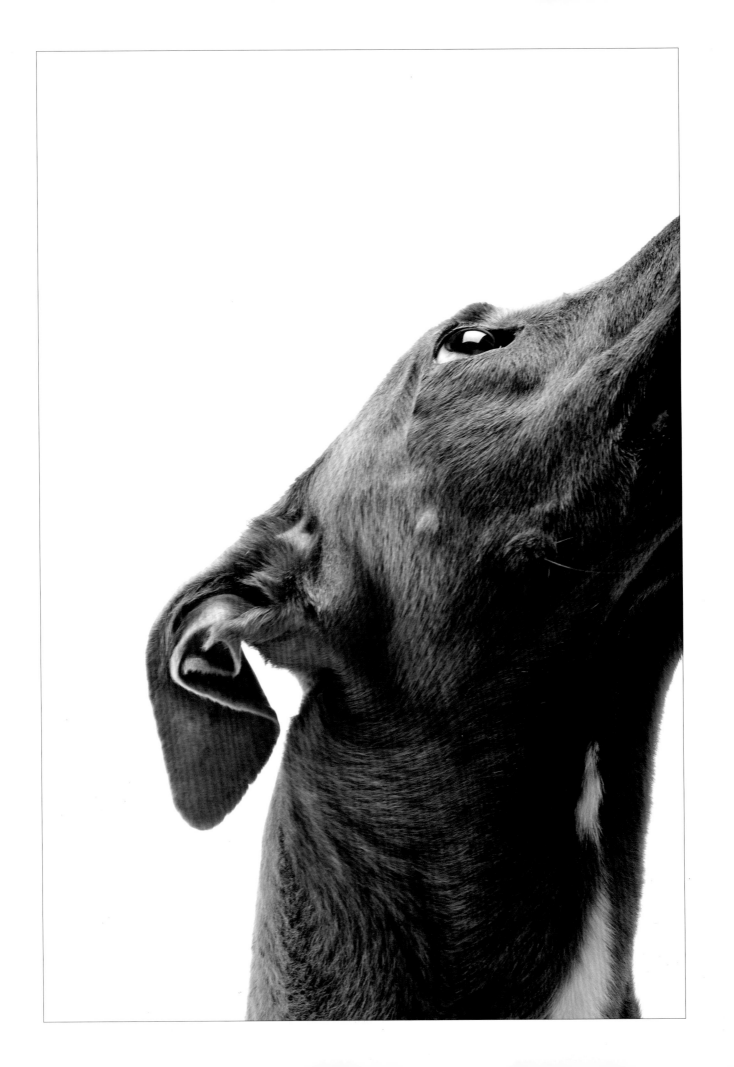

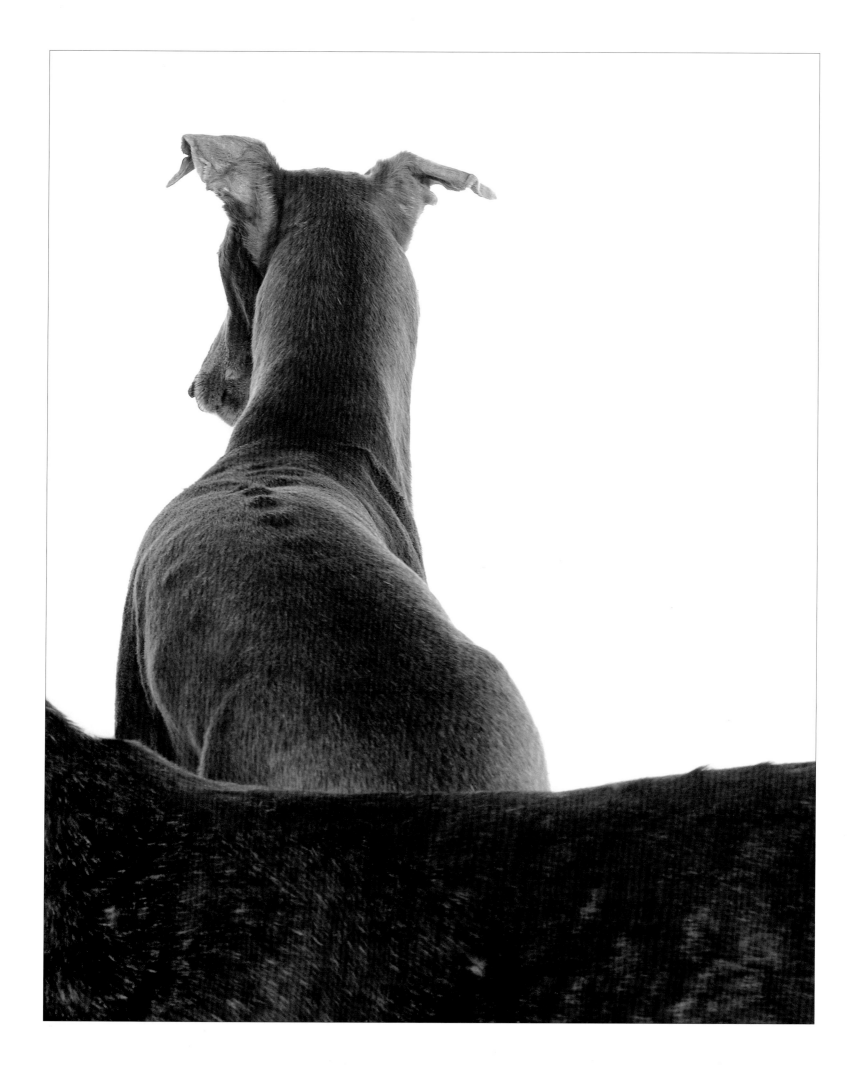

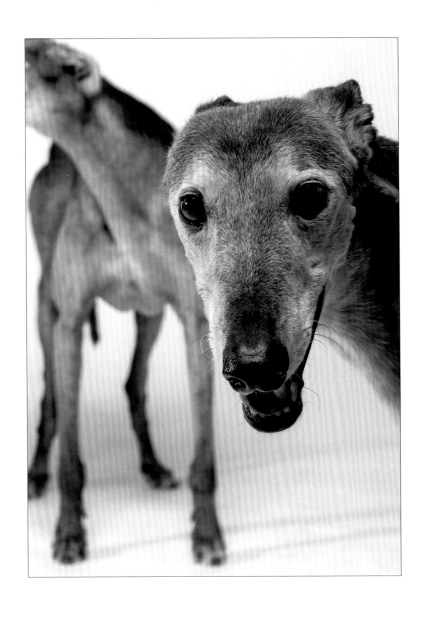
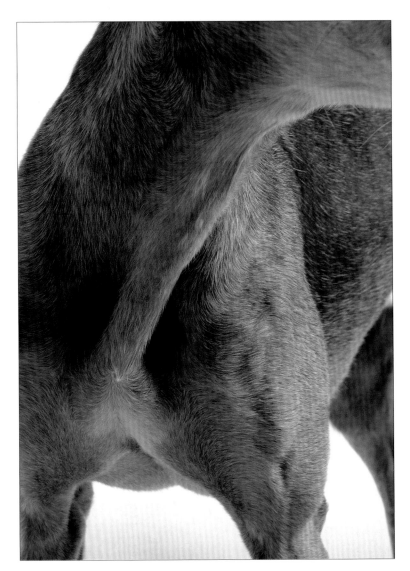

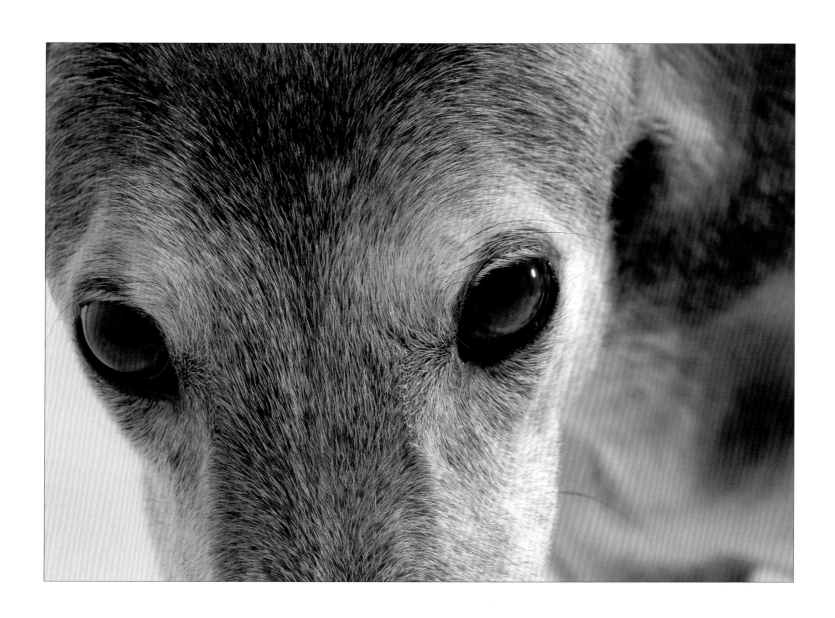

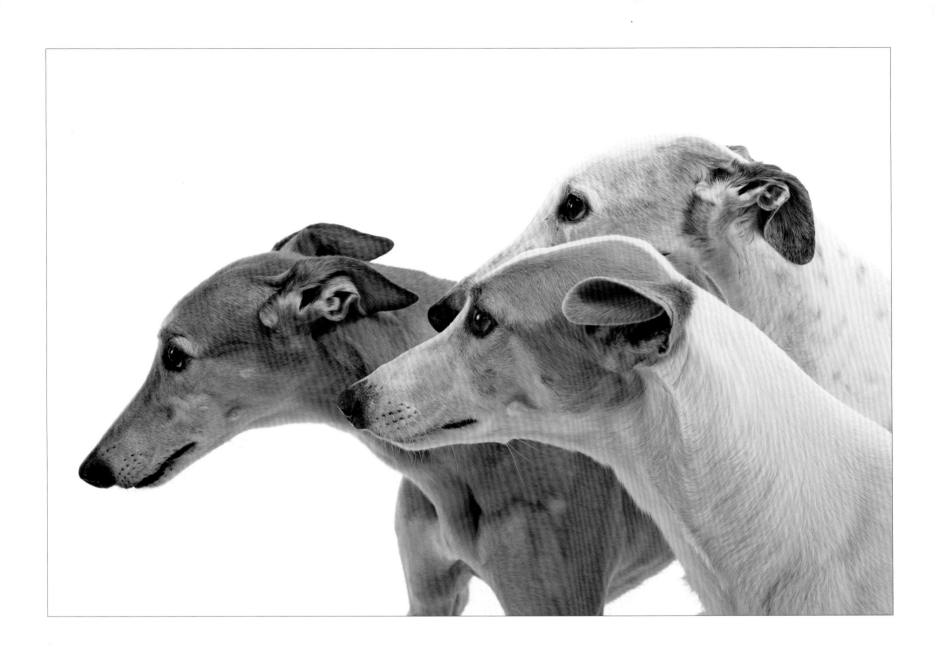

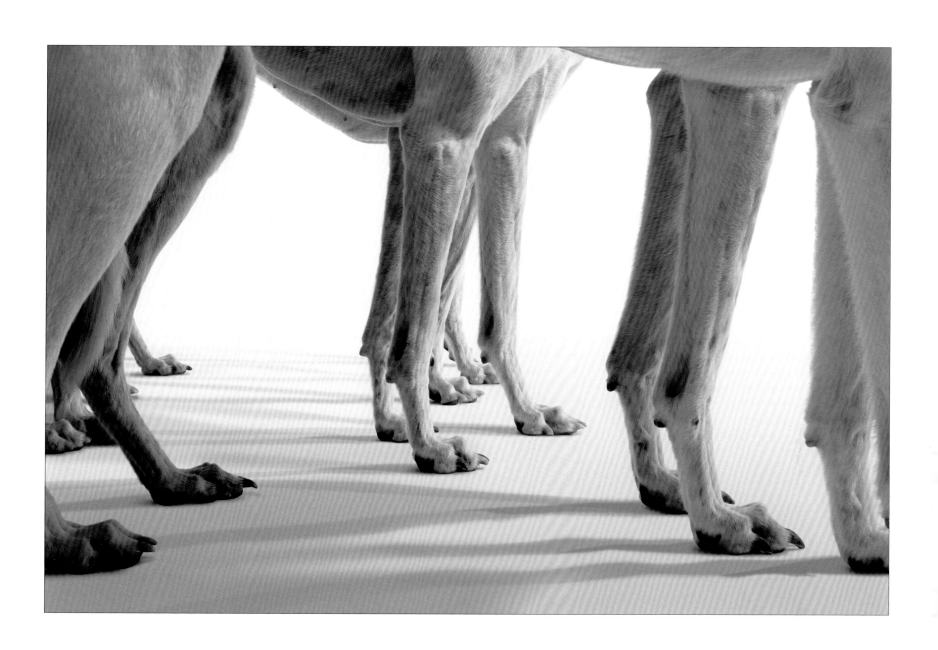

HE HARDLY TOUCHED THE ELASTIC CUSHIONS OF HIS FEET TO EARTH BEFORE HE AGAIN WAS SPREAD OUT LIKE A DARK, STRAIGHT THREAD. THIS GATHERING AND LEAPING MUST BE SEEN, TO REALIZE HOW MARVELOUS IS THE RAPIDITY AND HOW THE MOTION SEEMS LIKE FLYING, ALMOST, AS THE GROUND IS SCORNED EXCEPT AS A SORT OF SPRINGBOARD.

MRS. GEORGE CUSTER OF THEIR "SUPERB GREYHOUND CALLED BYRON," *TENTING ON THE PLAINS*, 1887

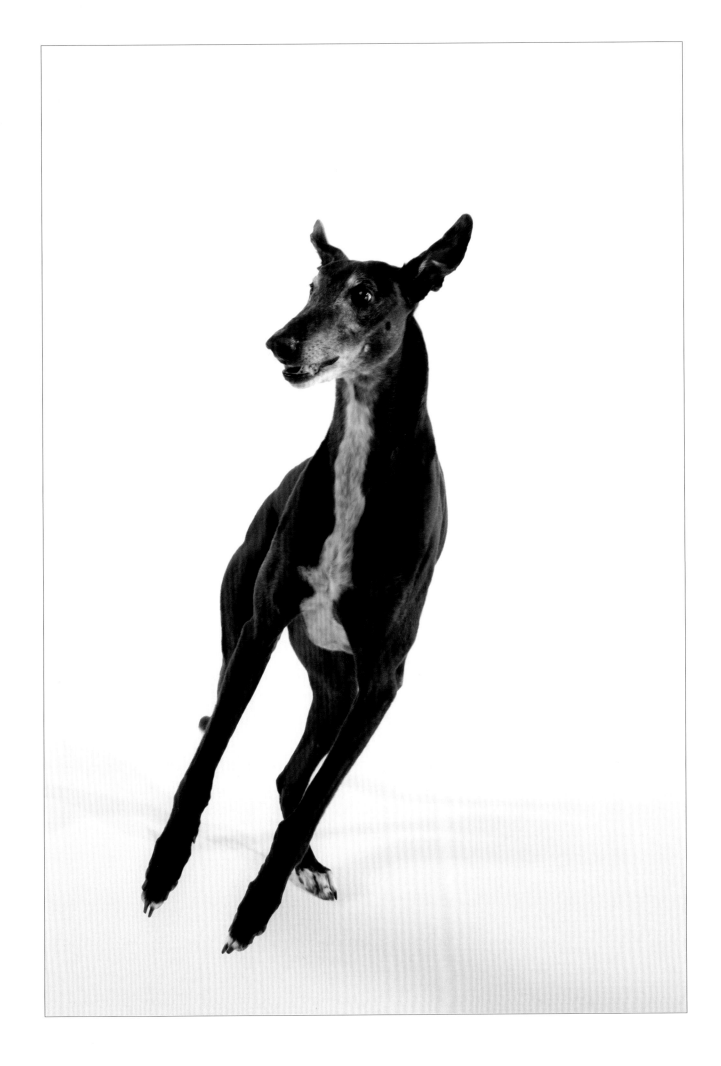

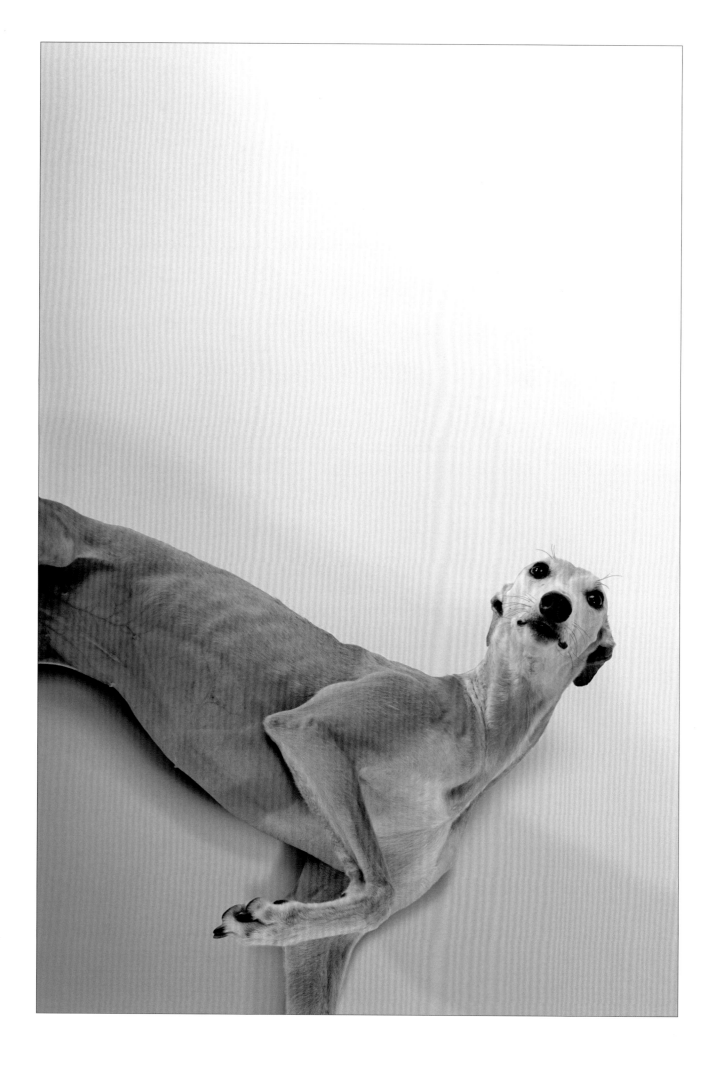

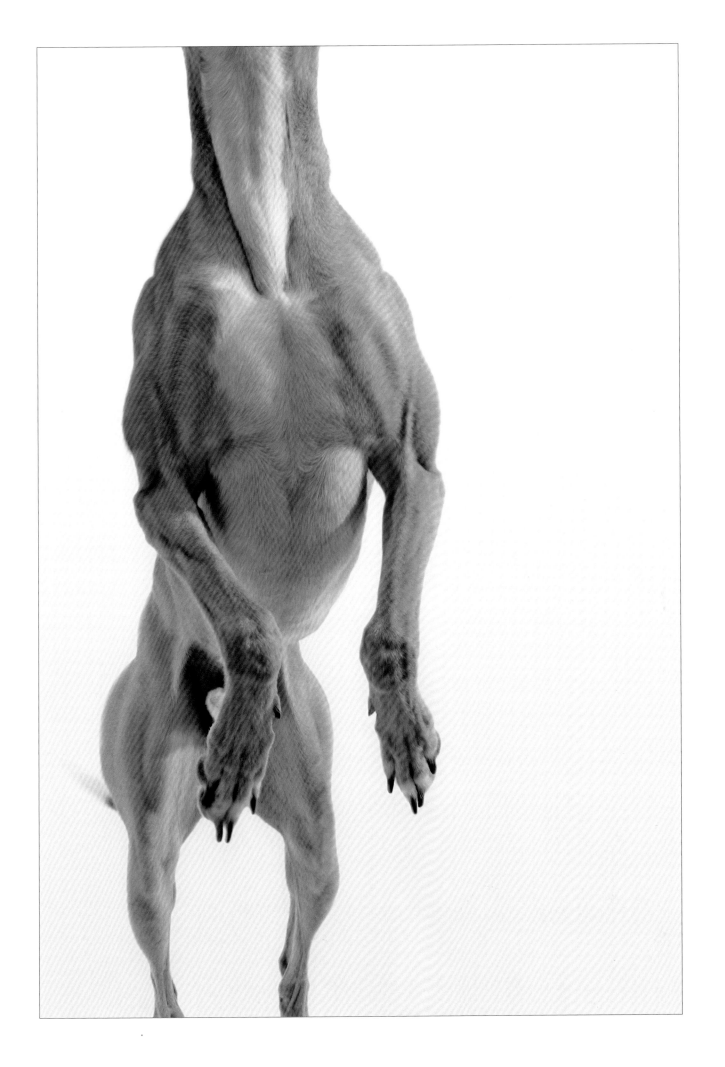

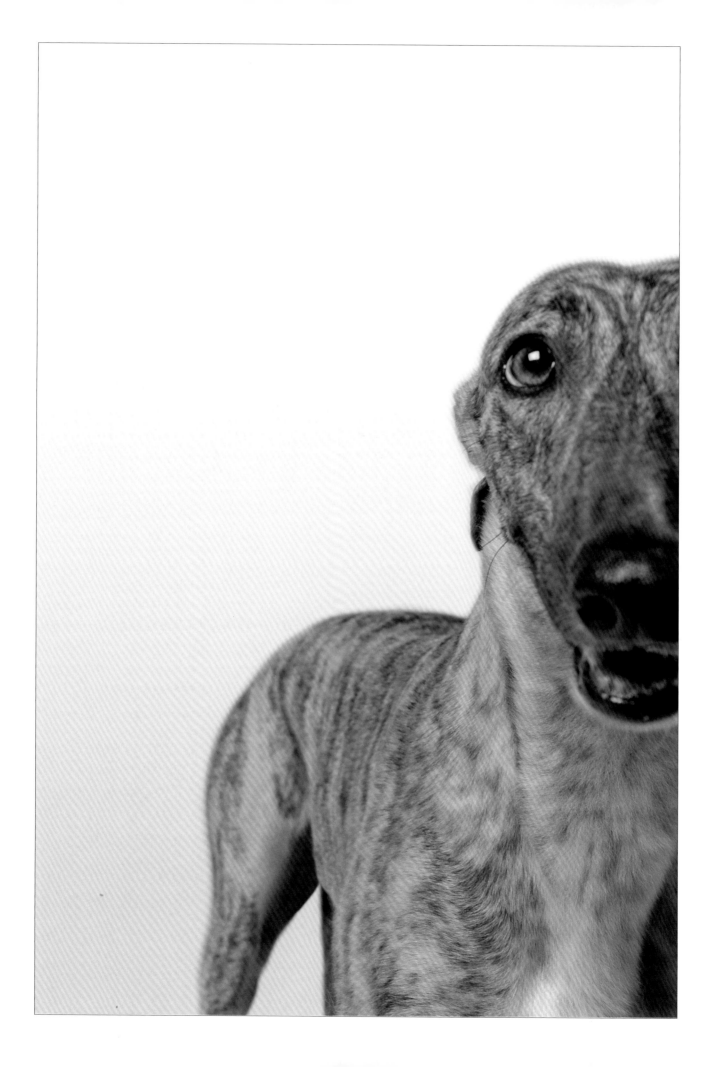

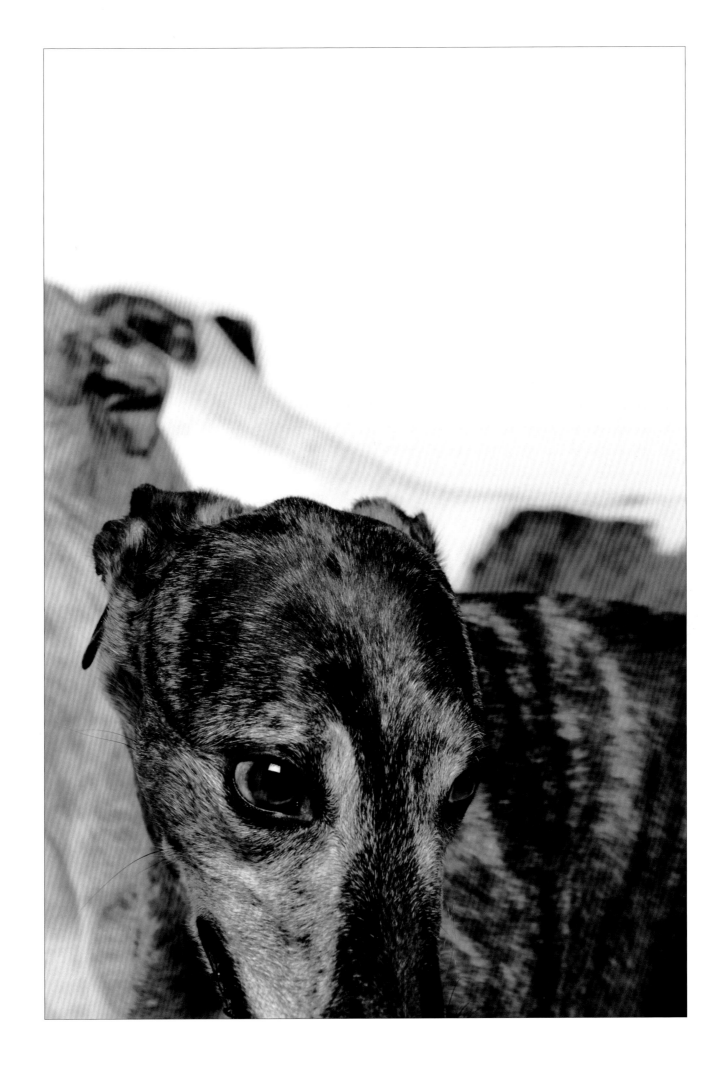

REMEMBER'ST THOU MY GREYHOUNDS TRUE?
O'ER HOLT OR HILL THERE NEVER FLEW,
FROM SLIP OR LEASH THERE NEVER SPRANG,
MORE FLEET OF FOOT, OR SURE OF FANG.

SIR WALTER SCOTT, *MARMION: A TALE OF FLODDEN FIELD*, 1808

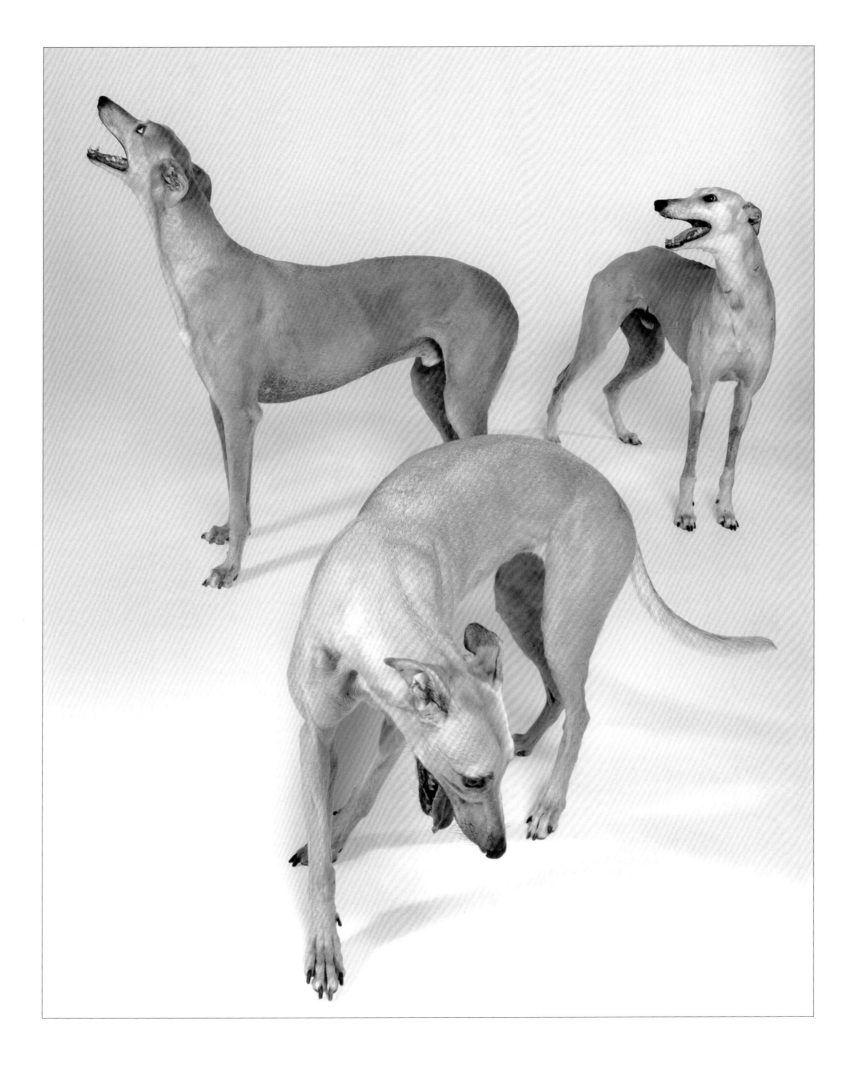

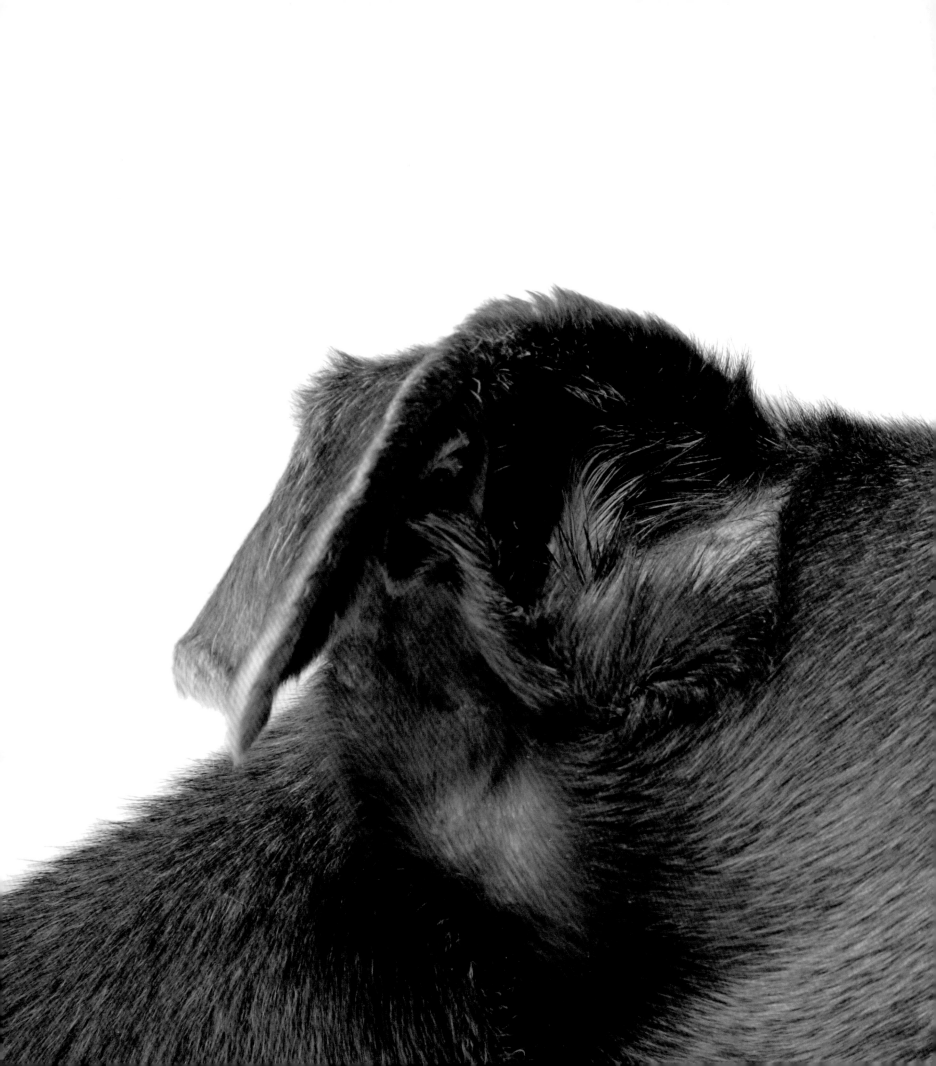

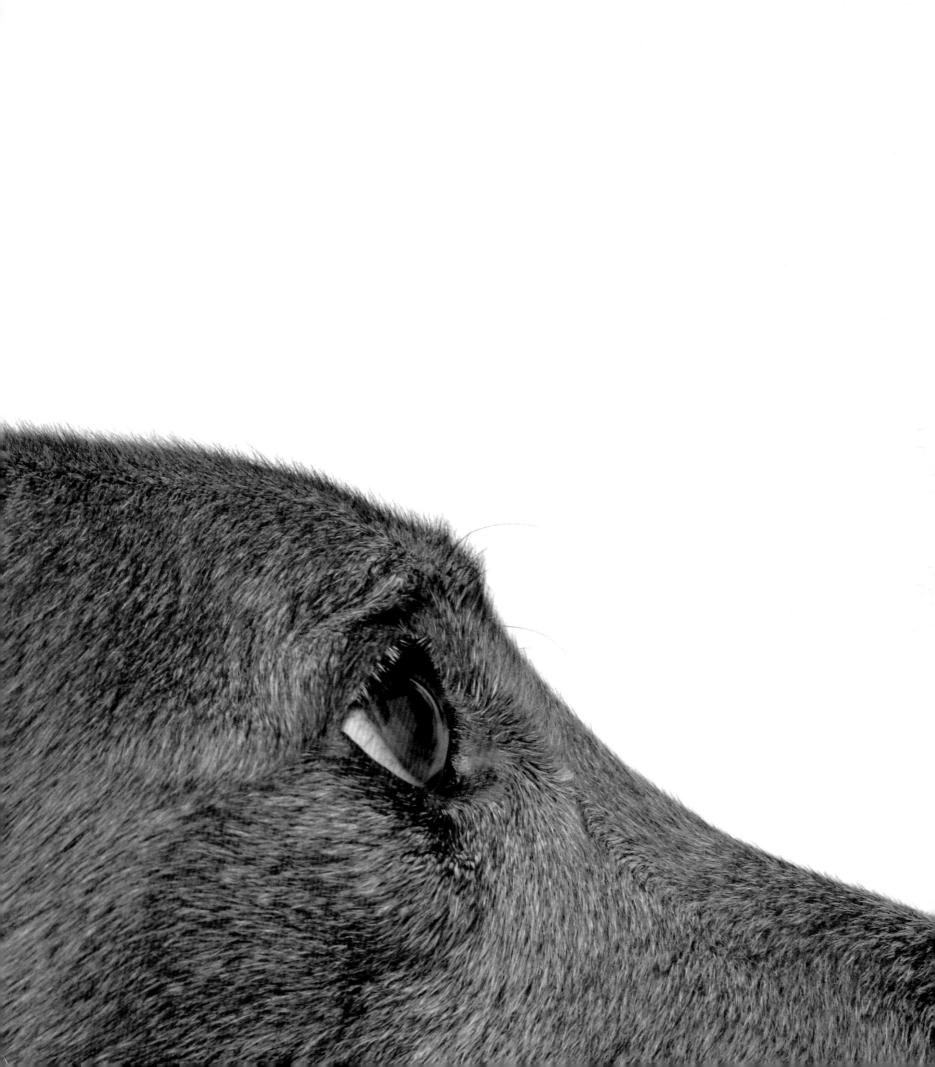

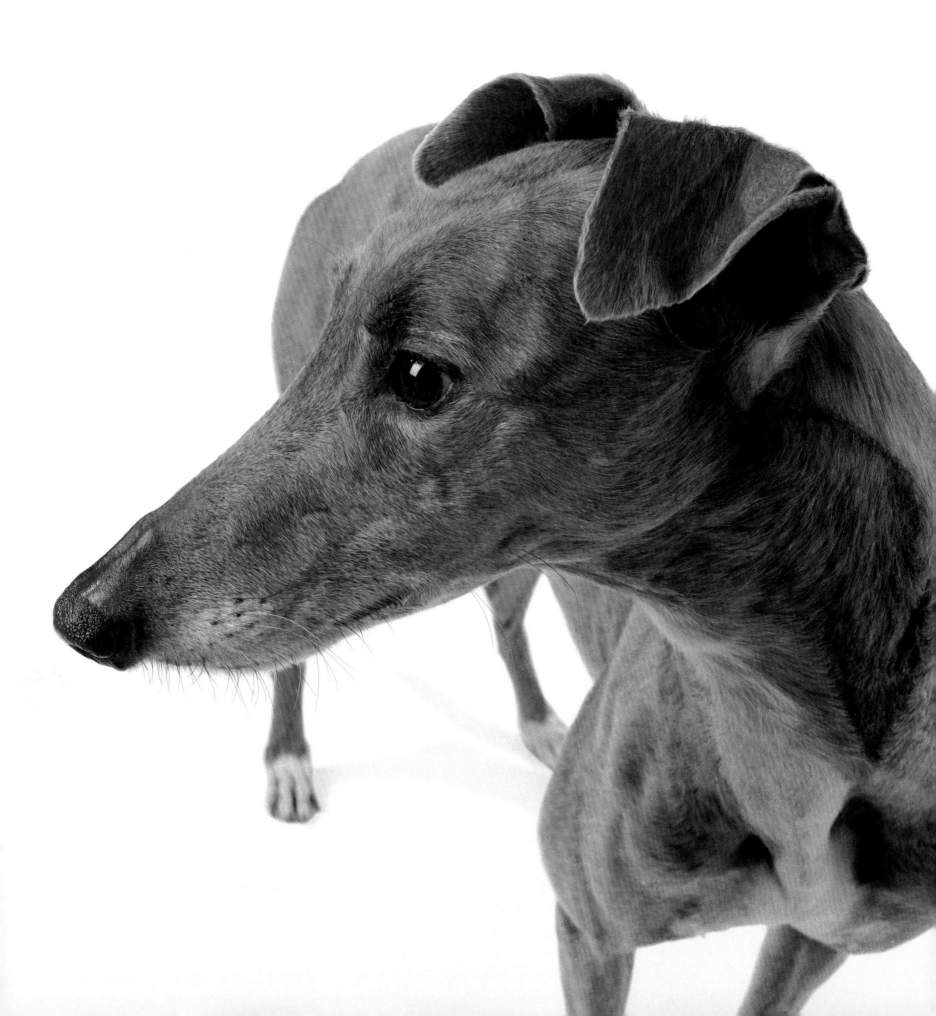

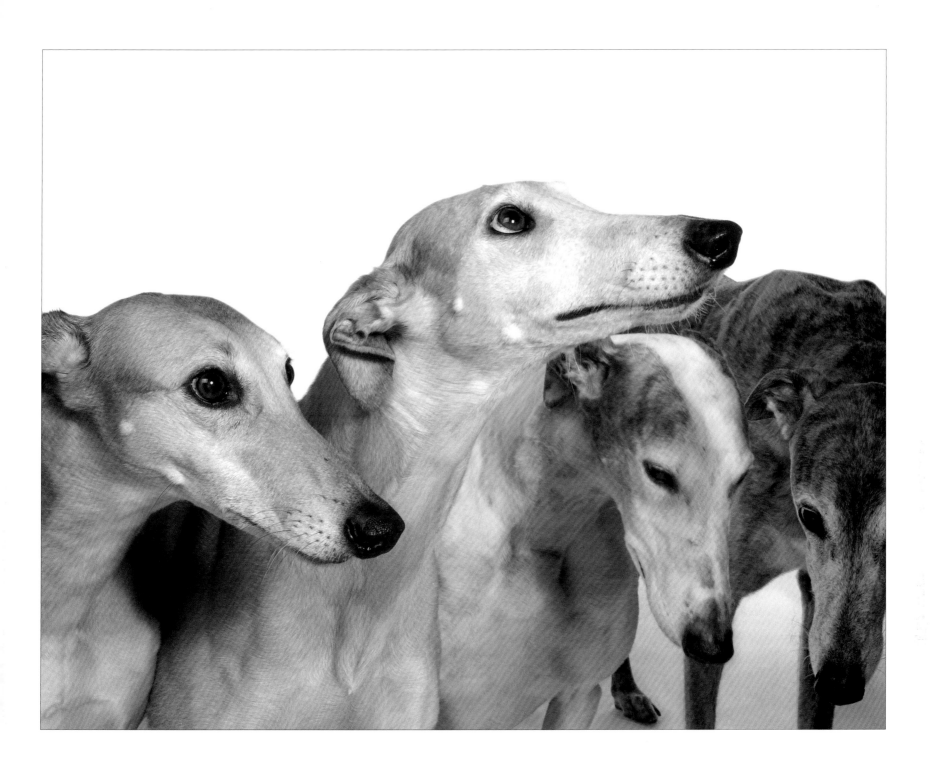

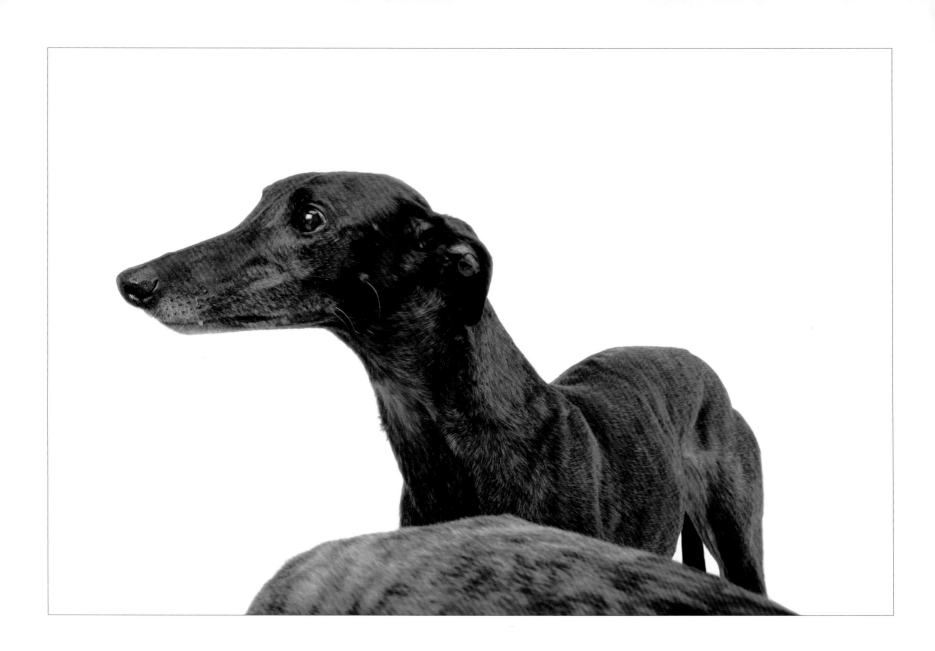

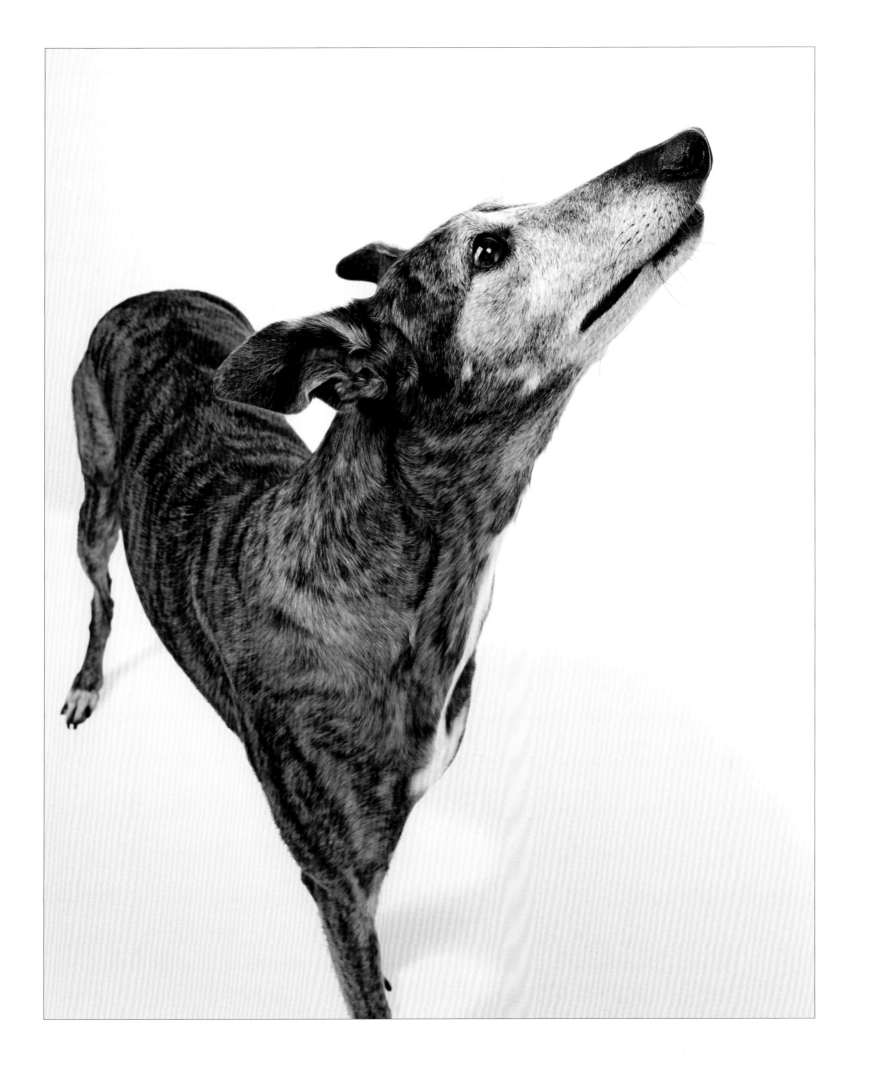

THEY GAVE HIM TO ME—FOR MY PLAY—
A GREYHOUND—SLENDER—SILVER-GREY
AS WINTER SKIES, AND SMOOTH AS THOUGH
THE QUEEN HAD STROKED HIM WITH HER HAND.

DAVID OSBORNE HAMILTON, "THE GREYHOUND," *FOUR GARDENS*, 1920

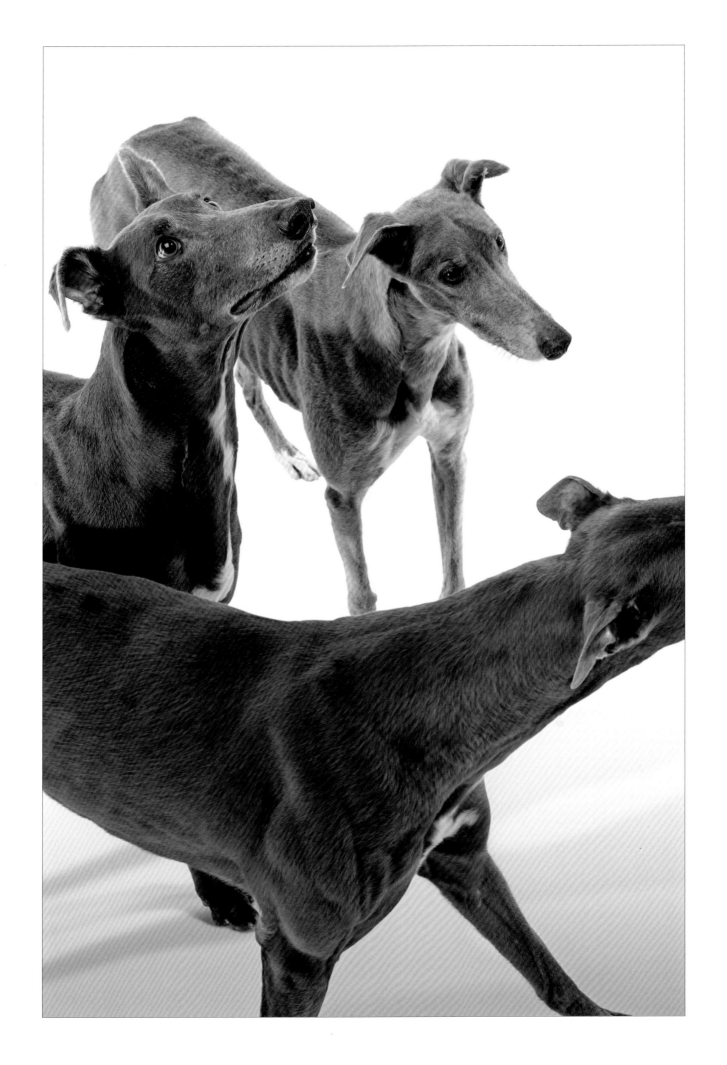

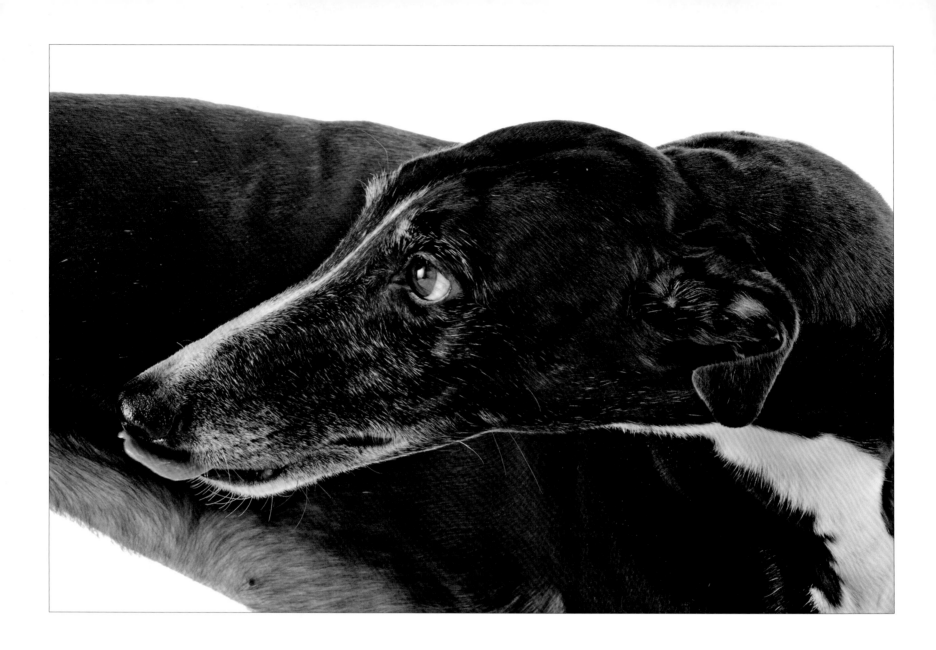

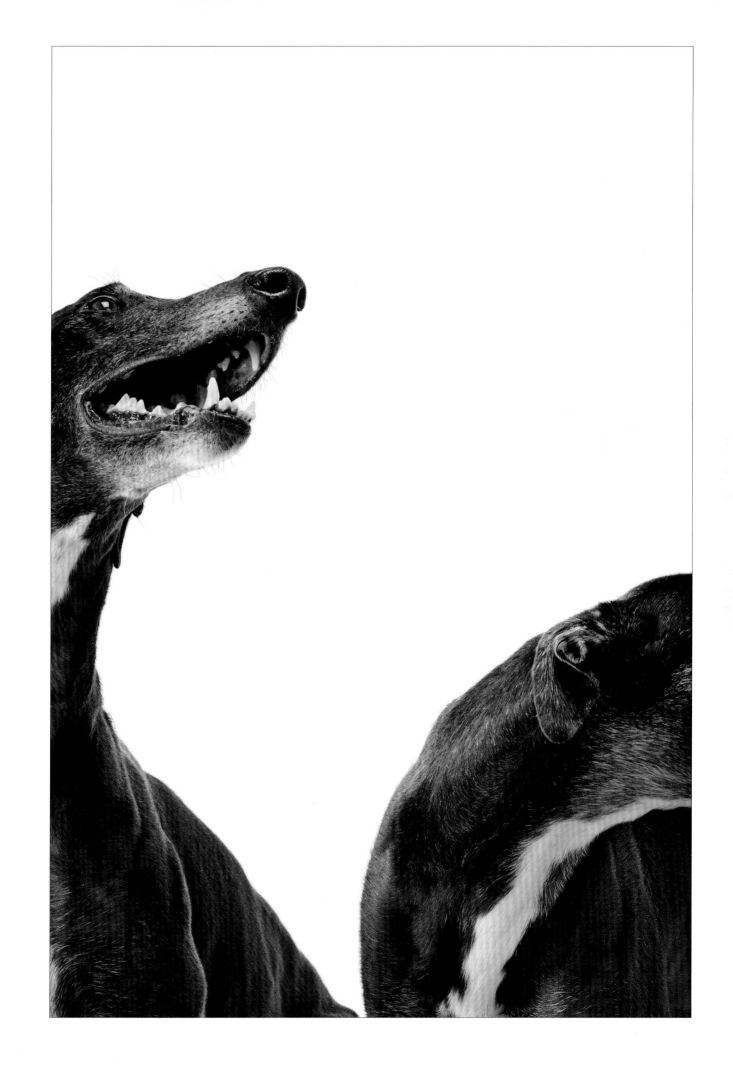

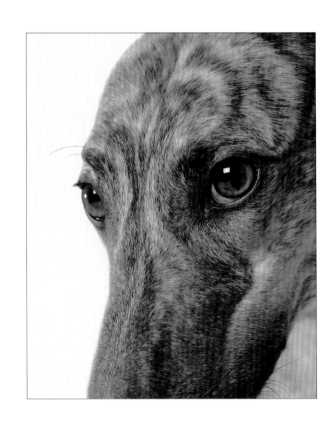

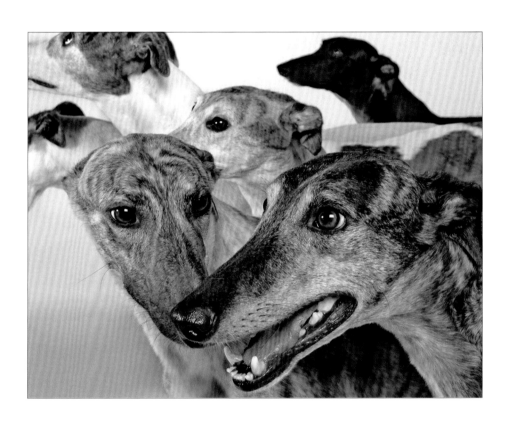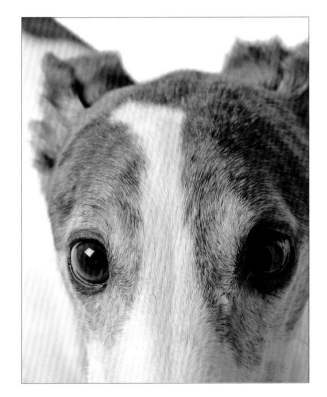

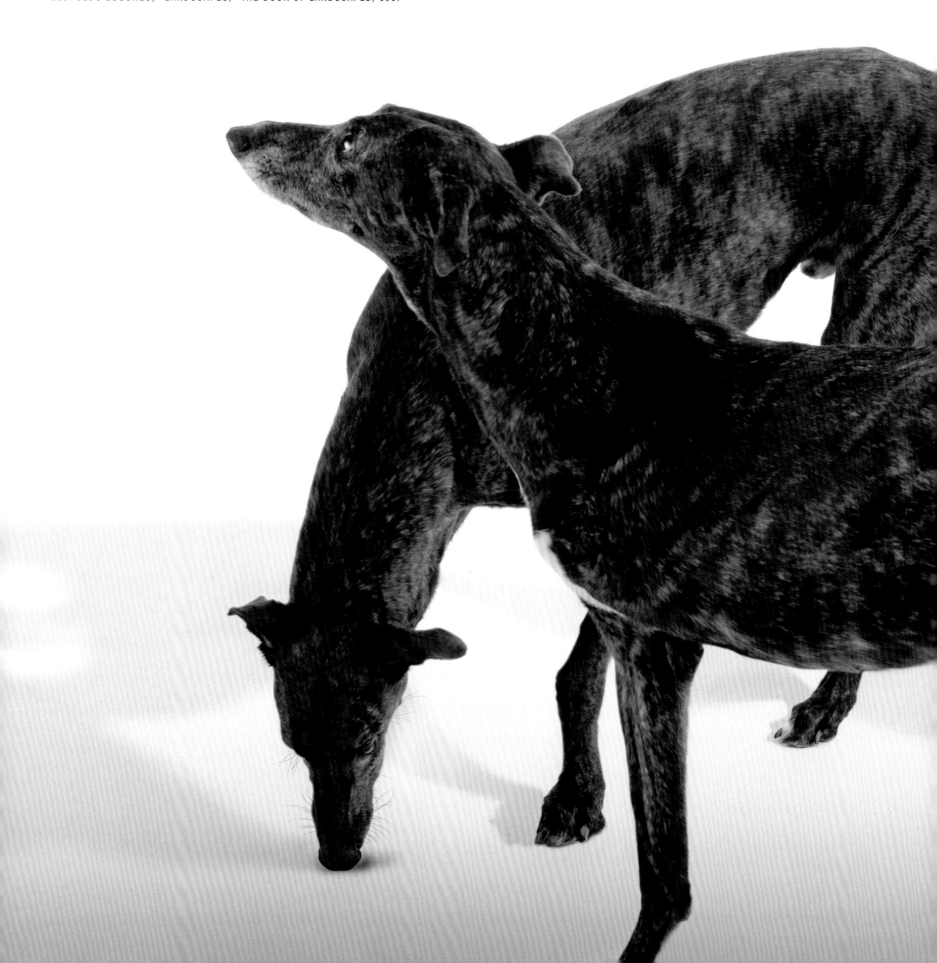

SILENCE WAS MOVING LIKE A LONG GREYHOUND.

LEOPOLDO LUGONES, "LANDSCAPES," *THE BOOK OF LANDSCAPES*, 1917

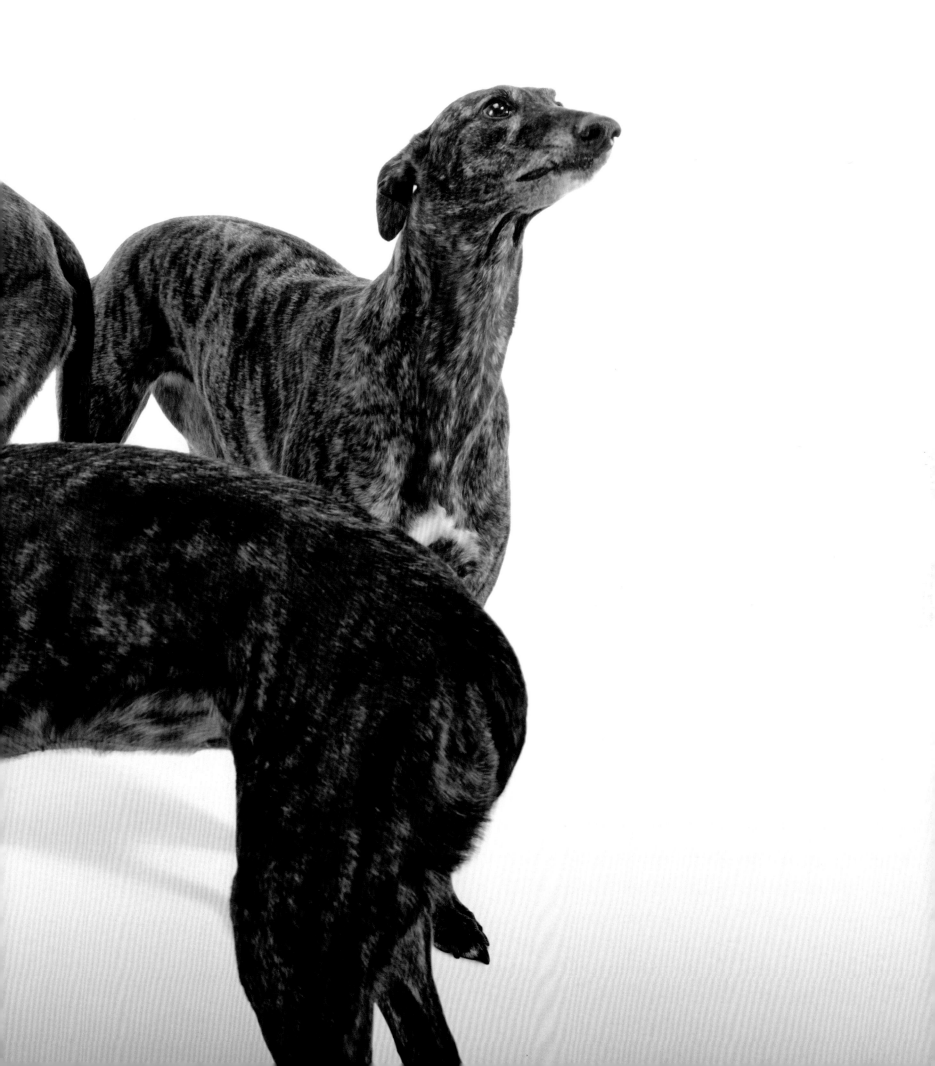

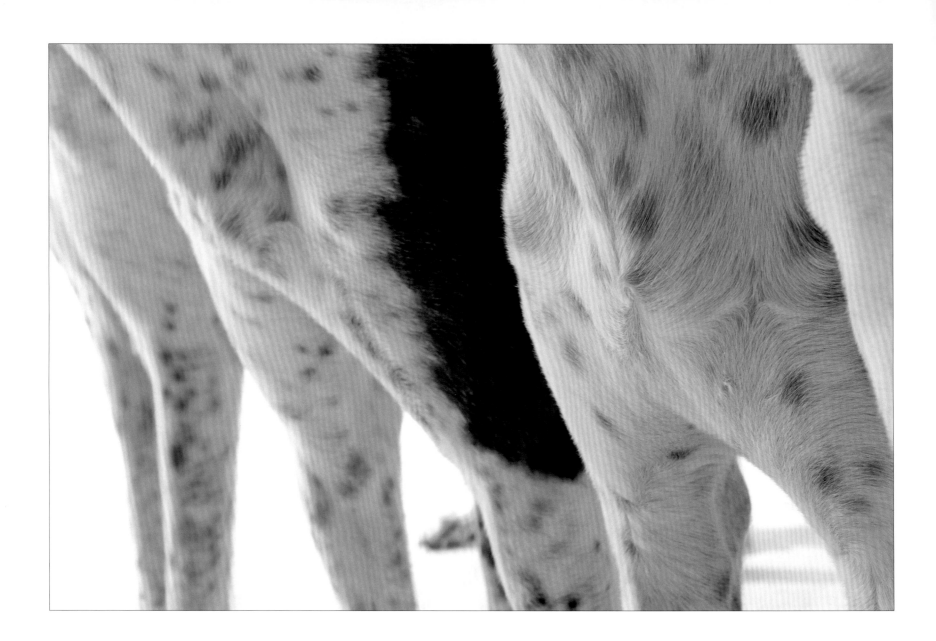

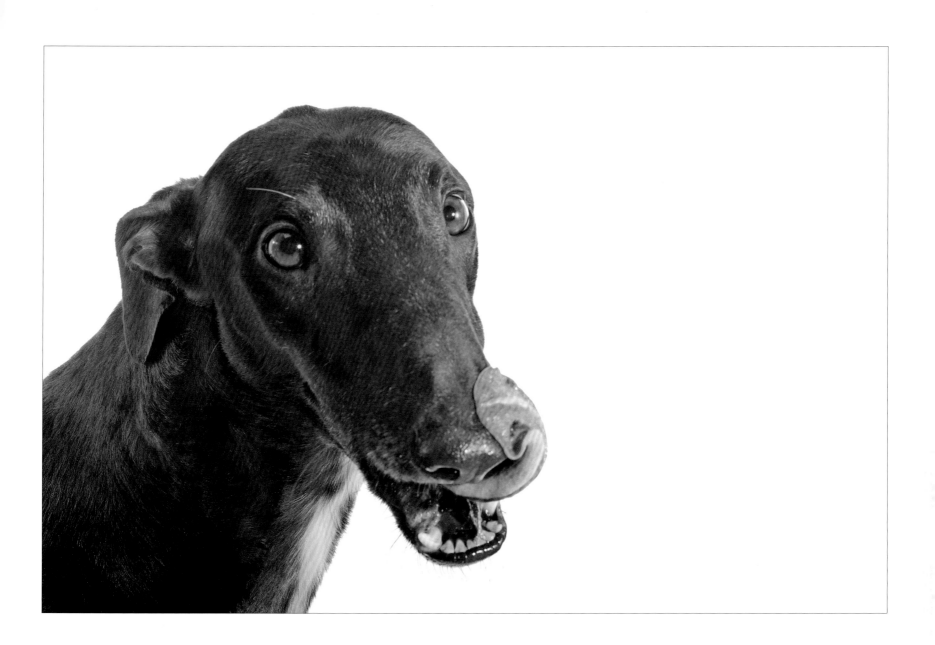

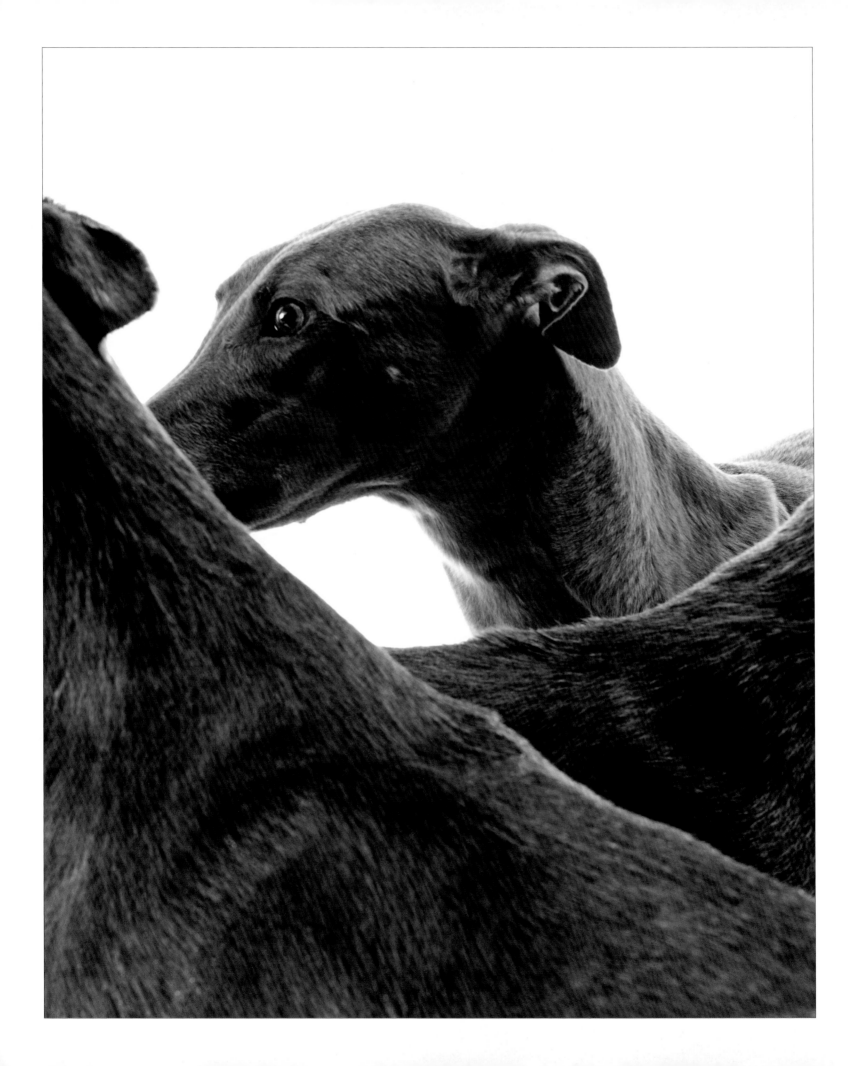

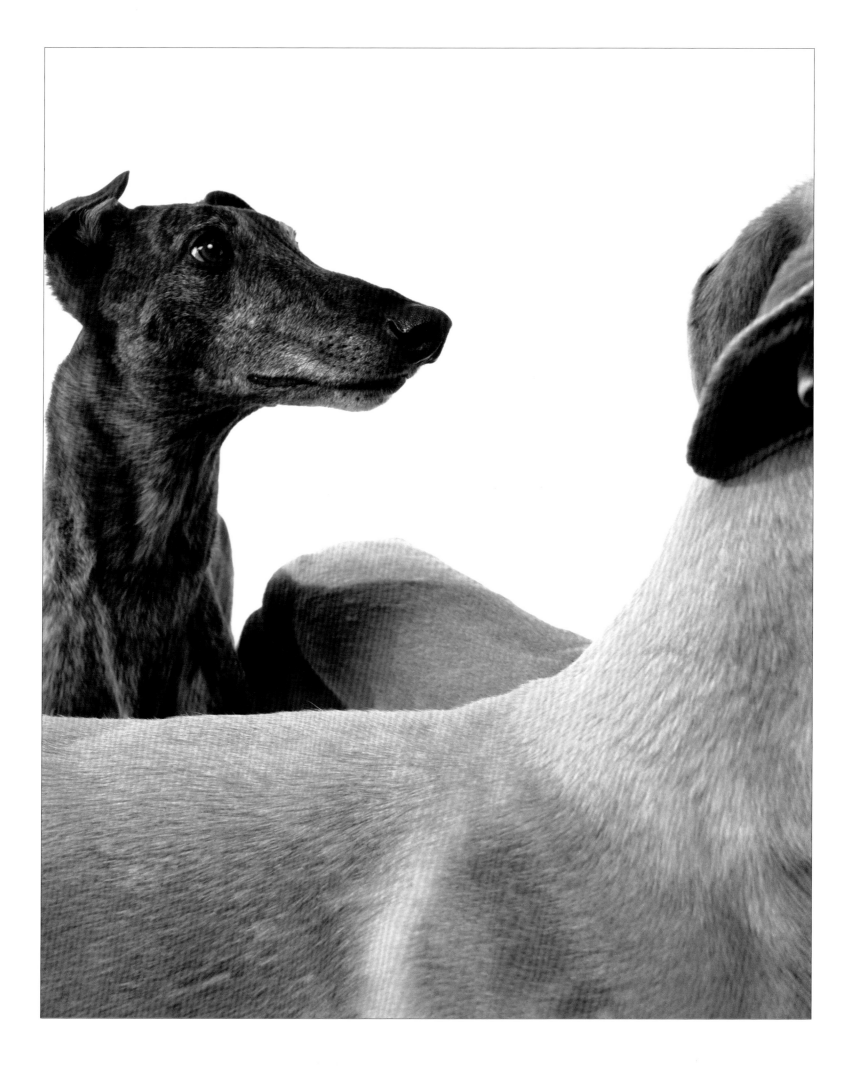

I WOULD DIE FOR YOU, OH MY MISTRESS!
I WOULD STEEP MY SOUL IN THE RIVERS OF DEATH,
FOR ONE SUCH CARESS AS YOU BESTOW
ON YOUR PET GREYHOUND!

LOUISE CHANDLER MOULTON, *JUNO CLIFFORD: A TALE,* 1855

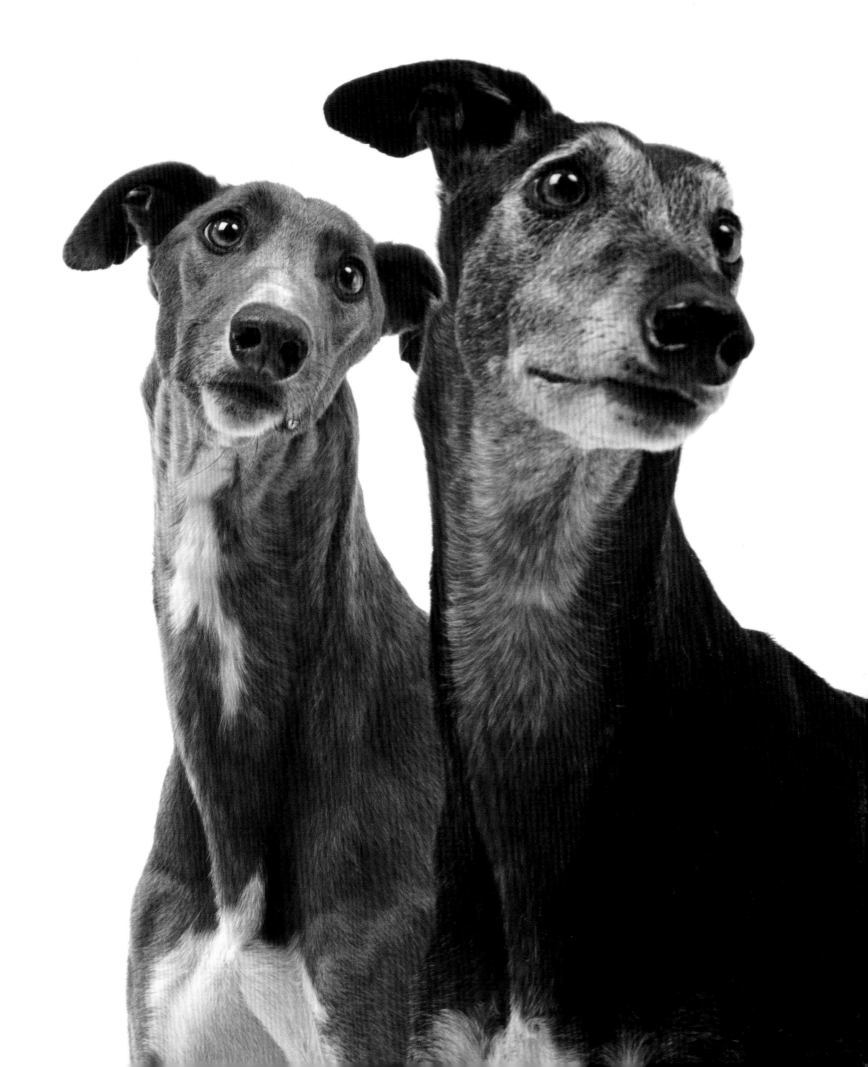

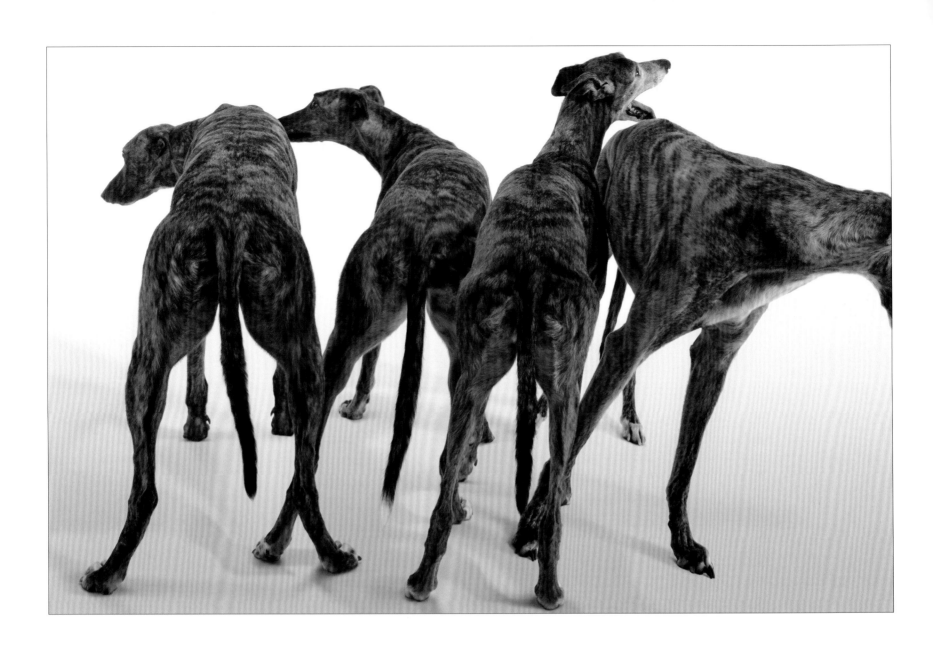

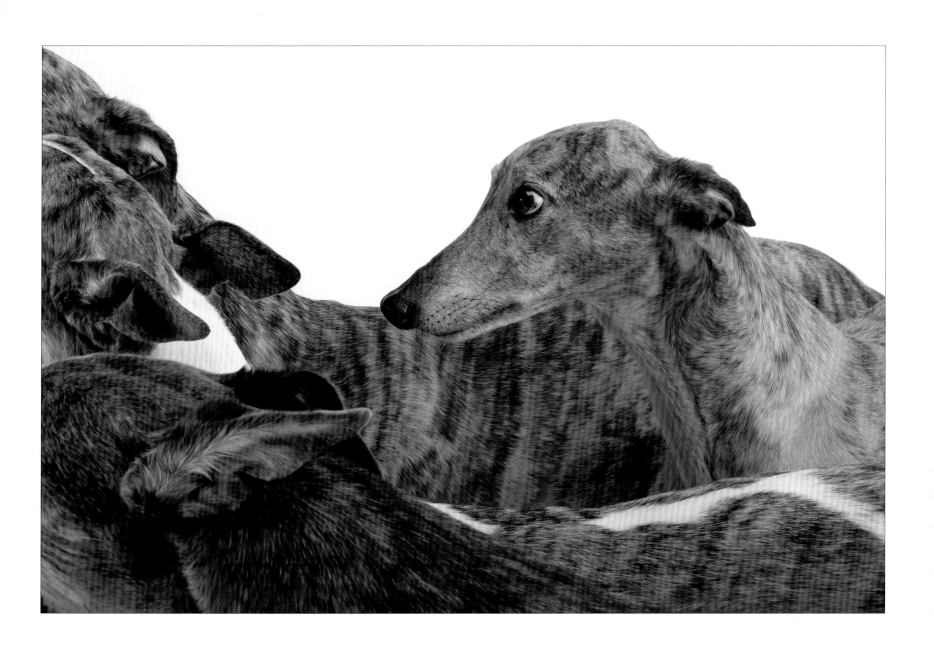

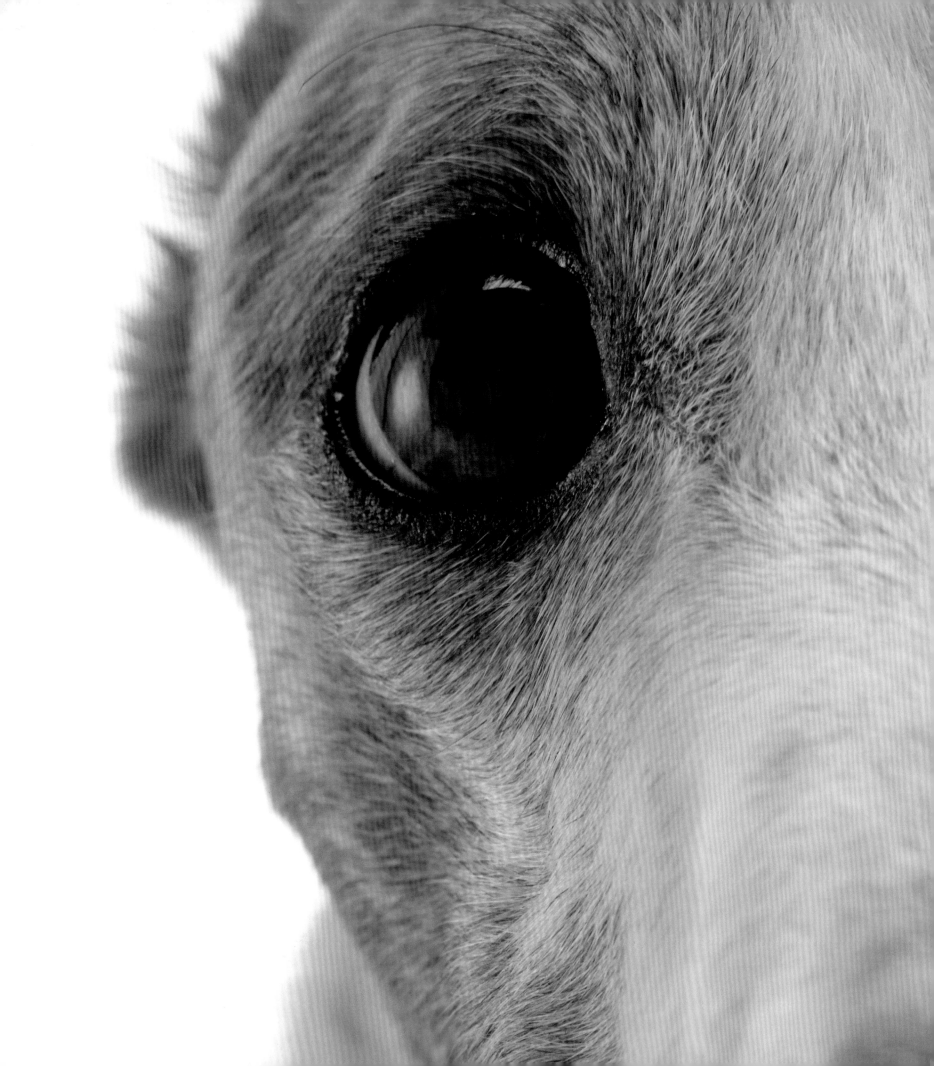

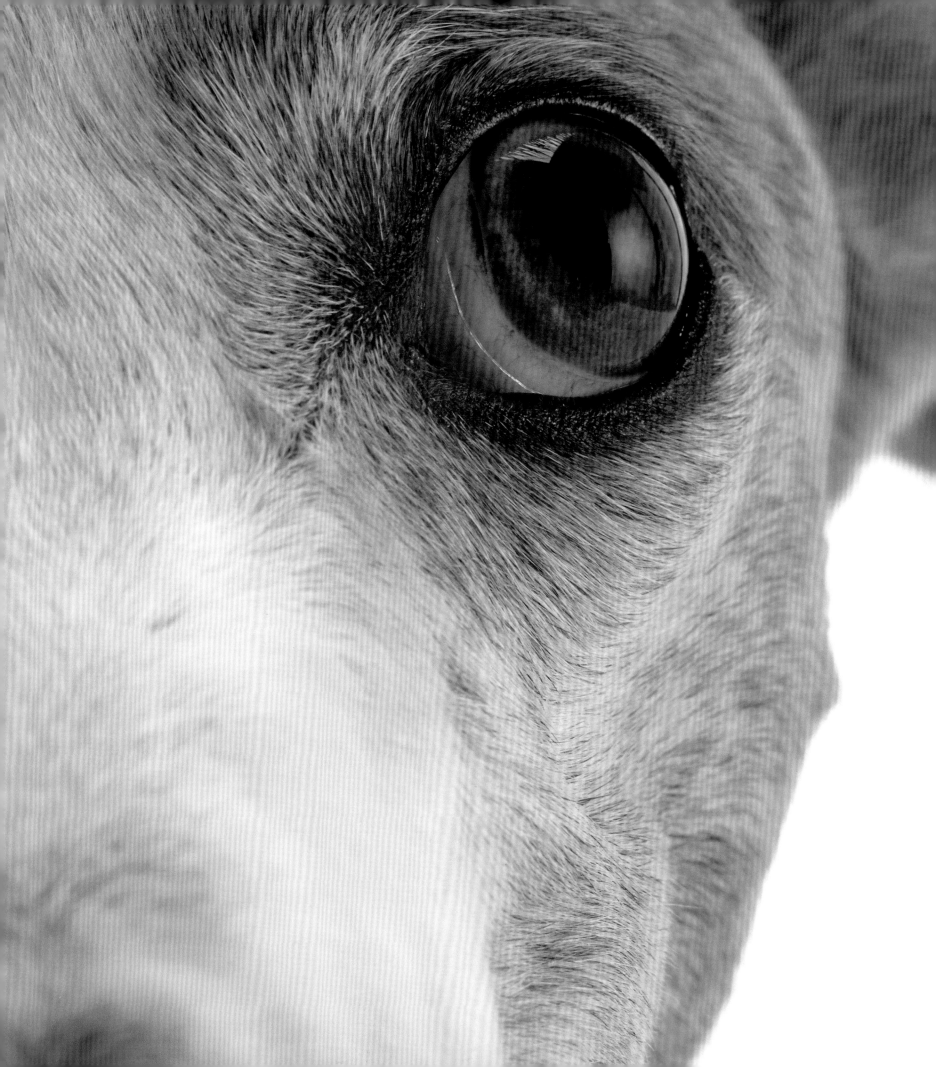

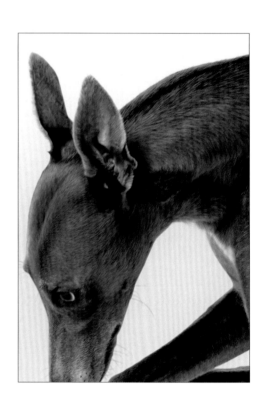

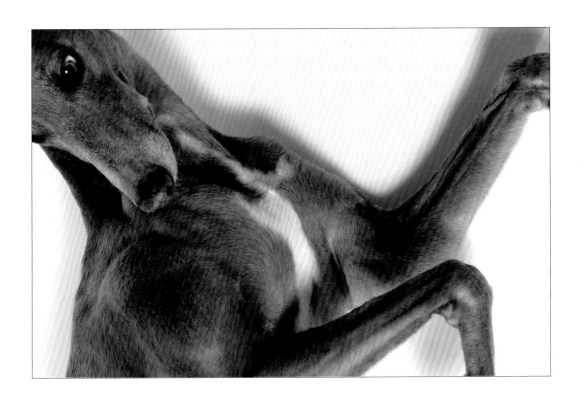
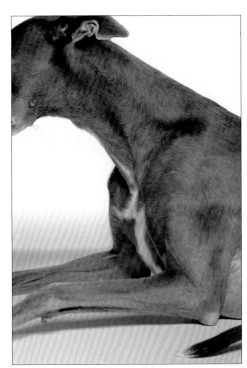

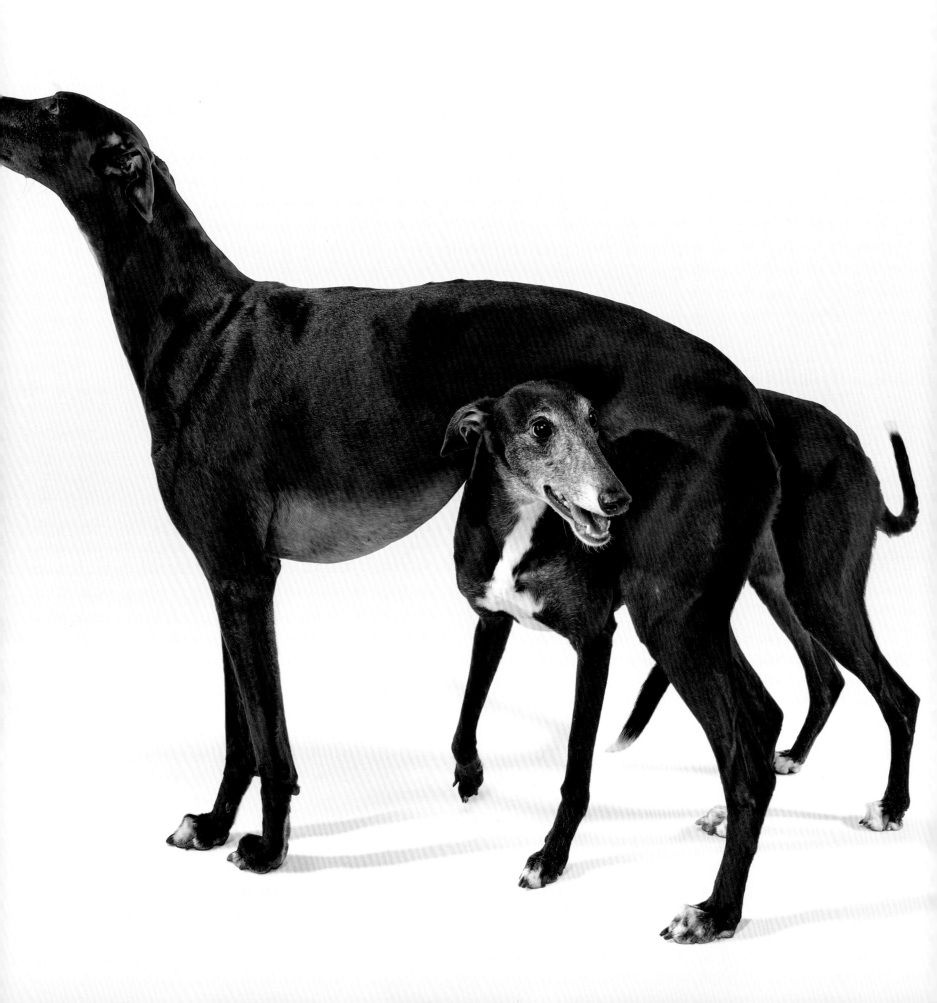

THE HAREHOUND, OR GREYHOUND,
WAS CONSIDERED AS A VERY VALUABLE
PRESENT IN FORMER TIMES, AND ESPECIALLY
AMONG THE LADIES, WITH WHOM IT APPEARS
TO HAVE BEEN A PECULIAR FAVOURITE.

JOSEPH STRUTT, *THE SPORTS AND PASTIMES OF THE PEOPLE OF ENGLAND*, 1801

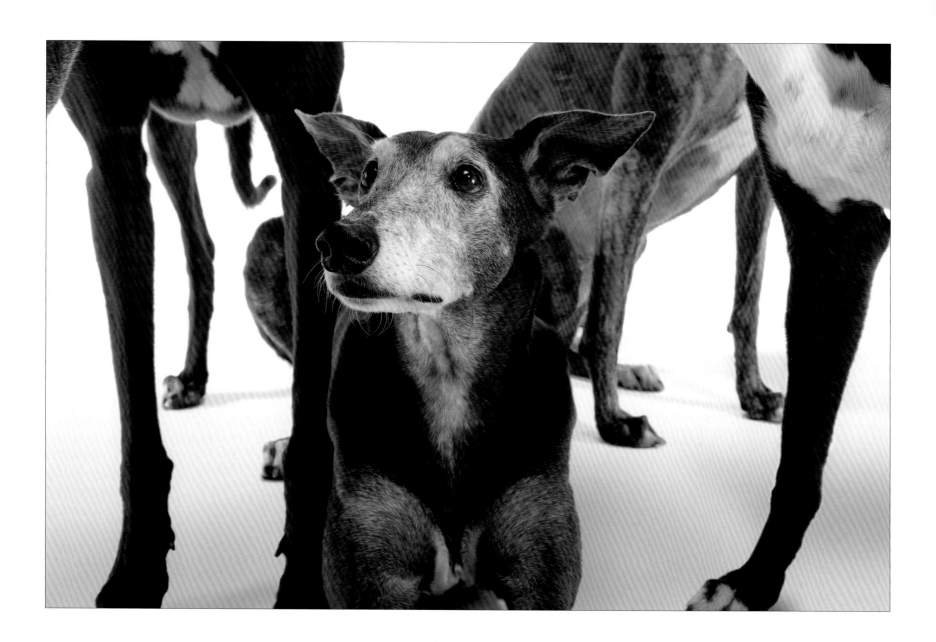

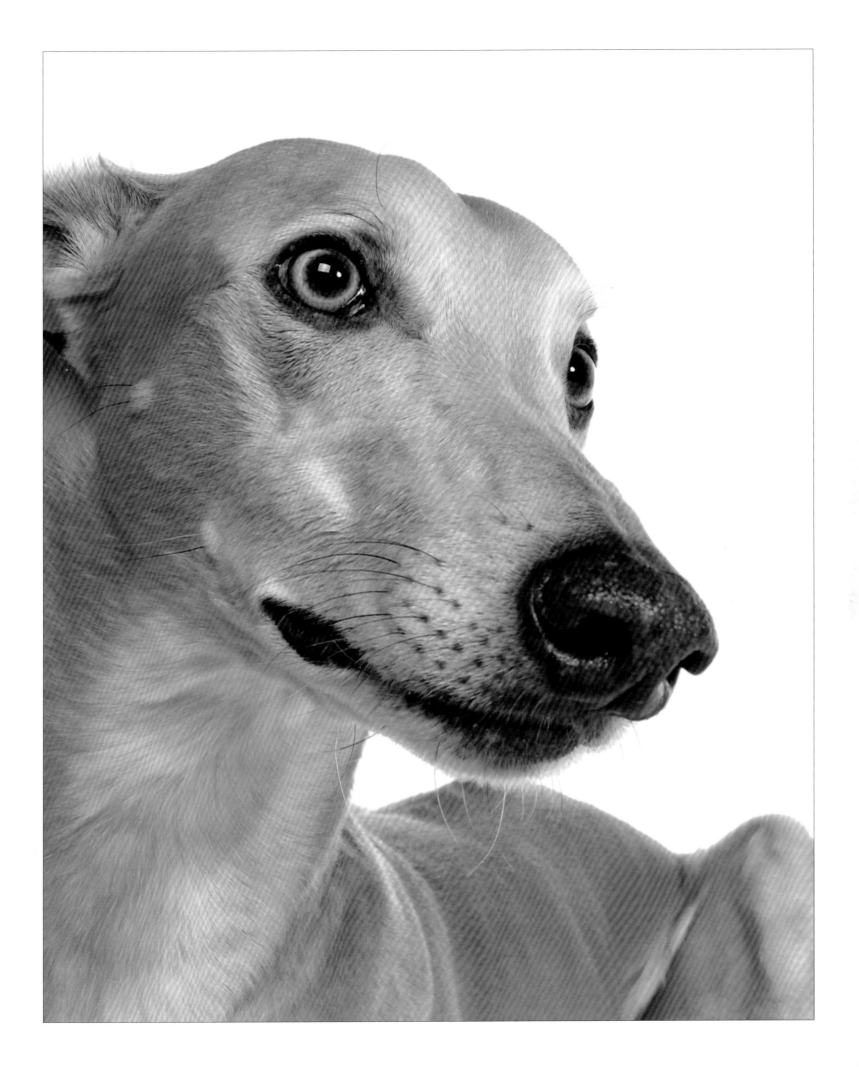

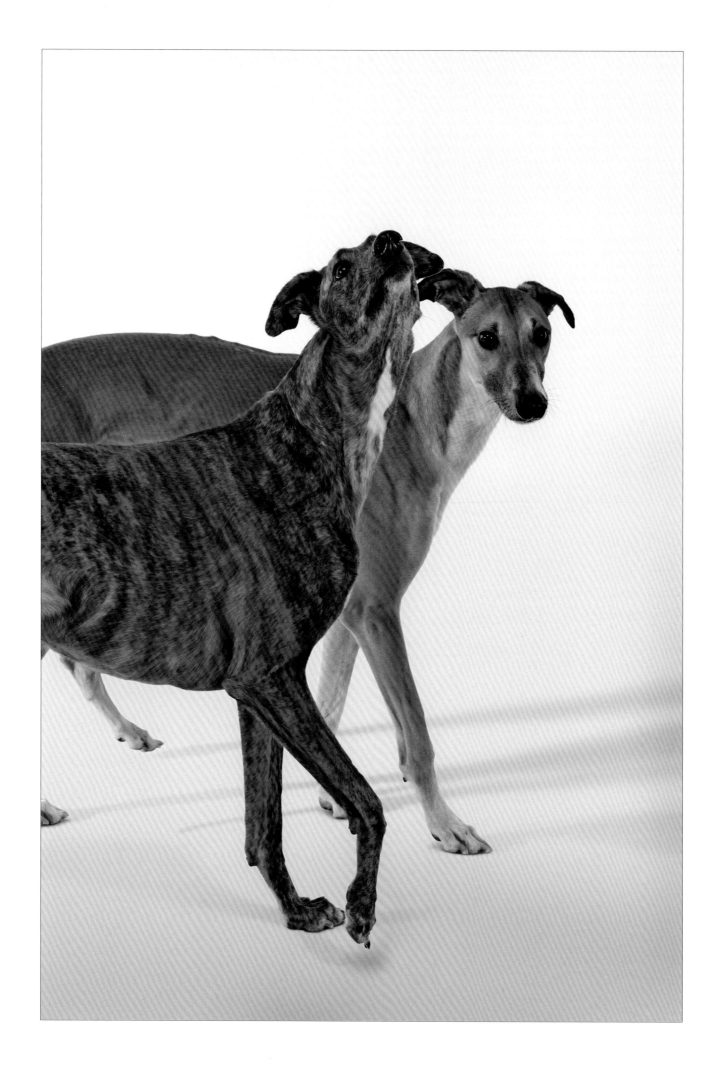

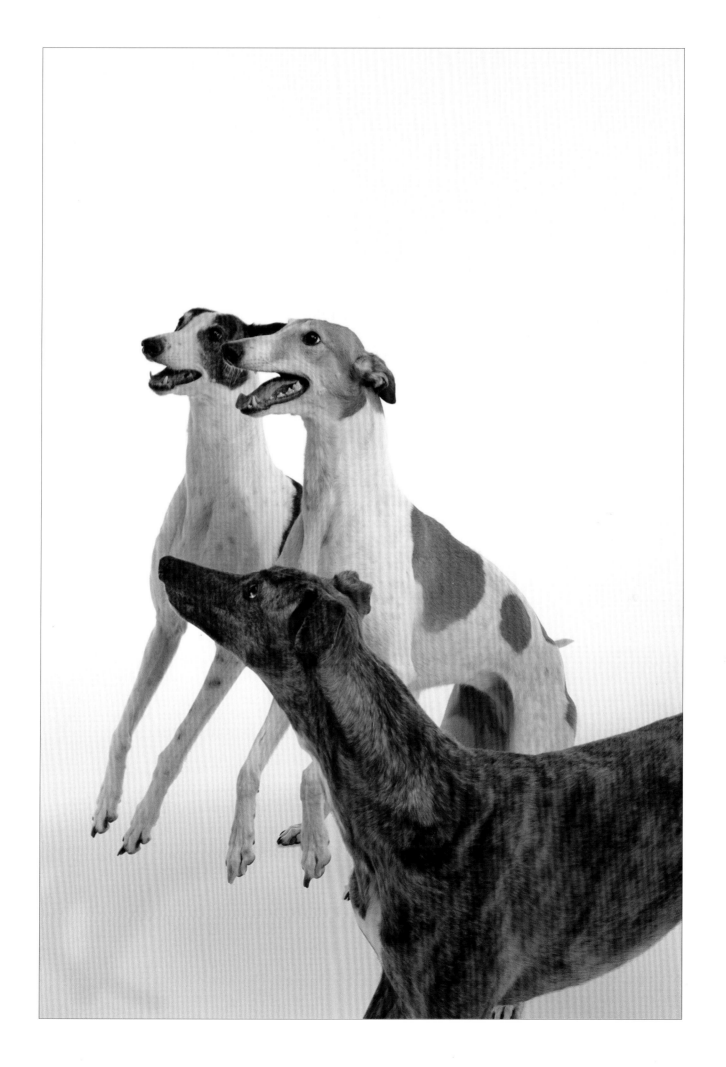

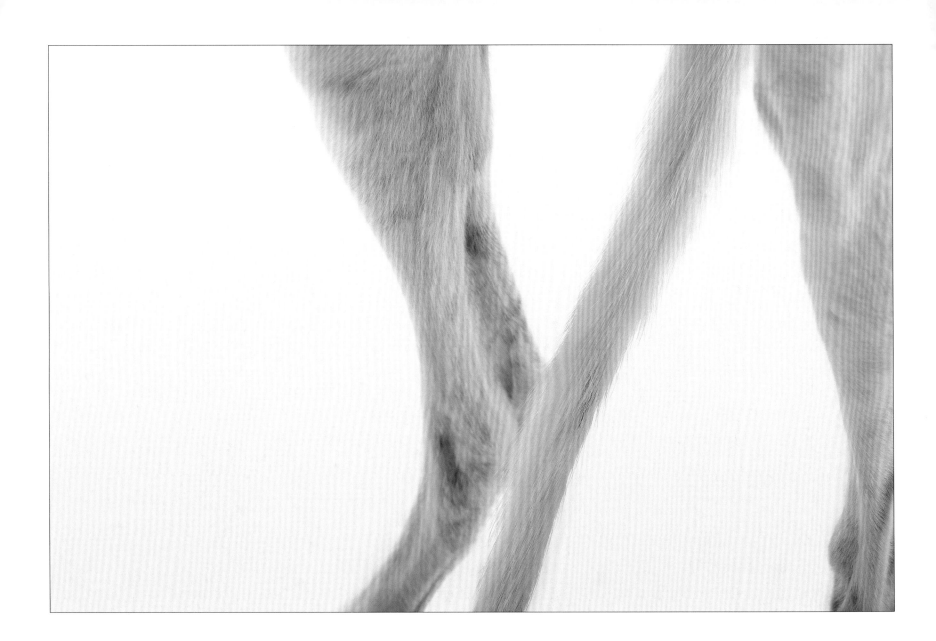

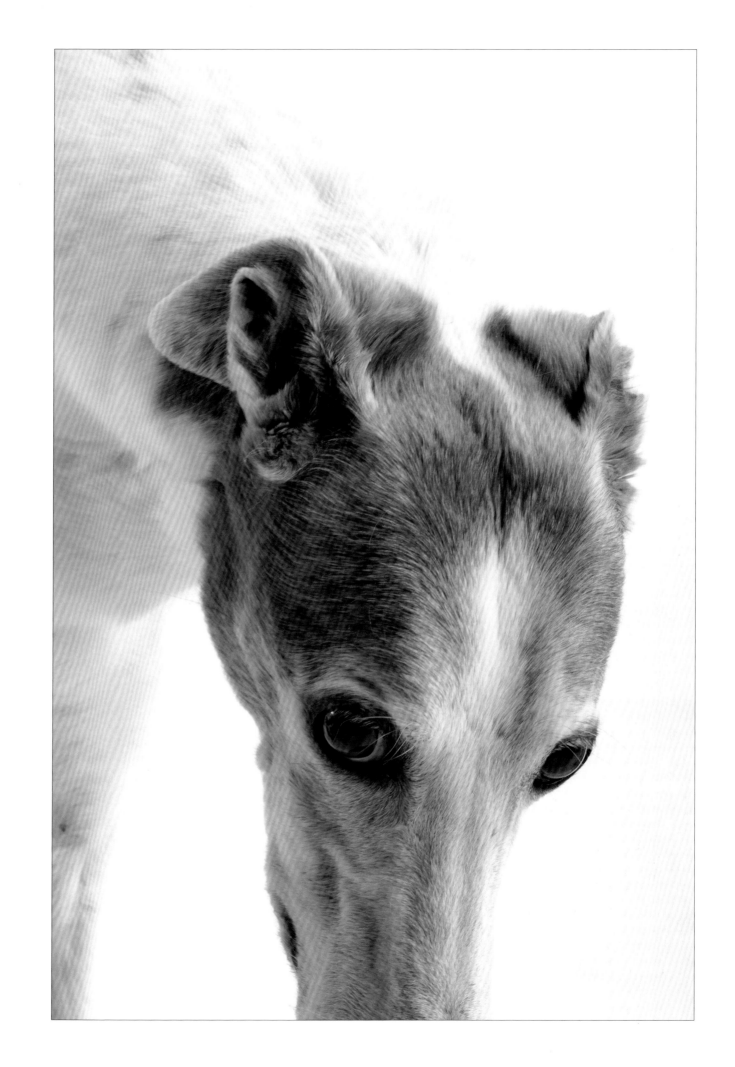

THE BLUE DAMPNESS OF A RAVINE.
A MEMORY OF LOVE, DISGUISED AS A MEADOW.
WISPY CLOUDS—GREYHOUNDS OF HEAVEN.

VLADIMIR NABOKOV, "CLOUD, CASTLE, LAKE," *NABOKOV'S DOZEN*, 1958

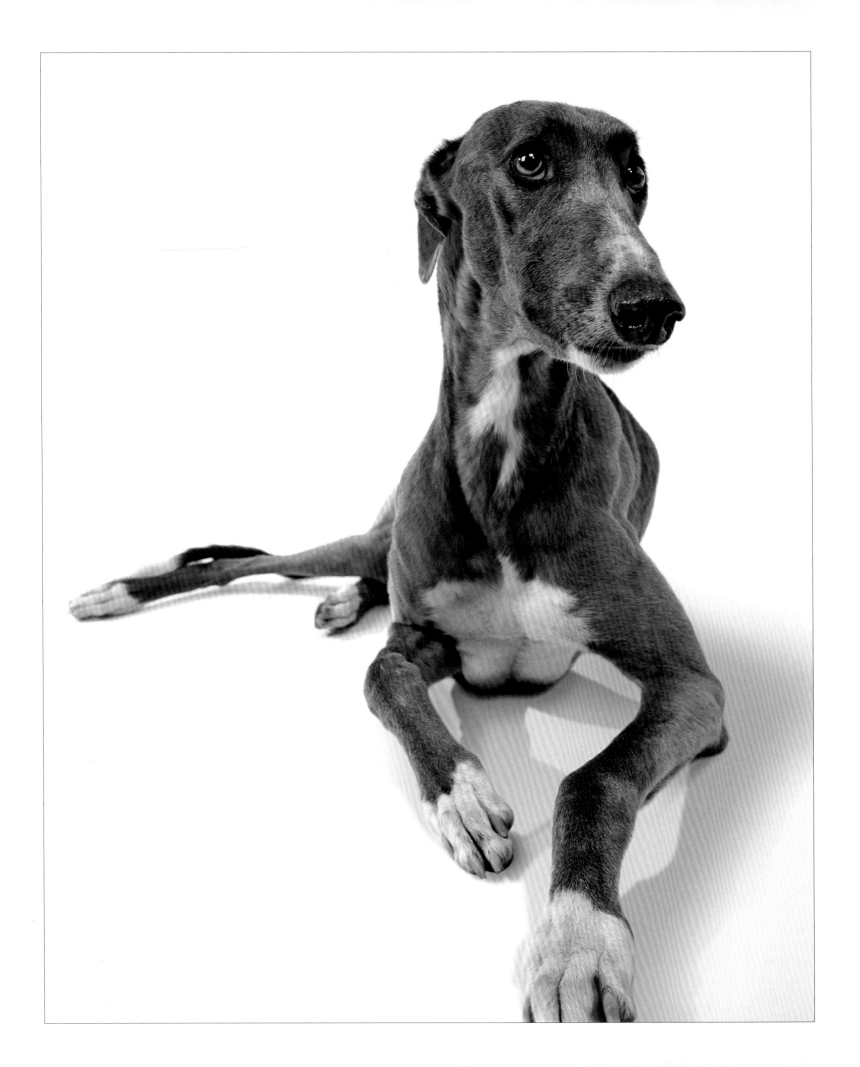

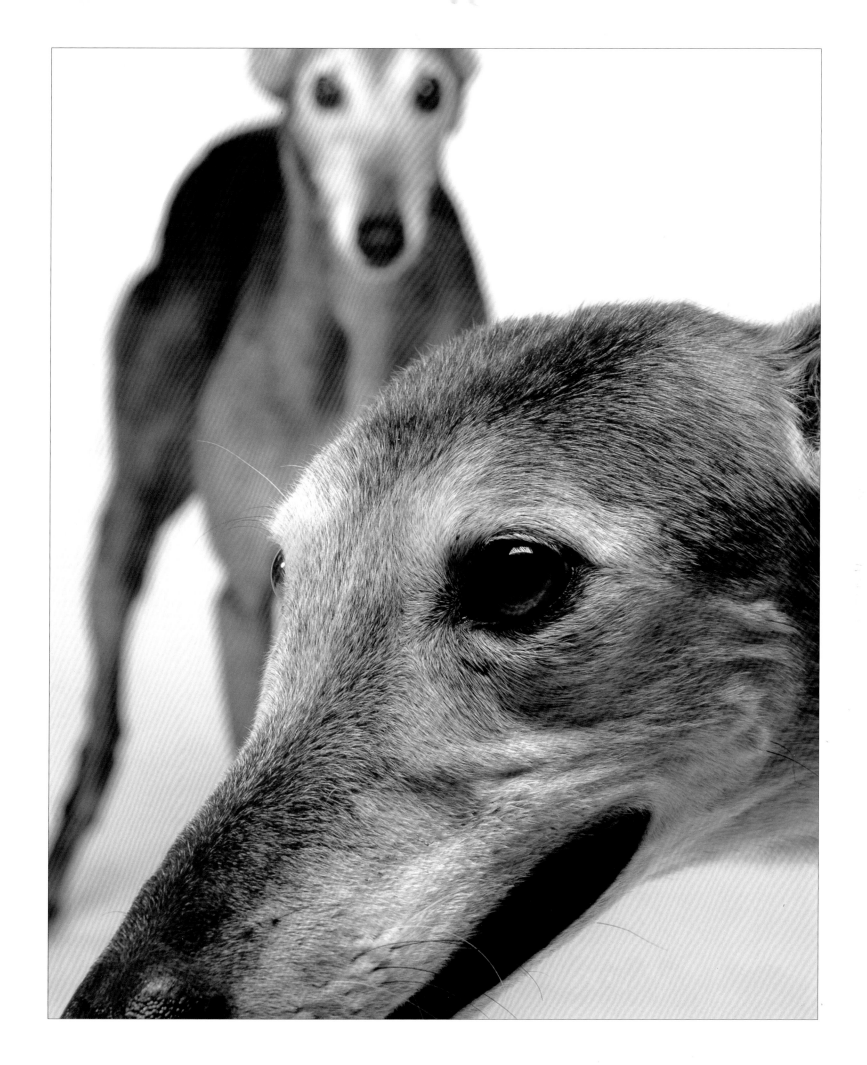

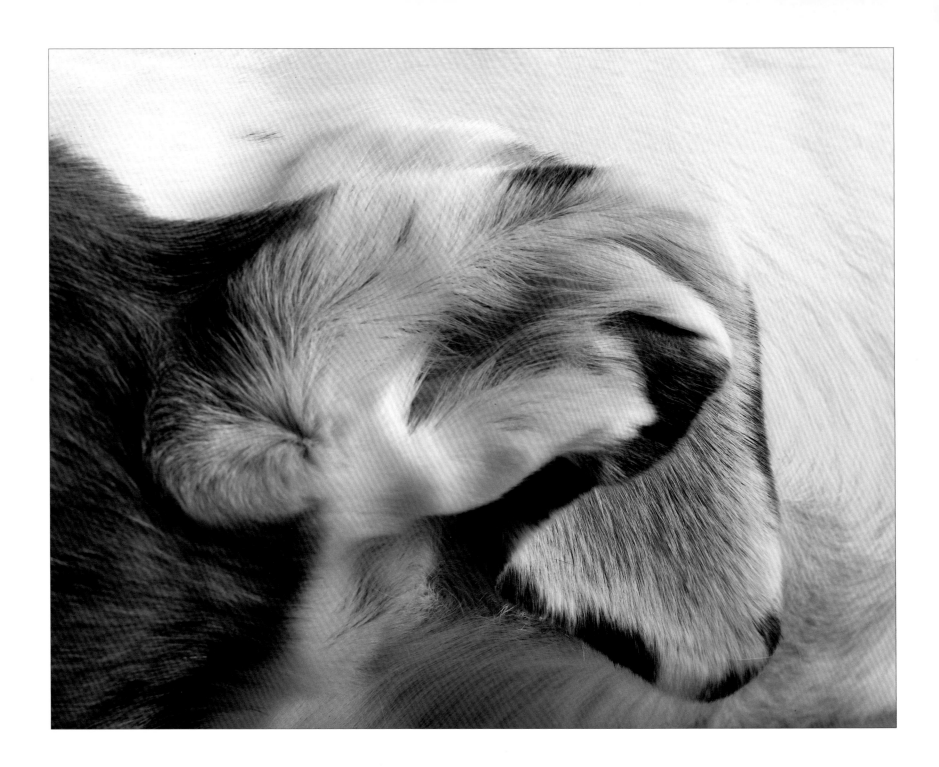

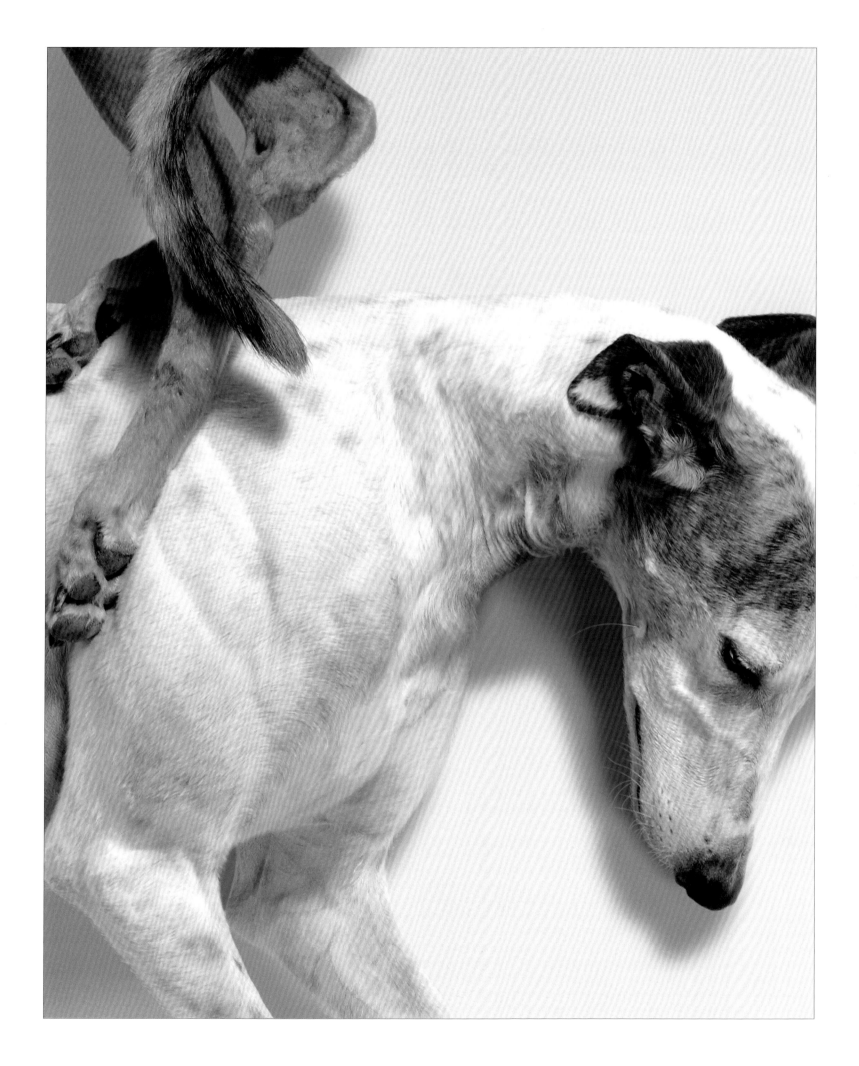

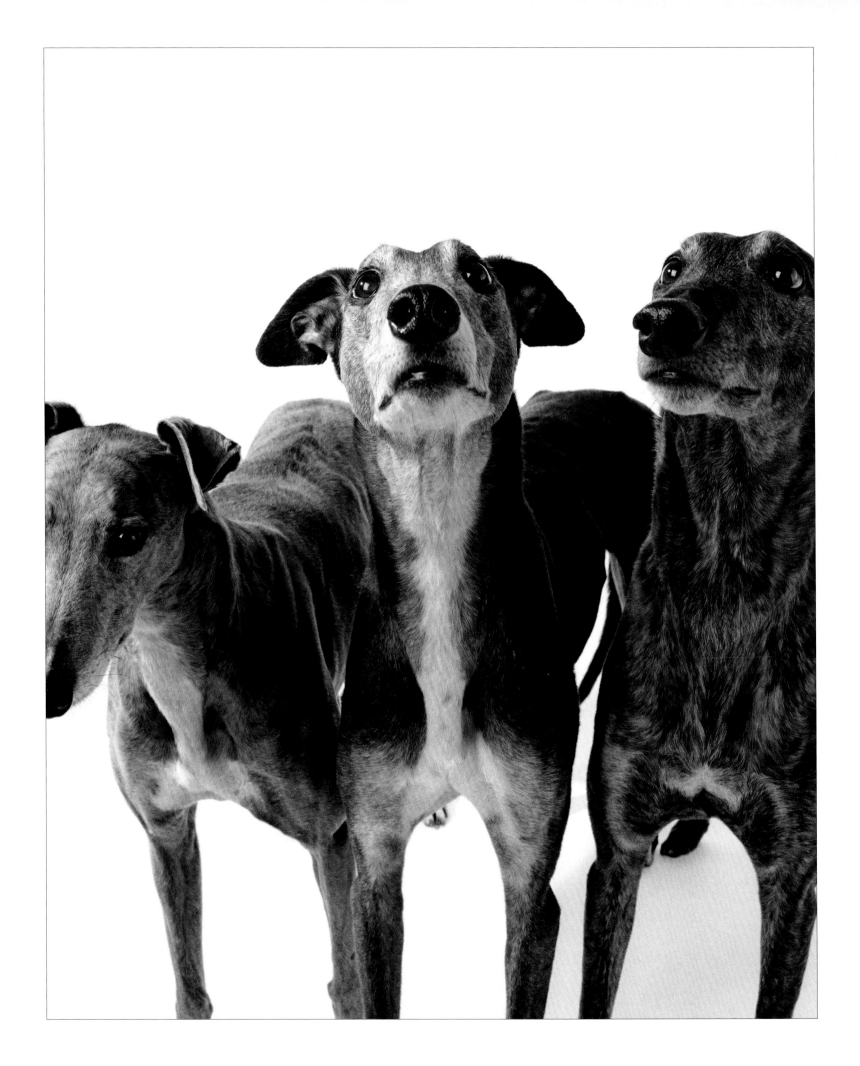

YVONNE ZIPTER
LIFE AFTER THE FINISH LINE

Consider that, as a favorite of the pharaohs and the Egyptian upper class, greyhounds were often mummified and buried with their owners to continue hunting in the afterlife. Consider that, during the famine-stricken Dark Ages, monastic sects used a portion of their meager resources to keep greyhounds, of all dog breeds, from extinction. Consider that, the only dog ever granted sainthood by the Catholic Church, St. Guinefort, was a greyhound.

I ask you to consider these things so that when I say there is something mystical about greyhounds, you will see the historical precedent. To be in the presence of one of these dogs is to know you are in the company of… a presence. Complete strangers, passing you with your greyhound on the street, recognize it. "God bless you," they will say, thinking they mean for rescuing a former racing dog. But in fact, God (or whatever higher power you believe in) has blessed those of us with greyhounds. We can feel it—some sense of peace and peaceful joy suffuses us when they are near.

I can't speak for what the ancients felt about greyhounds, but clearly there was some draw, for greyhounds are depicted as far back as 8,000 years ago in a Turkish sanctuary, in carvings and drawings from ancient Egypt, and in Greek and Roman mythology. Alexander the Great's favorite dog was a greyhound named Peritas, and General George Custer had a number of greyhounds. Greyhounds were there when the Spaniards found the United States. And even if those greyhounds were not what you'd call cuddly, they inspired awe, as illustrated by this excerpt from Captain Marcy's 1852 report to Congress about exploring Louisiana: "It is the most beautiful spectacle to mark the slender and graceful figures of the hounds as they strain every muscle to its utmost tension in their eager and rapid pursuit of the panic-stricken deer. It is a contest between two of the fleetest and most graceful and beautiful quadripeds in existence." While greyhounds are still bred to pursue prey, they are masters of tranquility, and their sense of ease helps smooth over the rough spots in one's day.

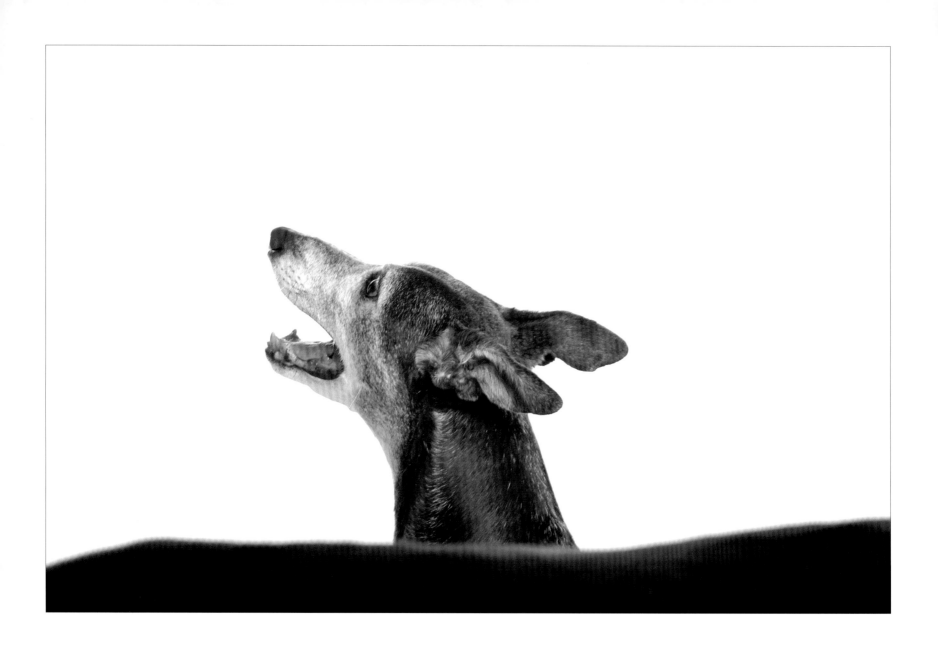

As a teenager, I would come home to find my parents and grandparents gathered around the fish tank as though it were a TV screen. "It's relaxing," they'd say. And I'd just laugh. But many is the time, now, as an adult, that my partner and I find ourselves gazing at our sleeping hounds, first Yoko and Nacho and, lately, Iris with a sense of awe and serenity. The way they sprawl—nearly hairless bellies exposed, thin legs vulnerable to a clumsy foot—is emblematic of the unquestioned trust with which they endow their human companions.

Many dogs, of course, from other purebreds to mutts, give trust and love, even on occasion where none is due. What amazes me about retired racing greyhounds, though, is they come to us, if not from the lives of abuse so sensationalized (and rightly) in the occasional horrific news story, then at least sometimes lives of deprivation, with limited human contact or affection other than at training time or on race days. But like the ascetics of the Middle Ages, living lives of poverty, want, and sometimes pain—the cuts and bruises, and perhaps broken bones or severed tails, borne of fierce competition on (and, from time to time, off) the track—greyhounds accept their lot without complaint and with unfailing good natures. They leave the track prepared to be endlessly loving and sweet. They lean into your thigh as though with a desire to meld their flesh with your own, to become finally and literally a part of you.

But to describe them thus makes them seem like dull slates, on which the same few words are written for each. Nothing could be further from the truth. Do not let their capacity for love and stillness mask their lively beauty. For as architecturally stunning as they are standing or reposing, the grace and athleticism they exude when running—cantering, trotting, galloping, flying—is enough to take your breath away. Spinning, leaping, pivoting, all four feet off the ground at once, they are acrobats of

They lean into your thigh with a desire to meld their flesh with your own, to become finally and literally a part of you.

speed. Greyhounds have become, after their time on the track, champion agility, flyball, jumping, and freestyle dancing dogs, though most are content simply to chase one another in their fenced yards or dog parks or to play tag with their humans. And what an electrifying thrill it is to have your hound run straight at you and, at the last second only, curve around you like a turn on the track. Breathtaking! And in those moments before they twist away from collision, every ounce of trust they invest in you, you return.

But neither are they simply canine running machines. They are also clowns, thieves, showmen, princesses, con artists, and scamps. They are dogs. Dogs who lick themselves, pass gas, burp, and stick their noses in embarrassing places. They are each and every one individuals. Nacho was our Wal-Mart greeter, the consummate greyhound "ambassadog", giving kisses indiscriminately. Afraid of cords and crossing the kitchen floor, he was an attentive listener who would do anything to please and had somehow mastered the ability to go backwards up stairs, if necessary. Yoko? She was our sullen teen, preferring to sleep in late, ignoring commands, giving dirty looks when reprimanded, pestering me until I would lie beside her on her bed for awhile every evening. Independent and spoiled, Yoko could be as sweet as she was sassy, with a winning way of pressing her head to your chest when hurt or frightened. And Iris—our laid-back, do-anything girl. We have taken her for rides in the canoe, to poetry readings, to sidewalk cafes, and even swimming—no small feat for a dog with minuscule amounts of body fat and so tending to sink. Even stingier with kisses than her half-sister Yoko, Iris is nonetheless a lover, submitting her face for kisses from you, her neck for hugs.

As a group, retired racing greyhounds—which make up the greatest percentage of companion animal greyhounds—owe at least some of their qualities to their lives on the track. This should not be considered an endorsement of greyhound racing but simply fact: handled constantly as they are by kennel workers and trainers, greyhounds are sociable, with a strong desire to be around people. They are also quick to adapt to new situations—including leaving racing behind to become pets—because they are often moved from track to track. Greyhounds are most often described as gentle, affectionate, quiet, loyal, friendly, even-tempered, and sensitive. And I have seen these traits in every greyhound I've ever met. Anatomically, racing greyhounds have large hearts. But it's about more than anatomy; it's about character.

I've always loved animals—from my grandparents' dogs to the small zoo we accumulated because we weren't allowed to have dogs where we lived: guinea pigs, chameleons, parakeets, turtles (snapping and dime store), salamanders, a bunny, gerbils, a kitten, and even an iguana for a short time. But I wanted a dog—my own dog—above all else, purebred or mutt. It didn't matter. And I still love dogs of all sizes and persuasions. But from the first day that long skinny dog walked into our house, I knew I'd never have a dog that wasn't a greyhound. He wasn't the fastest dog on the track, but it took only an instant for him to race into my heart.

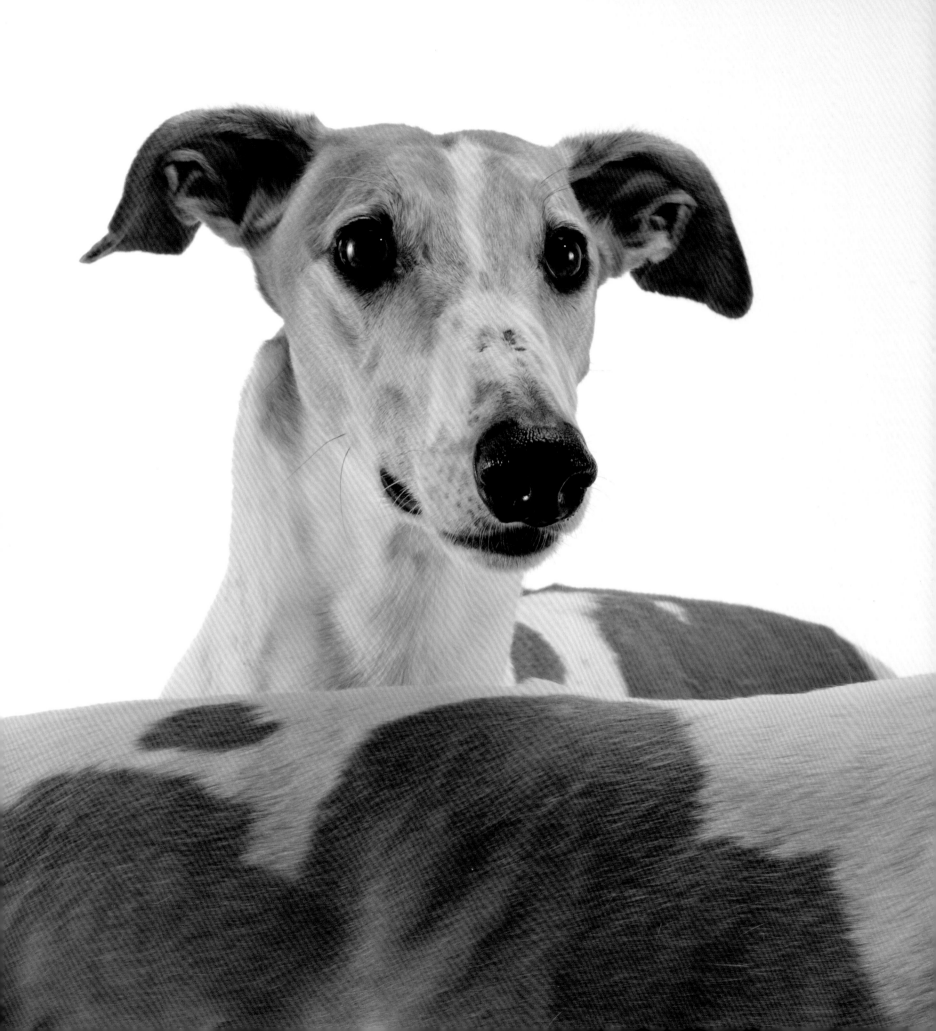

NEKO CASE
A PLACE IN MY HEART

As you've looked though this book I'm sure you've noticed how beautiful and elegant these dogs are. I'm sure you can also remember seeing antique statues, paintings, and even Egyptian hieroglyphics dedicated to them. Seeing photos and film stock of greyhounds running full out is nothing short of miraculous.

From an historical perspective, these dogs embody an ideal. There is a seriousness and formality in their representation. In real life, greyhounds are something else entirely. That's what I love about Barbara's photographs. She wants you to know them as they really are—somewhere between dog and cat and deer and sea serpent. Her love for them is apparent. Now, I'm no breed snob (I have two greyhounds, a pound hound, and several cats), or even species snob (I love all animals!), but there are a million reasons why greyhounds hold a special place in my heart.

They are the Bob Newhart of dogs. Subtle, smart, and hilarious. And, oh yeah, they just happen to be one of the fastest land mammals on earth. Don't let that intimidate you though—lounging is really their forte. Greyhounds have a very special kind of sensitivity and intelligence. They don't respond as well to barked orders as they do an actual physical hug. Nothing has taught me more about patience than spending time with greyhounds. Not because these dogs are difficult, but because of the way they reward you when you are soft with them. They really do blossom. It's funny, in the end they train you.

My dogs are my best friends who amaze me everyday. They take care of me. They love my friends, they remember everyone they meet and greet them with excitement, especially the kids, who are madly in love with these gentle hounds.

To those of you who are still scared to make the decision to go out and find your dog, let me say this: I would not compromise your quality of life for one more minute. I cannot recommend a companion with more conviction than these loving dogs. There is no equal to opening your front door and having that happy face there to greet you. No matter how crappy your day was, no matter how many mistakes you made, they love you. No questions asked! They are your biggest cheerleader. As the years go by, they keep on blowing your mind by becoming even more lovable and funny. There is a dog out there ready to show you all the love they have. C'mon! Your best friend is waiting…

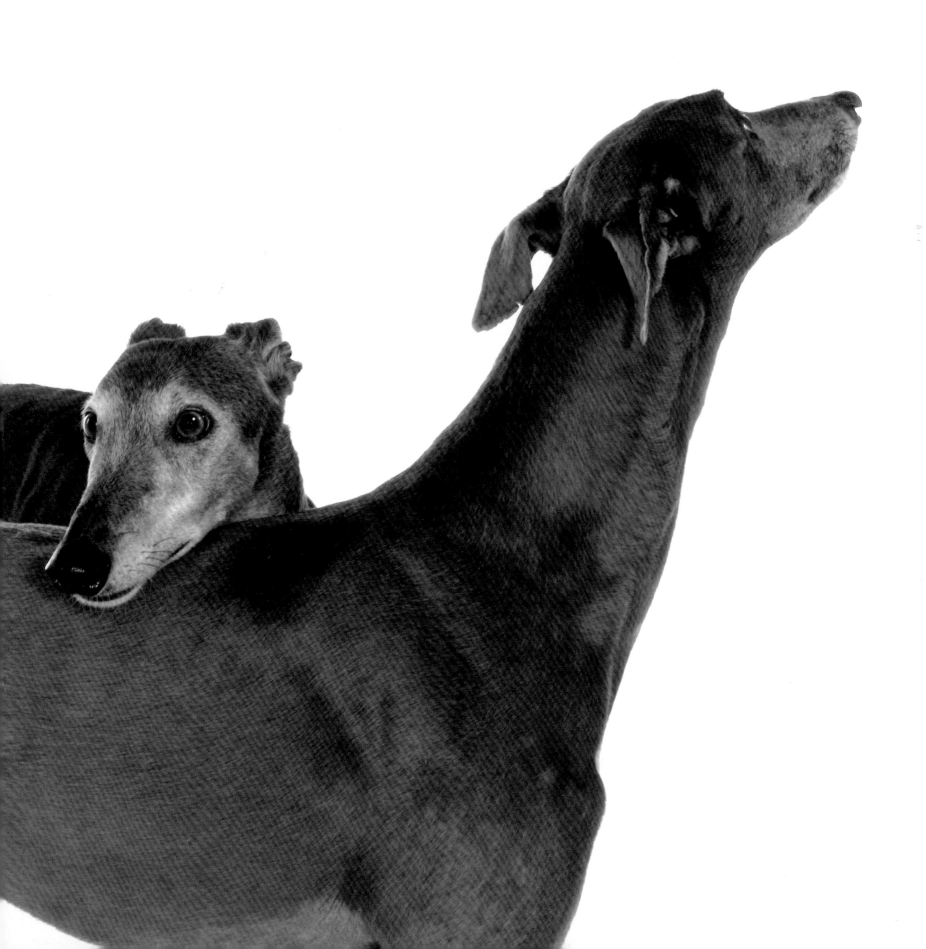

ADOPT A HOUND

No longer able to be competitive racers, each year thousands of young and healthy purebred greyhounds are in need of adoption. Most have worked the first two to five years of their lives as fine-tuned athletes and then, in some cases, after leaving the racetrack, go on to be used for breeding.

Greyhounds have a sensitivity that can transcend what might traditionally be anticipated of a pet. Despite their rigorous pre-retirement routine, they remain easygoing, spirited, and loyal. Their transition from life at the racetrack to life in the home is remarkable and almost effortless. They have a loving spirit as well as a humorous disposition which, when nurtured, can bring great pleasure to their human companions both young and old alike.

Female greyhounds generally range in weight from fifty to sixty-five pounds and the males weigh between sixty-five and eighty-five pounds. Their colors and markings are very diverse and many of them are unique in their combinations. The life span of a healthy greyhound is twelve to fourteen years.

It is in a greyhound's nature to love to run. They are sprinters who can achieve speeds of more than forty miles per hour, but once retired many of them are simply not interested in running. Despite a popular misconception, they are not hyperactive dogs and are well suited to urban living.

They generally spend the majority of their day comfortably snoozing. Most greyhounds are extremely sociable, possessed of a remarkable intelligence and gentleness. Some are independent, others choose always to be at your side, while others are shy and reserved. However, no matter the temperament, they are completely dedicated to their guardians. As a breed, they are eager to please and infinitely trainable with a patient and gentle hand. They are demonstrative and affectionate with their families and some are just in love with

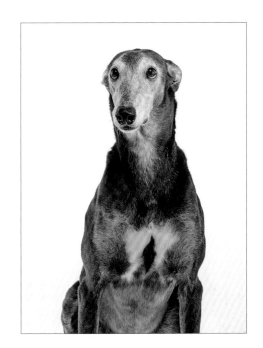

absolutely everyone they meet. Greyhounds are very adaptable and although they share many similar qualities, their personalities are as infinite as the range of their colorations. No matter what a prospective adopter's age, gender, family situation, or other pets, there is sure to be a greyhound that can be found to be well suited for any home environment: urban, suburban, or rural.

Most of the dogs represented in this book found homes with loving families through Greyhounds Only, Inc., a registered tax-exempt charitable organization. Nearly all were professional athletes, and that athleticism, agility and grace informs these portraits. Many of the dogs in *Greyhounds* no longer survive, but their vital and charismatic personalities, as captured in these timeless images, immortalize their unconquerable spirits.

If you live in northeastern Illinois or southeastern Wisconsin, Greyhounds Only, Inc. would be happy to see if a greyhound is the right pet for you. You can find out more about greyhounds and adoption at www.greyhoundsonly.com. If you live outside that area, there are hundreds of greyhound adoption groups in the U.S. and abroad. You can find a greyhound adoption agency in your home state or country by going to www.adopt-a-greyhound.org/directory/list.cfm. If adoption is not a possibility, please consider contributing your time or talents to assist your local rescue group in their efforts to adopt the hounds.

Adopting a greyhound can impact your life in ways beyond your wildest imaginings. Not only will you be committing to a wonderful new companion, your life will also be enriched by the myriad of remarkable people in the greyhound community—people who have also made the wise choice of sharing their lives with these exceptional dogs.

ACKNOWLEDGMENTS

Collaboration is a word that is inherent in greyhound rescue. The dogs could never make it from the racetrack to adoption without the support and cooperation of many people. Collaboration has also been the keynote for my book *Greyhounds*. What started out as merely a way to generate extra revenue for Greyhounds Only turned into a full-blown photographic project supported by the efforts of many creative and caring individuals.

I would like to thank so many people for their participation in this project: Jon Underwood, Pete Maloy, Rob Perisho, Geoff Nicholson, Shawn Miller, Rick Pannkoke, T. Harrison Hillman, and Tony Favarula for their efforts as both photographers and assistants during the many photo shoots through the years; Tamara Wilm and Kendra Brennen, the best interns-turned-assistants that I could have hoped for; Erik Sagerstrom for his meticulous eye; all the myriad of dog guardians who brought their greyhounds to my studio in the frigid cold and blazing heat to be photographed; Julia Archer for her creative counsel; Cara Brockhoff, Cindy Hansen, Michael McCann, and Barbara Judson for their networking,

recommendations, and greyhound introductions; Linda LaFoone, who oversaw my adoption of Easton (my first greyhound) and truly changed my life forever by that one act; Nancy Bush, Laura Dion-Jones, Joy Kalligeros, the Karants, the Prohovs, the Millers, Catalina Salley, Steven Toushin, and Paul Florian for their opinions and friendship; Mary Virginia Swanson for her time appropriate introduction; Leslie Stoker for her vision and commitment to *Greyhounds*; Kristen Latta for always being available to deal with questions or concerns regarding the creation of this book; Maria Grillo and Katherine Walker for their phenomenal design; Gary Chassman for his always supportive and prudent counsel; and Alice Sebold, Alan Lightman, Yvonne Zipter, and Neko Case for the memorable and lyrical words—articulating sentiments in ways I never could—surrounding my photography and taking the book to another dimension. Finally, although they would rather have a treat than thanks, I want to mention Slim, Turtle, Fancy, and Silvie, my foster dog, with their benign, silly, and loving demeanors, for bringing humor into the workplace. Lastly, I thank Lauren Hilty, who kept everything on track and was the voice of reason, the maven of organization, through the most difficult part of this project, which has culminated in this book.

—Barbara Karant

Developed and produced by Gary Chassman
Verve Editions, Burlington, Vermont

Library of Congress Control Number: 2008924220

ISBN 978-1-58479-735-7

Project editor: Kristen Latta
Production manager: Jacquie Poirier
Project manager for Verve Editions: Darrah Lustig

Book design by The Grillo Group, Inc.

The text of this book was composed in Trade Gothic.
Printed and bound in China.

10 9 8 7 6 5 4 3 2 1
First Printing

HNA ▌▌▌▌▌
harry n. abrams, inc.
115 West 18th Street
New York, NY 10011
www.hnabooks.com

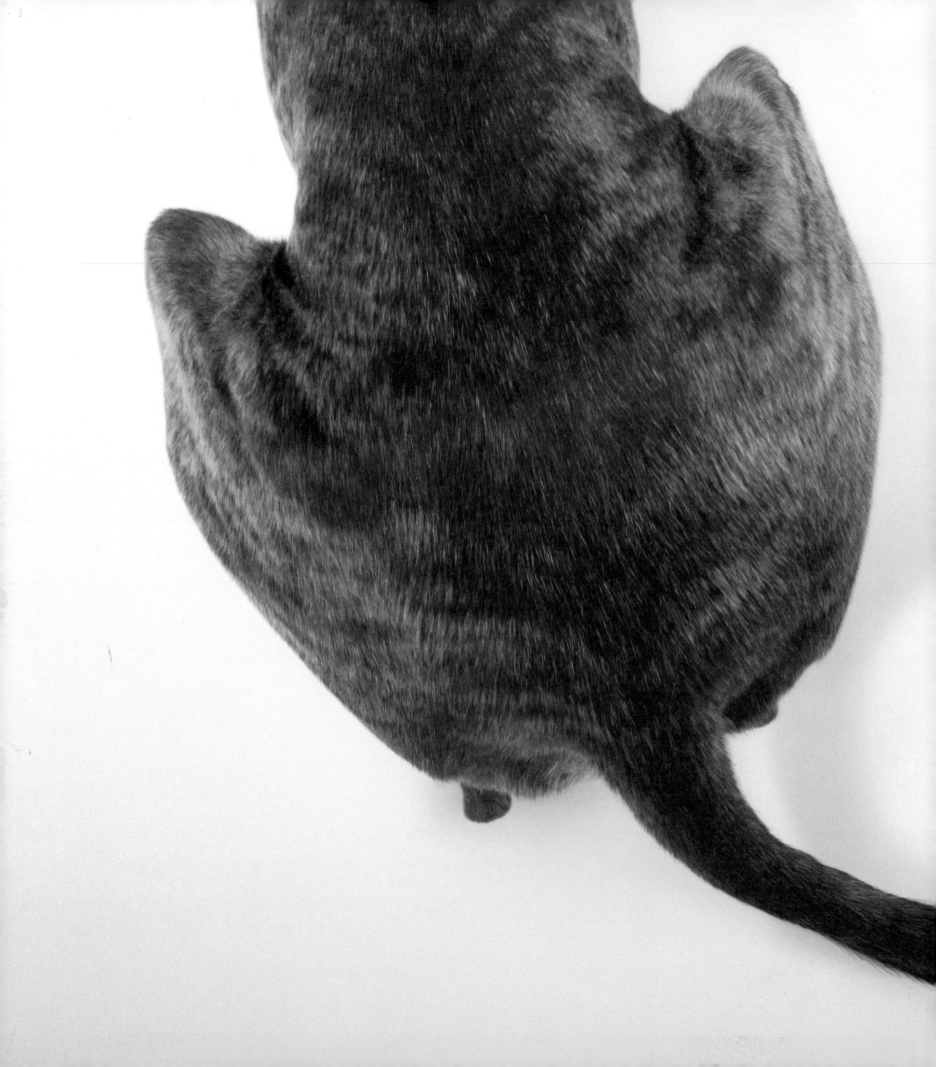